STYLE
BOOK II

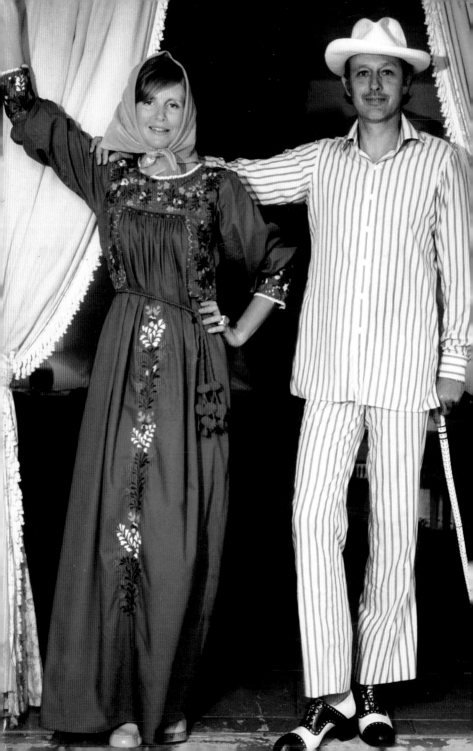

ELIZABETH WALKER

STYLE BOOK II

PATTERN AND PRINT

Flammarion

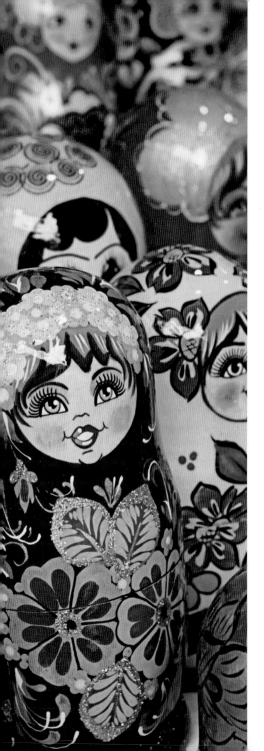

Design: Tea Aganovic
Picture Research: Jennifer Jeffrey
Proofreading: Helen Woodhall
Production: Mary Osborne
Special thanks to Liz Ihre
Color Separation: Anderson Technology Pvt. Ltd.
Printed in China by Imago

Originally published in Great Britain:
Copyright © Endeavour London Ltd. 2013

This edition:
© Flammarion, S.A., Paris, 2013

13 14 15 3 2 1

ISBN: 978-2-08-020162-1

Dépôt légal: 09/2013

Left Fluttering their eyelashes, wearing
flowered costumes painted in primary
colours.
20th Century Wooden matryoshka
dolls from Prague in the Czech Republic.

Previous page Island inhabitants in striped
pyjamas and brogues, and an embroi-
dered kaftan.
1973 Colin Tennant, 3rd Baron Glen-
conner, and his wife, Anne, on Mustique
in the West Indies.

CONTENTS

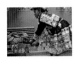
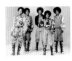
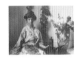
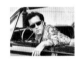

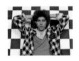

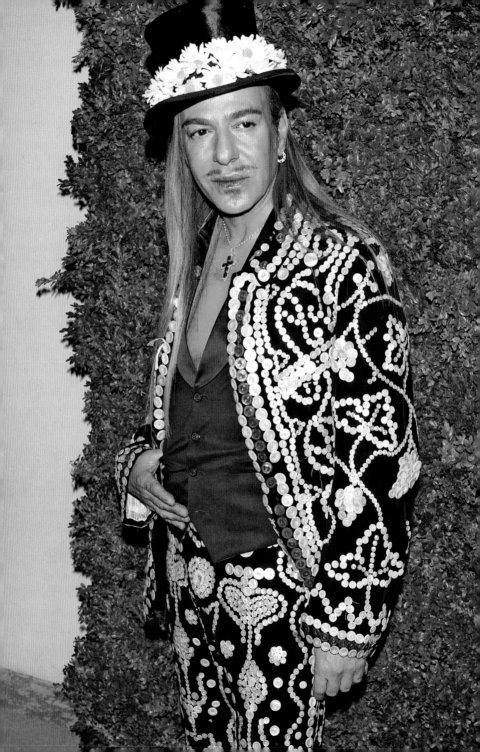

pattern and print

As a fashion editor, my uniform was fairly monotone, basically black with a bit of white, grey or chocolate brown thrown in for good measure. Pattern was limited to a smattering of spots, stripes and the odd check. Recent designer collections have burgeoned with bright flowers, neons have added shock appeal to simple shapes, but black never goes away for very long.

My house, however, is a cacophony of colour mixing Schiaparelli pink, tangerine with touches of turquoise. The floor is black-and-white check and I have a small collection of kilims and hangings, purchased largely on my travels to far-flung locations. I am a serious tourist shopper; embroidered kimonos from Japan, batiks from Indonesia, Paisley from India and France, bright kangas from Kenya and a tablecloth from Hawaii printed with red hibiscus, also known as Bunga Raya, the national flower of Malaysia. All these purchases fuelled my passions for print and textiles and gave me a healthy curiosity as to their origins.

On one of my many visits to the Victoria & Albert Museum in London I came across an inspiring book, *Woven Cargoes, Indian Textiles in the East* by John Guy, one of the curators. It tells tales of trading in textiles, fabrics and spices all around the eastern hemisphere. It is fascinating to comprehend the origins of the likes of chintz, to wonder why the same flowers appear in prints as far afield as Africa and Mexico, and to understand the inspirations for contemporary fashions and fads.

ELIZABETH WALKER

Pearly prince before his fall in a black suit of pearls and a hat covered in daisies.
2008 British designer John Galliano of Dior, at a *Vogue* party in New York.

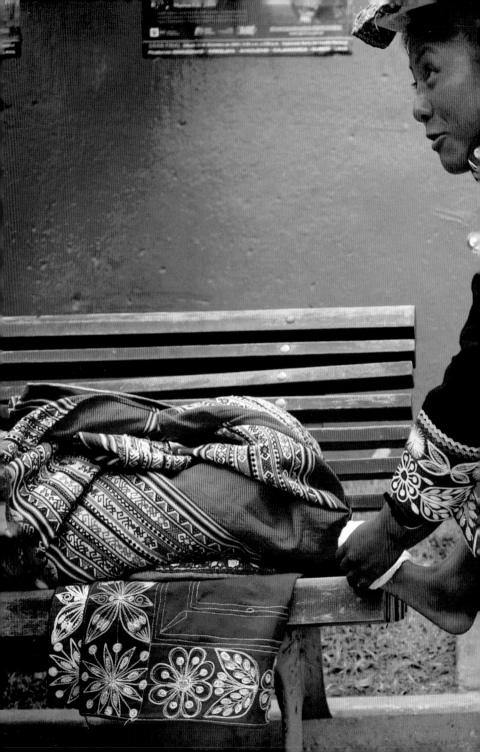

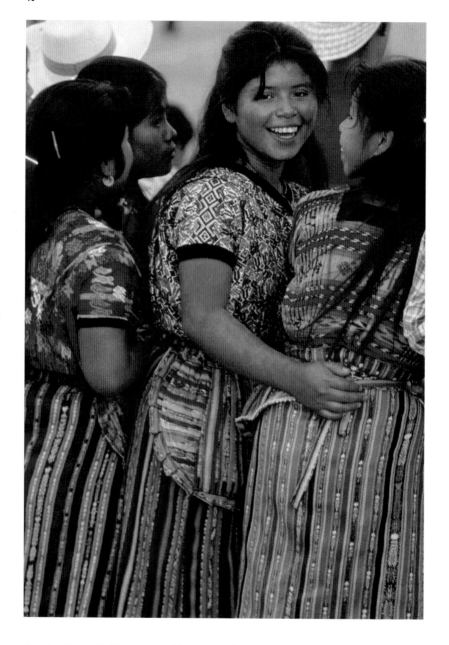

Bright smiles and bright blouses with neither a skeleton nor a spook in sight.
1968 Mayan teenagers at Day of the Dead celebrations, Sumpango, Guatemala.

Previous page Perfect Peruvian prints, woven and appliquéd, a mamacha (Andean woman).
2009 A trader before a football match outside the National Stadium in Lima, Peru.

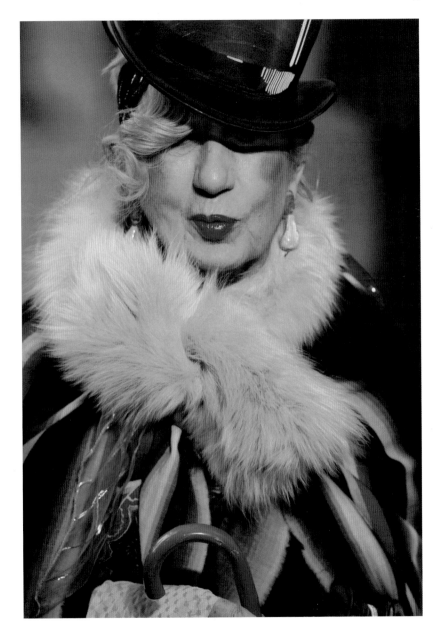

Famous fashionista in a Mexican-inspired striped coat, cap and pink fur tippet.
2010 Anna Piaggi attends the Missoni spring/summer fashion show in Milan.

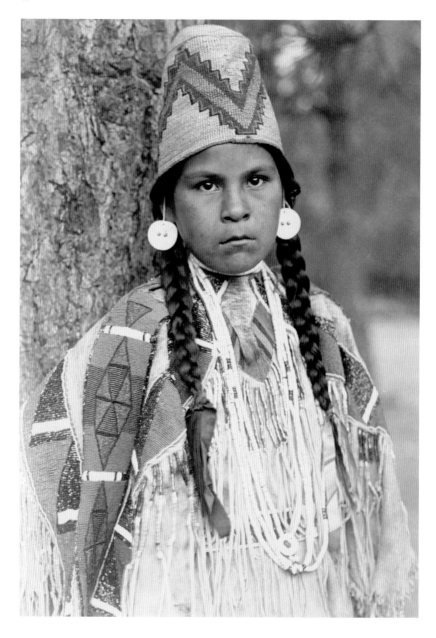

Natural style, a beaded buckskin dress, shell jewellery and a woven grass hat.
c.1910 A Umatilla woman on an Indian reservation in Oregon, USA.

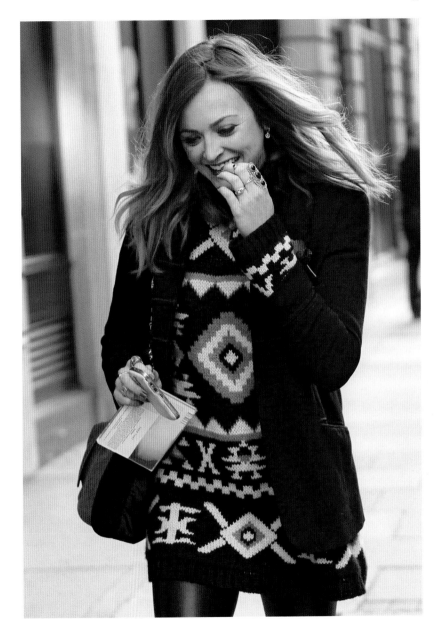

Rock chick kitted out in a Peruvian knit tunic over skin-tight leggings.
2010 Television and radio presenter Fearne Cotton in London.

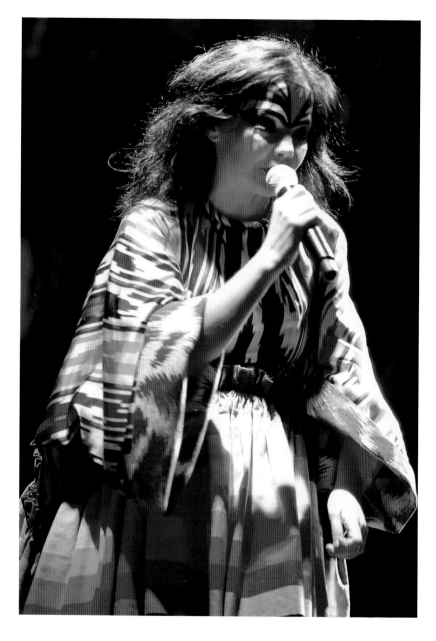

International inspirations, a brilliant costume from the Mexicans or the Mayans.
2008 Icelandic musician Björk performs live at the Apollo, Manchester, England.

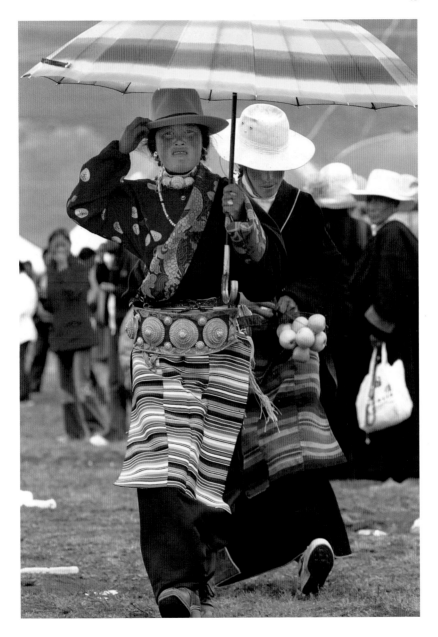

High-altitude fashion complete with aprons, straw hats and a bright umbrella.
2006 Tibetan women during the Litang Horse Racing Festival in Sichuan, China.

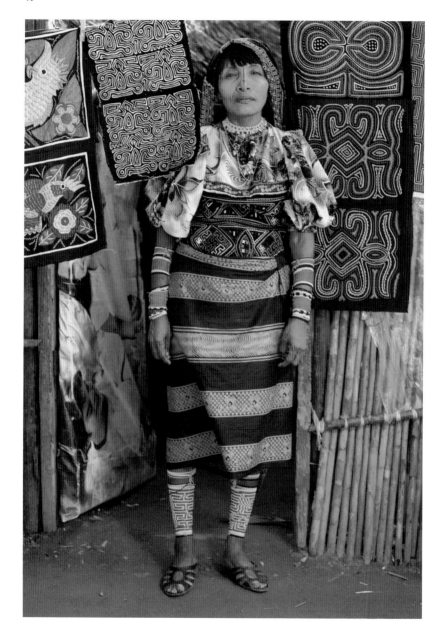

Traditional trappings, striped and appliquéd, beaded bracelets and leggings.
c.2009 A Kuna woman with molas (embroidered panels) in Colombia.

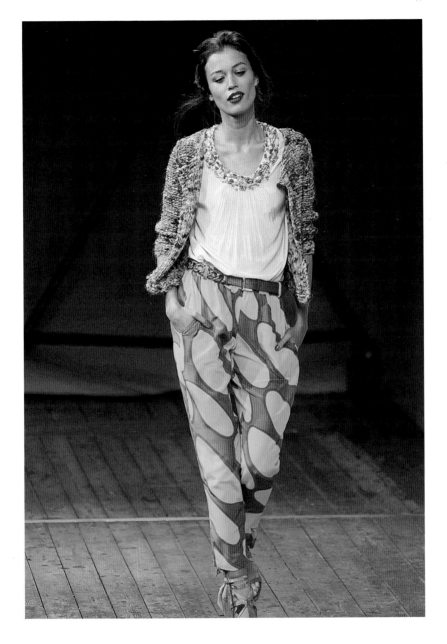

A beautiful bolero knitted with ribbons worn with bright botanical-print pants.
2011 Moschino Cheap & Chic spring/summer fashion show in Milan.

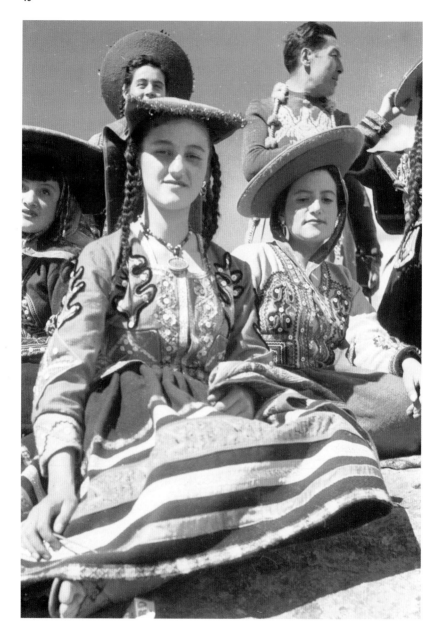

Colourful costumes celebrate the Incan myth of the Festival of the Sun.
c.1955 Quechua Indian girls at the ancient Inti Raymi ceremony in Peru.

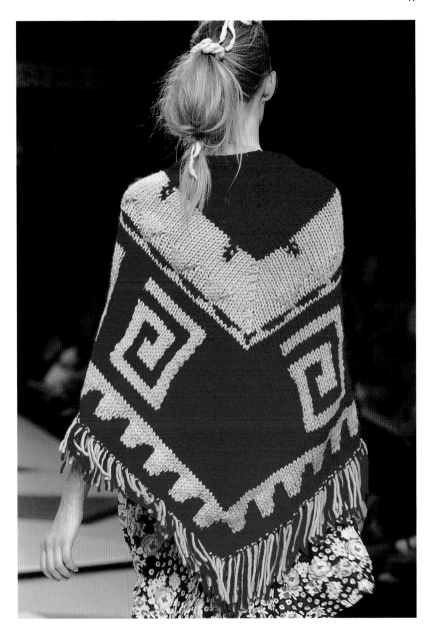

A perfect traditional poncho worn with a flirty, flowered skirt.
2005 Super Lucy in the Sky autumn/winter fashion show in Rio de Janeiro, Brazil.

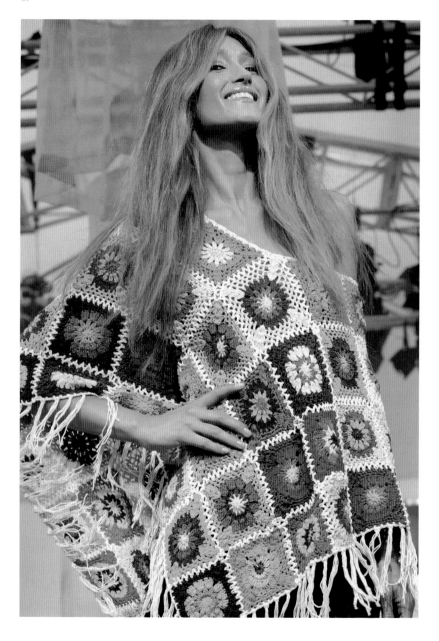

Crocheted and cool, a multicoloured poncho with a nod to the sixties.
2010 Leonard St. spring/summer fashion show in Melbourne, Australia.

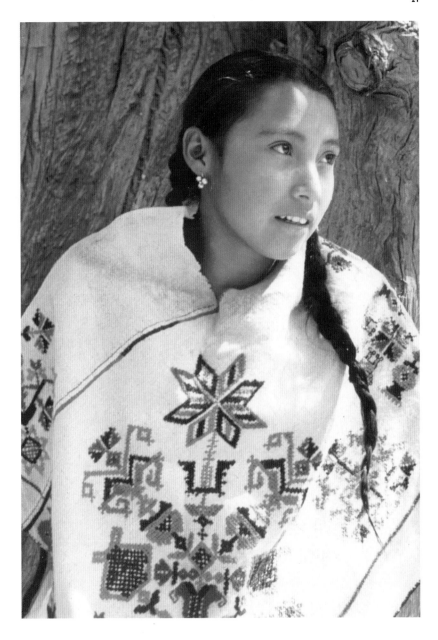

Fashionable over a demi-century ago but just as stylish if worn today.
c.1955 A Mexican girl wearing a hand-embroidered poncho.

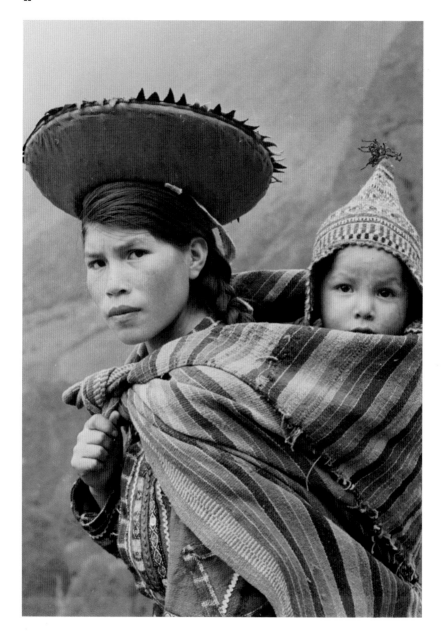

A flying-saucer hat, a cosy cap and layers of shawls ward off the winter winds.
c.1955 A Peruvian woman trekking through the Andes with her baby.

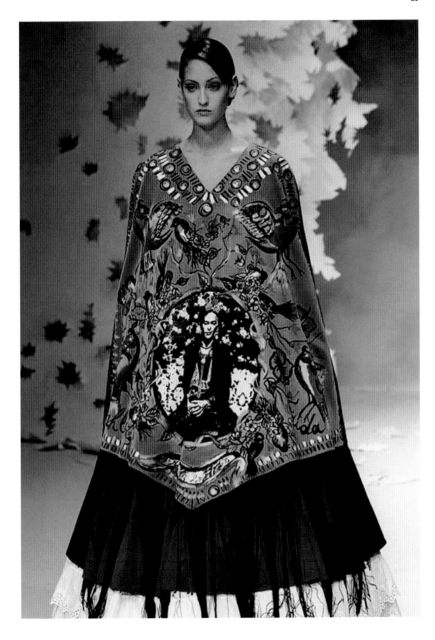

A curious mantle in crimson with a medallion print worn over a full silk skirt.
1996 Franck Sorbier spring/summer fashion show in Paris.

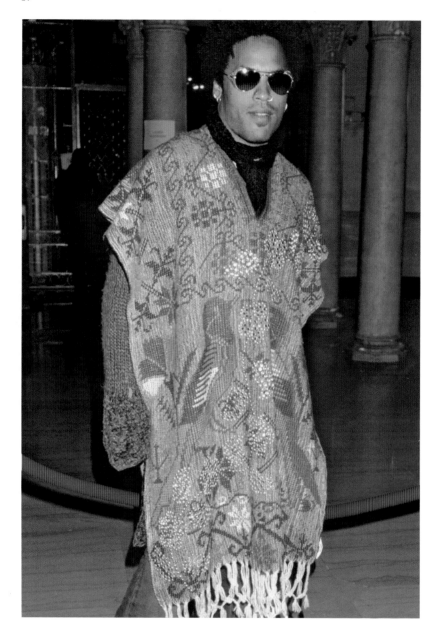

An ethnic cape embroidered with flowers and birds – a holiday souvenir?
2000 American singer/songwriter Lenny Kravitz at an MTV charity auction.

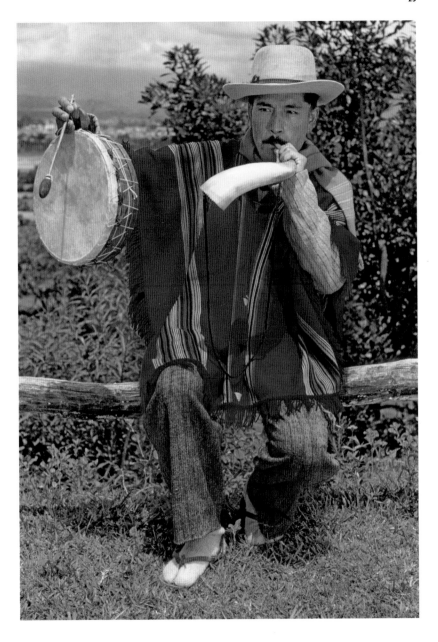

A folkloric homemade costume and instruments to wow the crowd.
1958 A musician playing a drum and horn, San Salvador de Jujuy, Argentina.

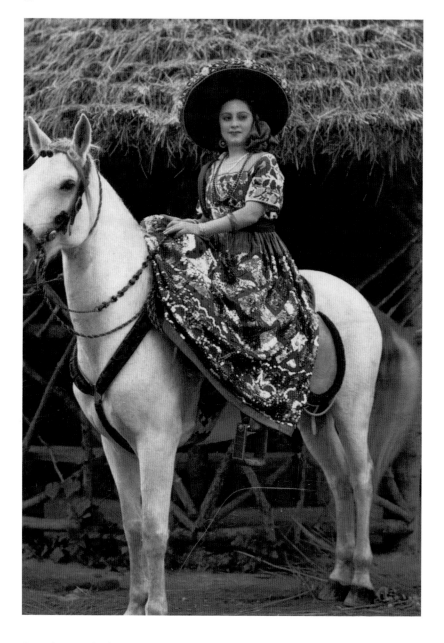

A sombrero and a frock appliquéd with flowers, perfect for a day in the saddle.
1940 A señorita in costume outside a traditional dwelling in Mexico.

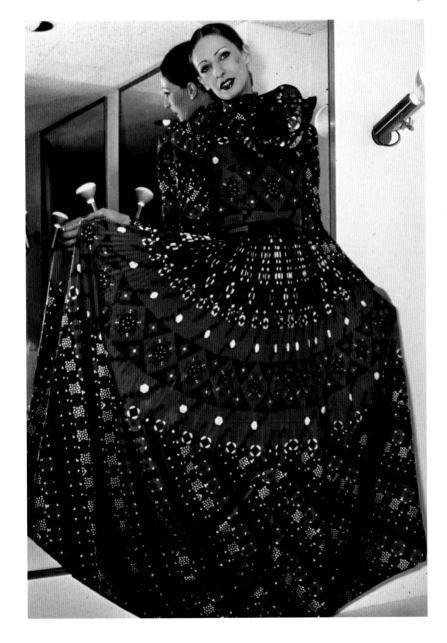

A Byzantine-inspired print in red, white and blue with a sunray-pleated skirt.
1972 An haute couture evening gown in taffeta by Lanvin, Paris.

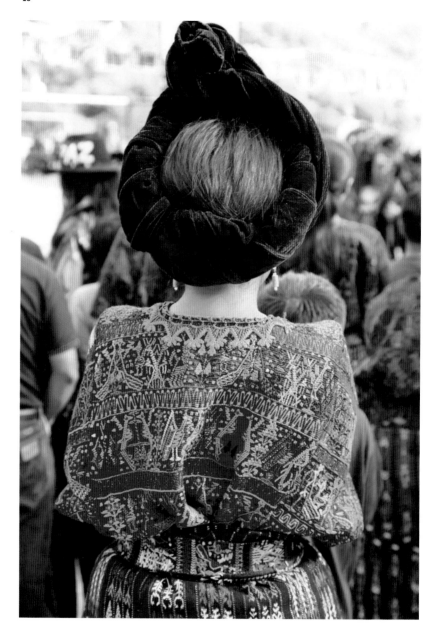

A cintas (headband) in deep red woven into the hair and wrapped around the head. 20th Century A Mayan woman in ceremonial dress, Guatemala.

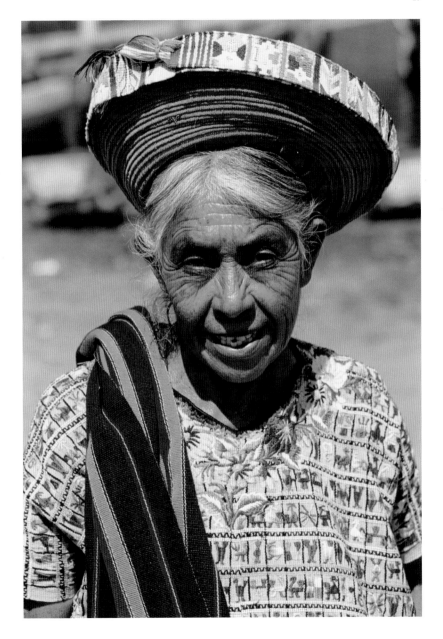

Flowers and tiny animals, beautifully embroidered, mixed with bright stripes.
20th Century A Tzutujil woman wearing a traditional huipil (tunic), Santiago, Guatemala.

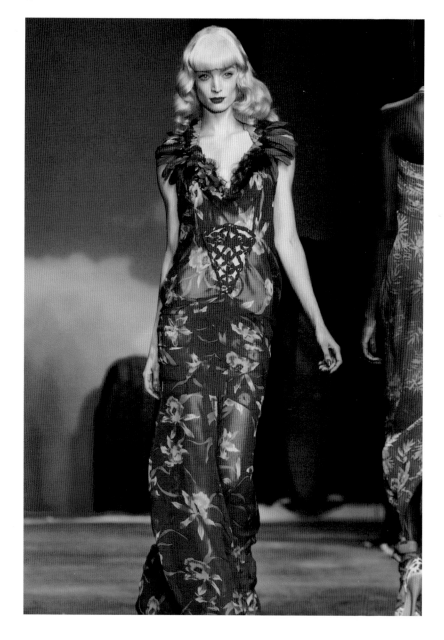

A long, lean red dress printed with tropical flowers and edged with feathers.
2011 Christian Dior spring/summer fashion show, Paris.

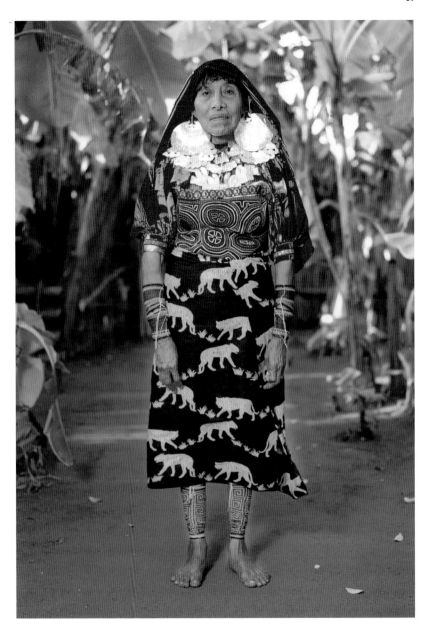

Pumas prowling across a black skirt, a red blouse and scarf adorned with flowers.
20th Century A Kuna woman wearing traditional garb in the Colombian jungle.

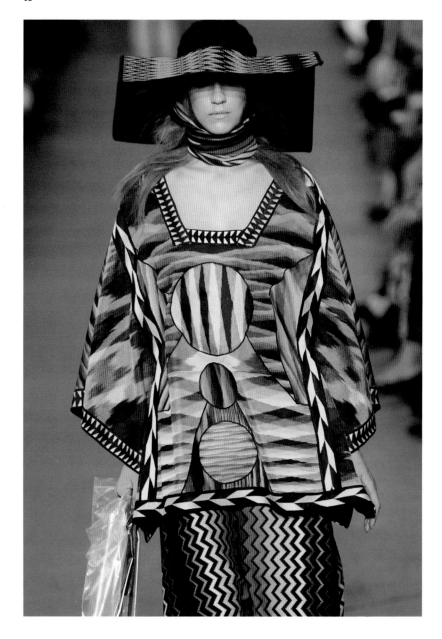

Brilliant knits zigzag across a top and long, lean skirt inspired by Andean prints.
2011 Missoni spring/summer fashion show in Milan.

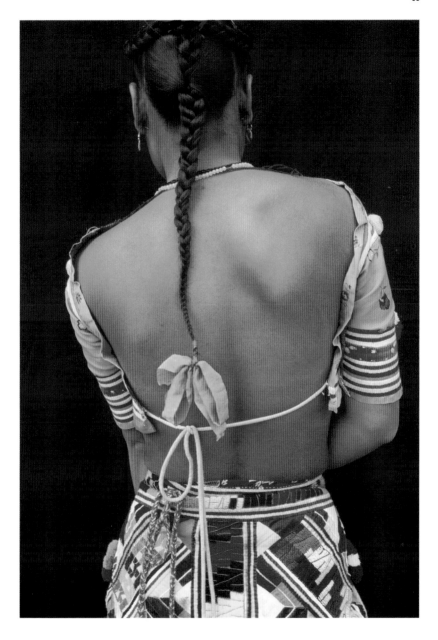

A bright palette of primary colours adorns an embroidered skirt and a cropped top.
20th Century A Nepalese woman in traditional clothing with a beautiful bare back.

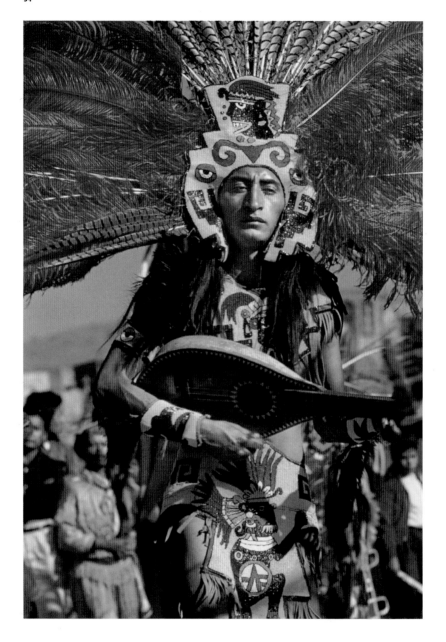

The Sun King bedecked in exotic carnival clothes explodes onto the city streets.
1961 An Aztec musician in an elaborate feathered headdress at a fiesta, Mexico.

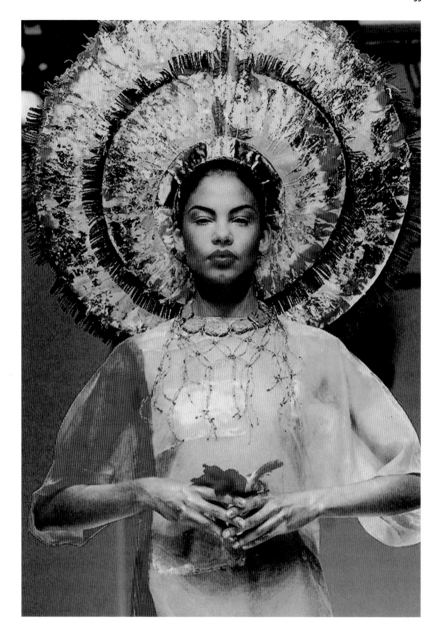

An Incan-inspired bride wearing a feathered headdress shining like the sun.
1998 Mary McFadden spring/summer fashion show, New York.

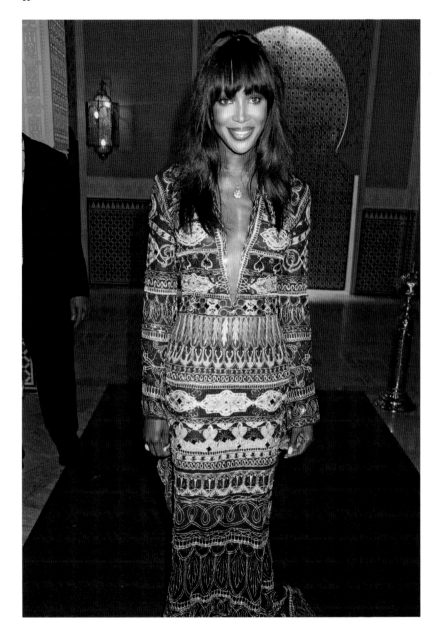

An exotic diva in a kaftan-like gown inspired by Arabian tiles.
2009 Model Naomi Campbell at the opening of a resort in El Jadida, Morocco.

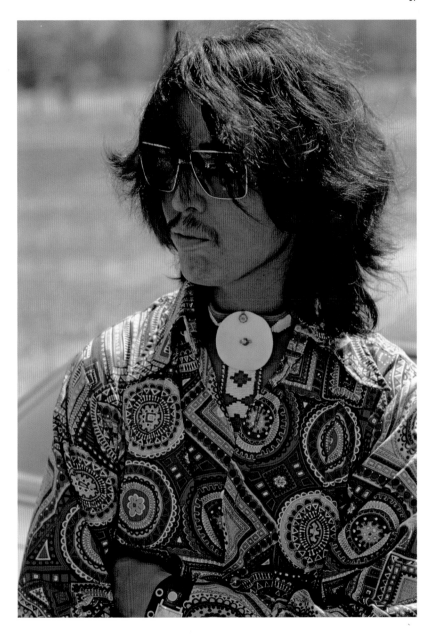

A print shirt and a silver disc necklace inspired by George Harrison of The Beatles?
1973 A Nez Perce Indian wearing both traditional and modern styles, Idaho, USA.

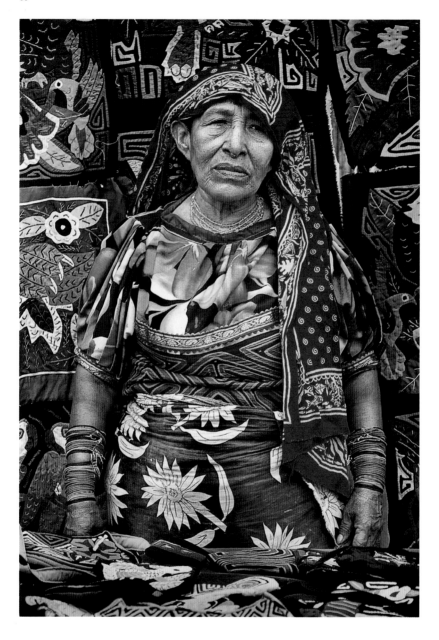

Leaves, flowers, birds and fish all tell a tale from the South American jungles.
20th Century A Kuna Indian selling molas (embroidered panels) in Colombia.

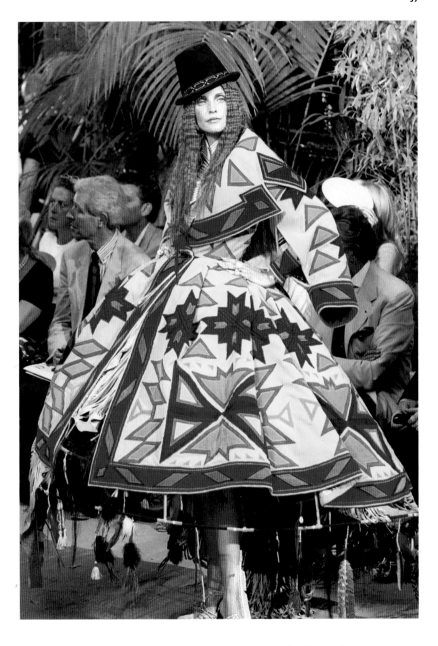

Designer John Galliano inspired by a trip to visit the tribes of South America.
1998 Christian Dior autumn/winter haute couture show, Paris.

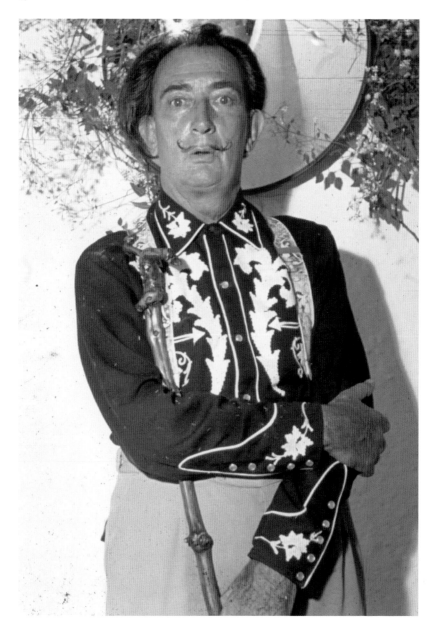

Clad in the clothes of a caballero, wearing a crisp black-and-white appliquéd shirt.
1963 Spanish surrealist Salvador Dalí at home sporting his famous moustache.

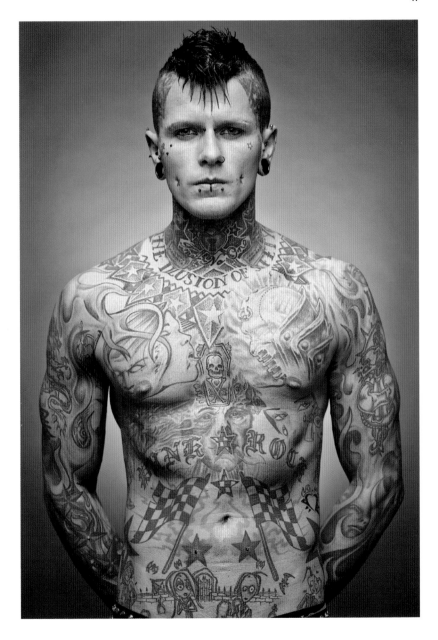

Maori-inspired, covered from top to toe with flags, serpents, skeletons and stars.
20th Century A muscly man dressed in tattoos, with hardly a patch of bare skin.

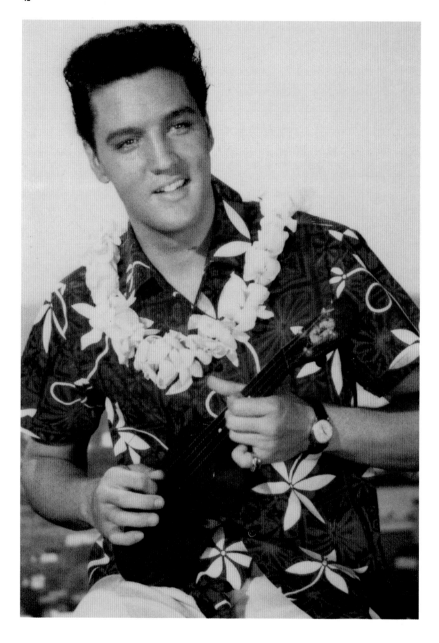

Heavenly in a Hawaiian shirt, printed with hibiscus, complete with lei and ukulele.
1961 American singer Elvis Presley in a still from the film *Blue Hawaii*.

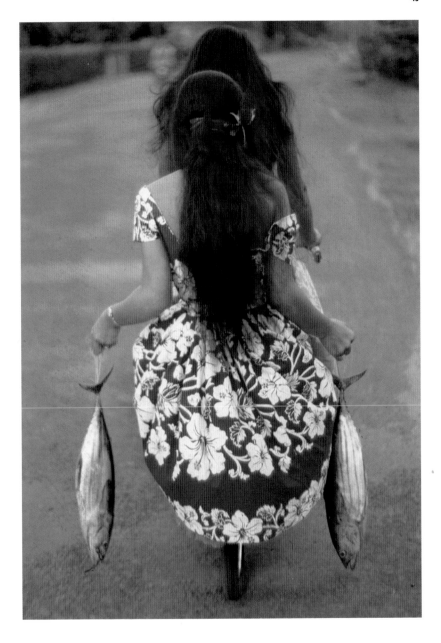

Pretty flowered frocks with the national bloom and fabulously fresh fish too.
1962 Two girls ride a bicycle carrying supper home, Tahiti, French Polynesia.

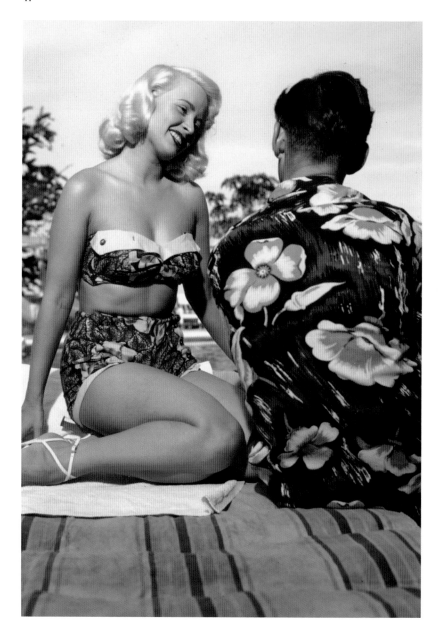

His and hers, a (very big) bikini and a matching shirt both printed with hibiscus.
1950s A couple canoodling on a boardwalk in the USA.

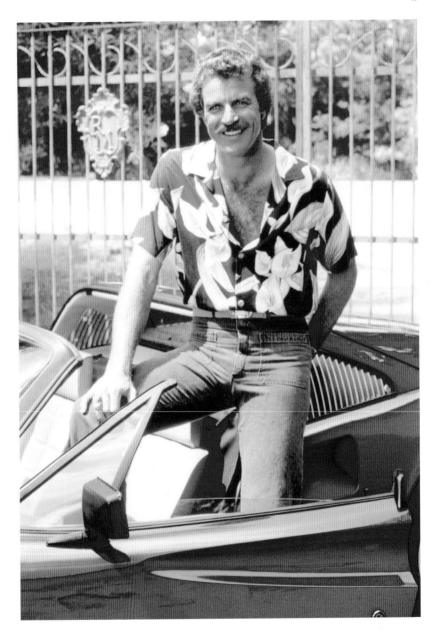

Man on a mission, in a Hawaiian shirt and tight jeans, perched on a red Ferrari.
c.1985 American actor Tom Selleck in the television series *Magnum P.I.*

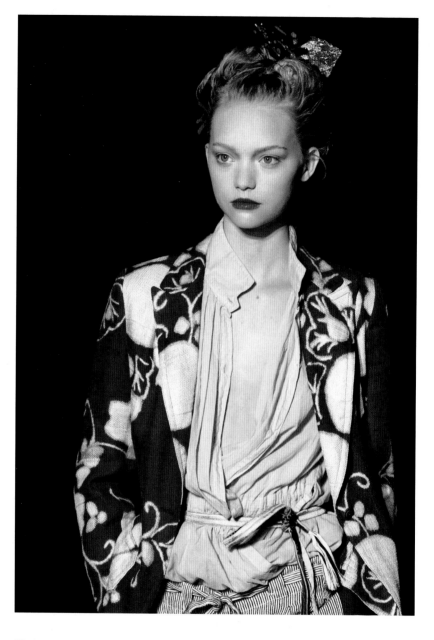

The master of a perfect print, the Belgian designer cuts a fine floral blazer.
2006 Dries van Noten's spring/summer fashion show, Paris.

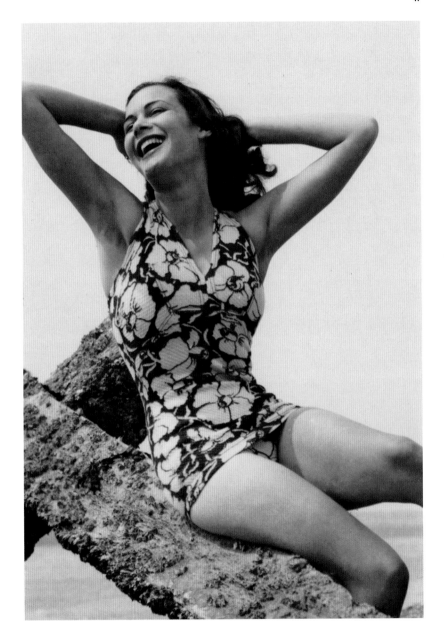

Hollywood-inspired happy snap showing a super swimsuit with huge blooms.
1940 Snapshot of a woman posing on a breakwater at the seaside in Britain.

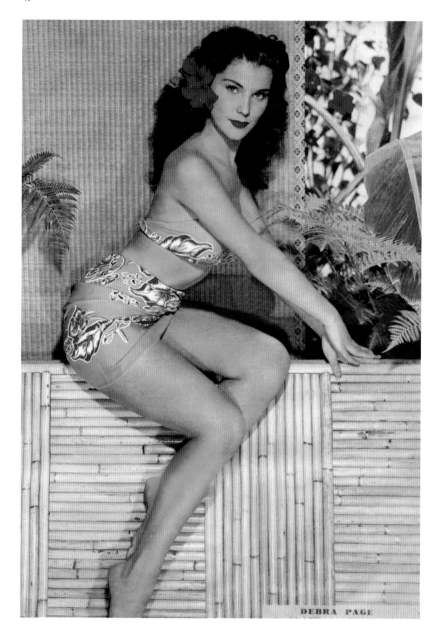

An American actress posing as a Tahitian beauty with a hibiscus in her hair.
1952 Jacqueline Pierreux on the cover of *Cinémonde* magazine.

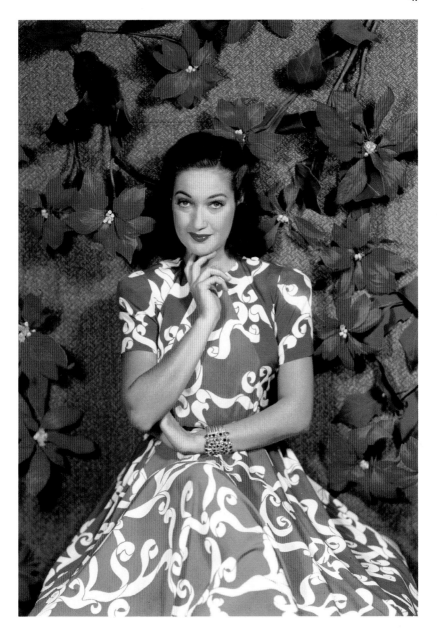

A South Pacific aloha, with a backdrop of gigantic tropical flowers in a hot hue.
1940 American actress Dorothy Lamour, as bright as a button in red and green.

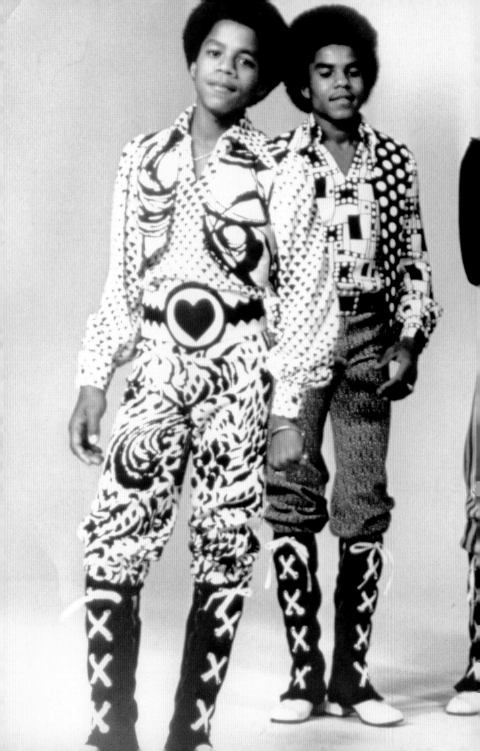

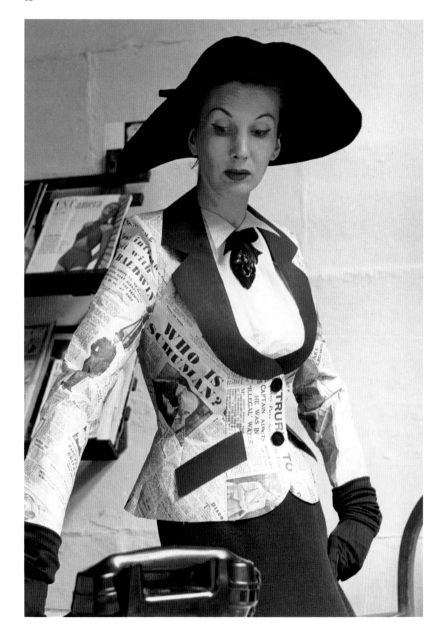

Economy chic, a suit tailored in newsprint with a black collar, skirt and smart hat.
1959 A novelty jacket from a collection called 'Crazy Clothes', London.

Previous page Knickerbocker glory in every graphic print imaginable, stripes, spots, chevrons.
1972 American group The Jackson 5: Marlon, Tito, Jackie, Michael and Jermaine.

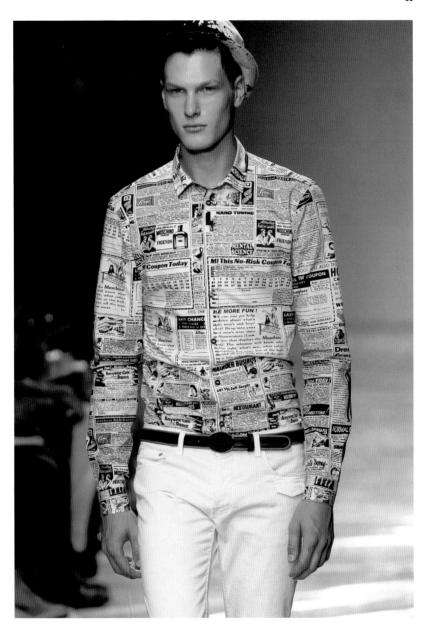

Classified ads in English, a fascinating shirt, handy when conversation is sticky.
2010 Moschino spring/summer men's fashion show in Milan.

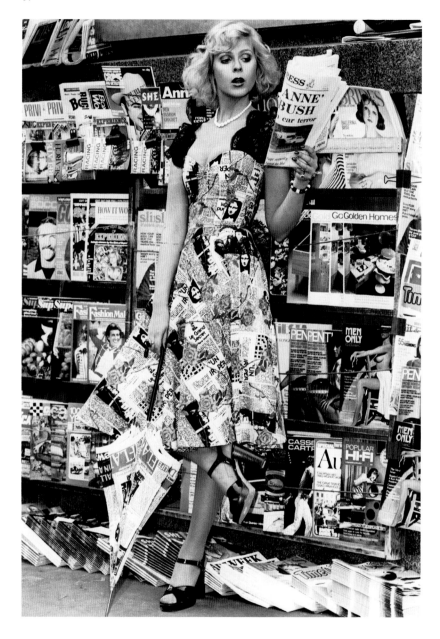

A curious camouflage in print, reading the daily paper surrounded by magazines.
1973 A model wearing a dress with a newspaper pattern, London.

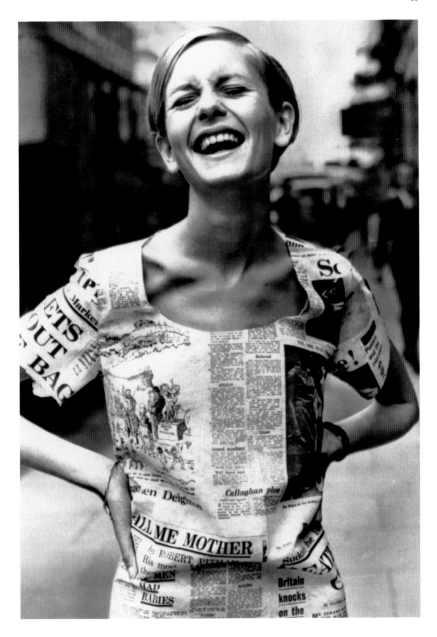

A swinging-sixties disposable shift, cut in paper, to wear once and throw away.
1967 British model Twiggy wearing a newsprint dress in London.

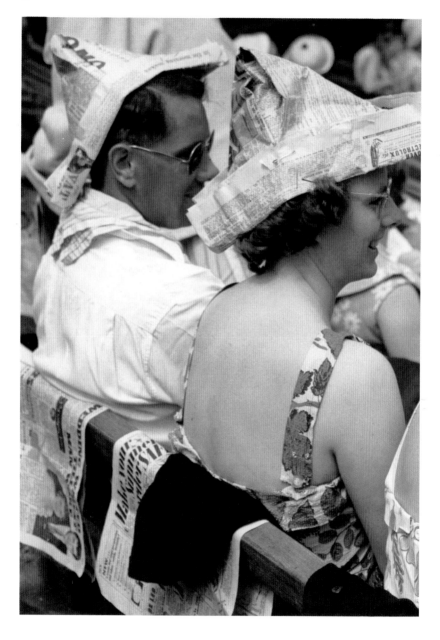

'Anyone for tennis, phew it's hot', wearing boat hats folded from newspapers.
1954 Wimbledon fans protect their heads from the sun with paper hats, England.

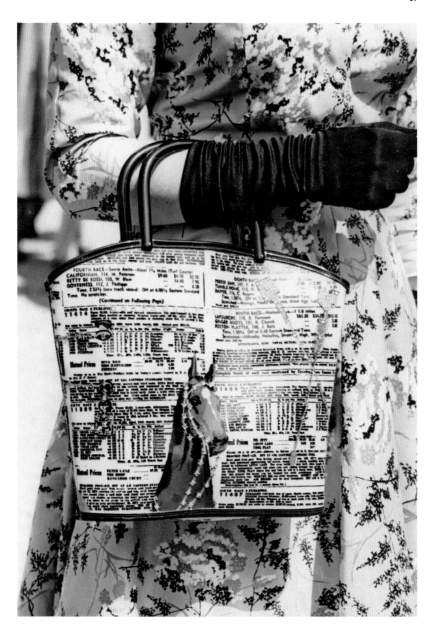

Odds-on favourite, pretty posh in a floral-print dress with bracelet-length gloves.
1955 A woman carrying a handbag made from race cards at Ascot, England.

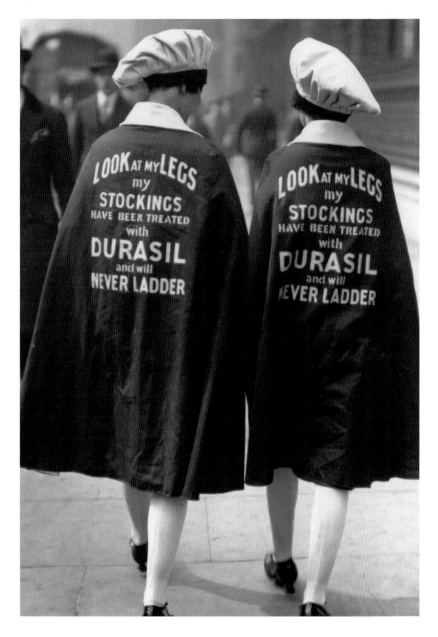

Pretty pins in black bar shoes, capes with white collars and baker-boy hats.
1926 Two women wearing cloaks advertising the new never-ladder stockings.

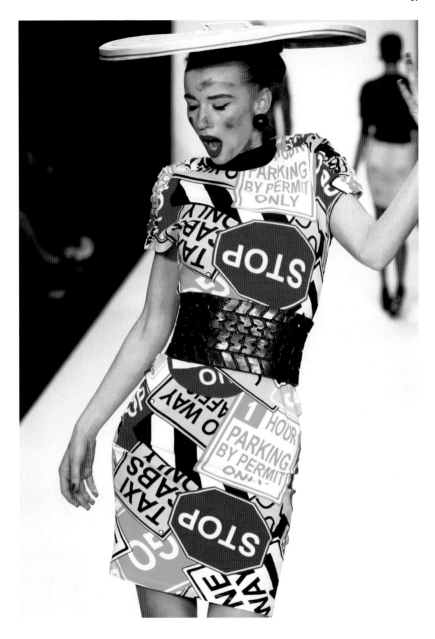

A traffic-stopping dress in primary colours of red, yellow and emerald-green, 2008 Jeremy Scott's spring/summer show in Culver City, California.

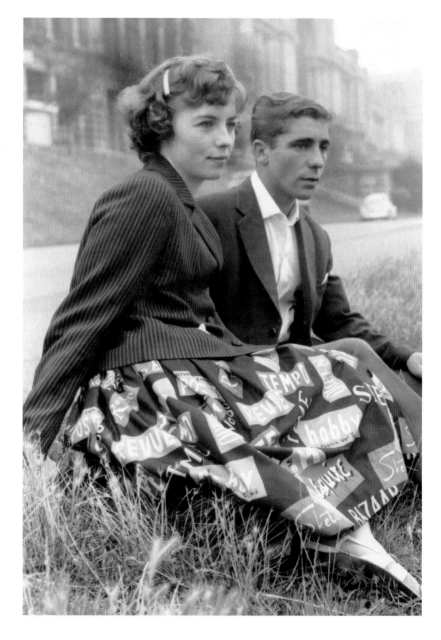

Magazineaholic, a full summer skirt with logos including Esquire and Revue.
1959 Teenagers spend the afternoon in Alexandra Park, Hornsey, London.

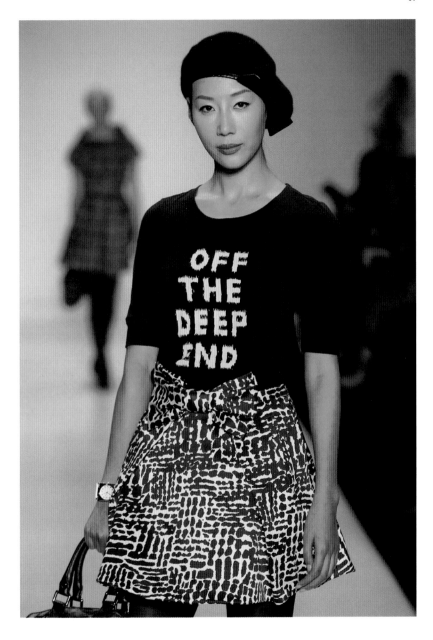

Dive in at the deep end, wearing a black T-shirt and beret with a digital-print skirt.
2008 Marc By Marc Jacobs spring/summer show in Hong Kong.

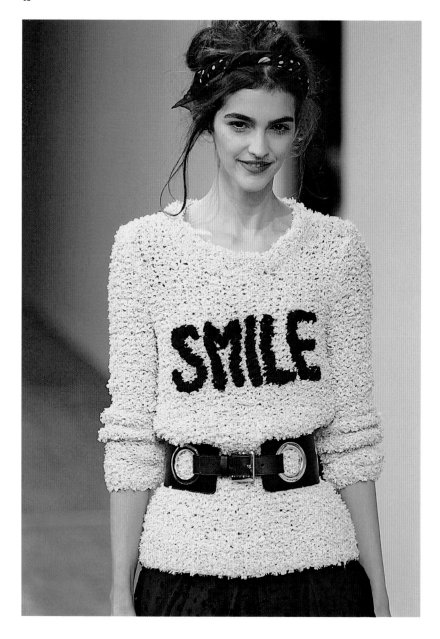

'Hallo sunshine', a brilliant yellow sweater with a bold black belt and bright smile.
2011 Moschino Cheap & Chic spring/summer fashion show in Milan.

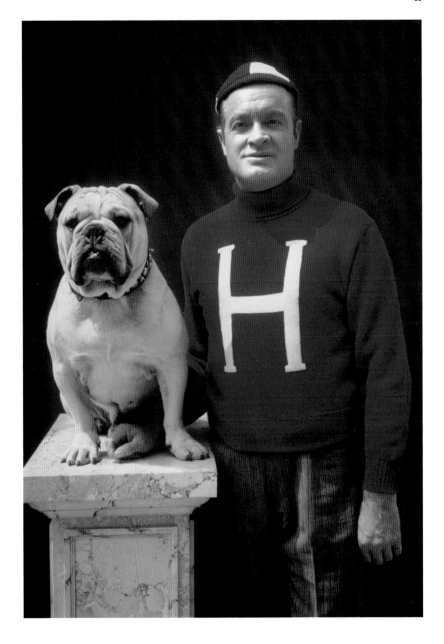

A matching beanie and a bulldog are essential accessories for a Brit abroad.
c.1955 British-born actor Bob Hope wearing a varsity football jersey, USA.

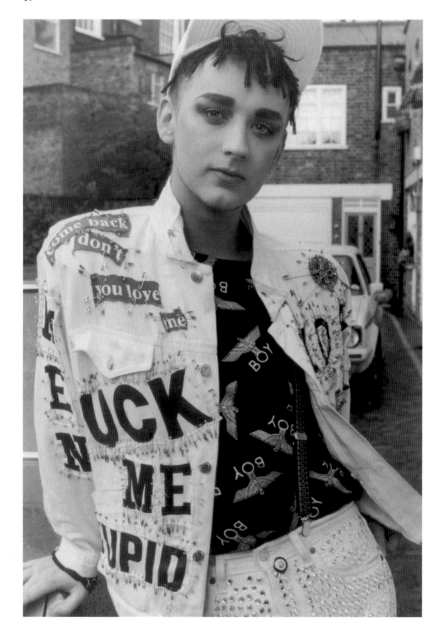

Graffiti geezer, a white jacket printed with rude words, worn with twinkly jeans.
1986 British New Romantic pop singer Boy George of Culture Club in London.

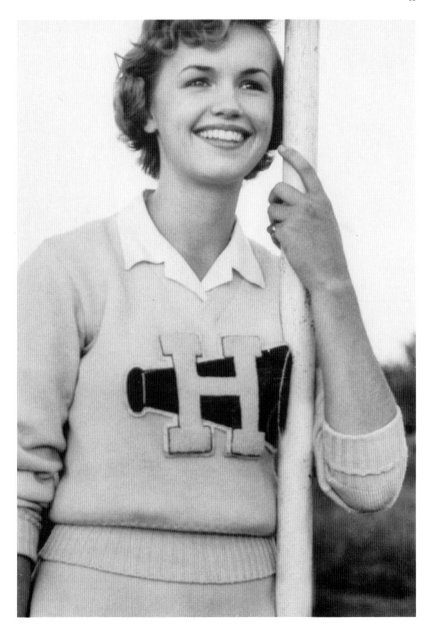

'H' stands for hero or halfback, a thick knitted sweater worn over a simple shirt.
c.1950s Shirley Ann Majors, sister of American football player Johnny Majors.

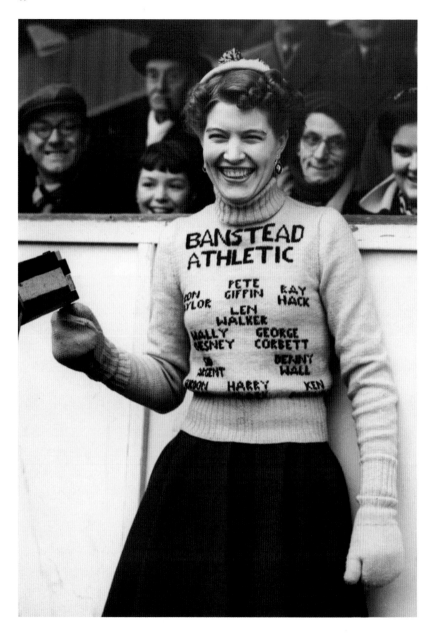

Loyal and besotted, wearing a sweater with the names of the players in the pattern.
1955 Marion Bryan, an enthusiastic fan of Banstead Athletic in Surrey, England.

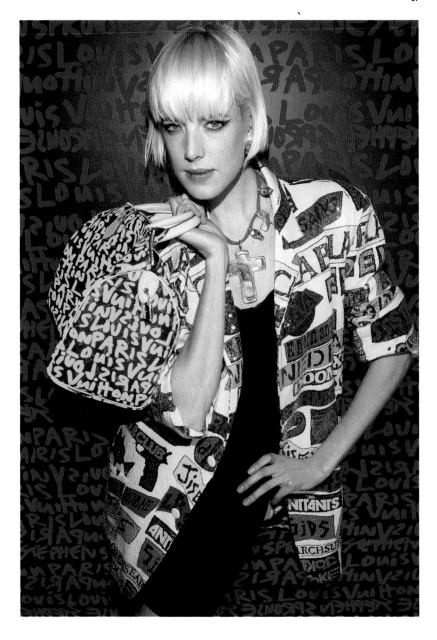

Collected and much copied, the *handbag-du-jour* designed for Louis Vuitton.
2009 English model Agyness Deyn at the tribute to Stephen Sprouse, New York.

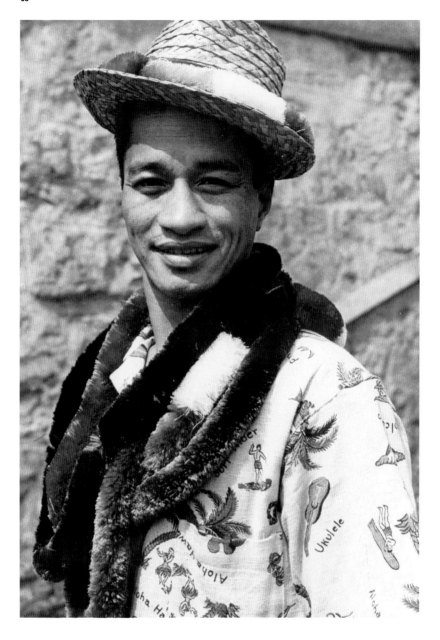

Very 'South Pacific', a shirt printed with surfers, palm trees, dancers and ukuleles.
1947 Hawaiian flyweight boxer Salvador Dado Marino with celebratory garlands.

Every picture tells a story, a brilliant yellow jacket with birds, horses and more.
2004 British model Ben Grimes at a party for Burberry Fragrance, New York.

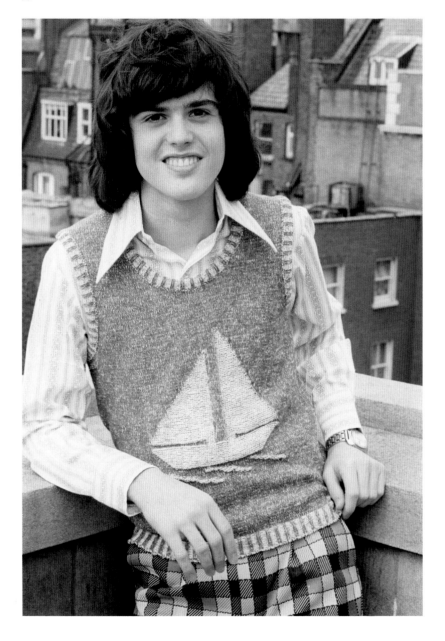

'Puppy Love', sporting a girlish bob in a knitted, sleeveless sweater with a boat.
1973 American pop singer Donny Osmond during his solo tour of London.

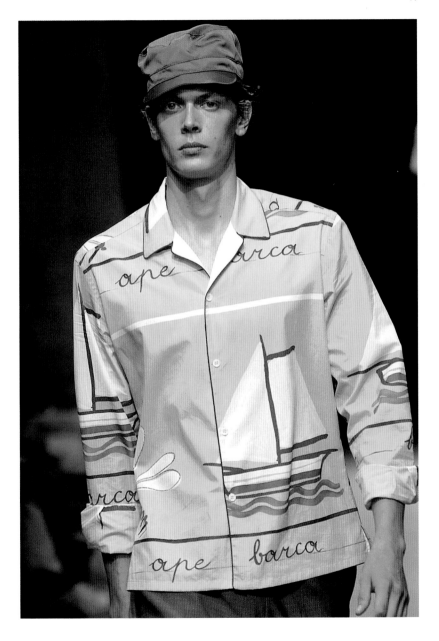

'Hallo Sailor', a sunshine-yellow shirt with naïve drawings of yachts on a blue sea.
2005 Prada spring/summer men's fashion collection in Milan.

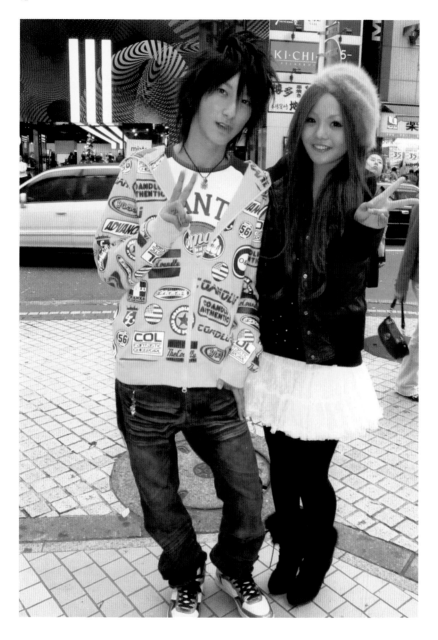

Street style, a jacket laden with logos for him, for her a tutu and a beret.
2009 A couple of teenagers in the latest gear on the streets of Tokyo.

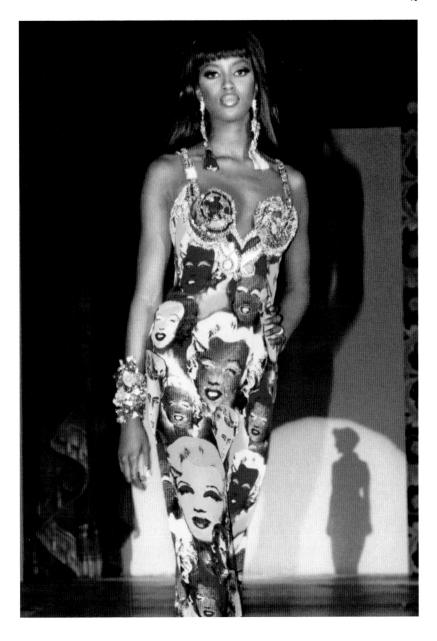

Super style, a sexy siren in a gown featuring the Andy Warhol print of Marilyn Monroe.
1991 Naomi Campbell in the Gianni Versace spring/summer show, Los Angeles.

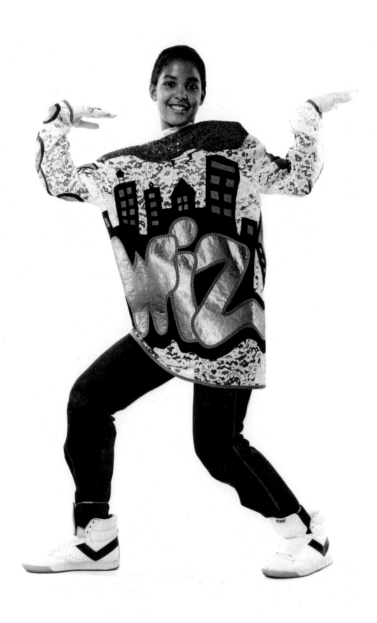

Graffiti girl with a big grin, wearing a printed smock-dress over denim jeans.
1987 Hip-hop fashion sporting Pony high-top basketball sneakers, New York.

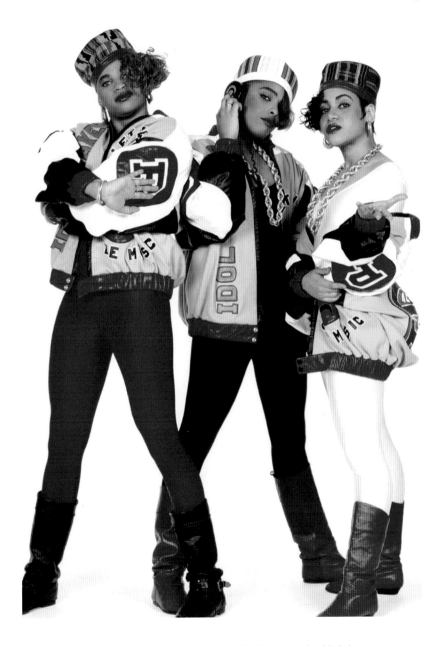

Giving attitude, Pepa, Spinderella and Salt in basketball jackets and gold chains.
1987 The hip-hop group Salt-N-Pepa, posing for their record album, New York.

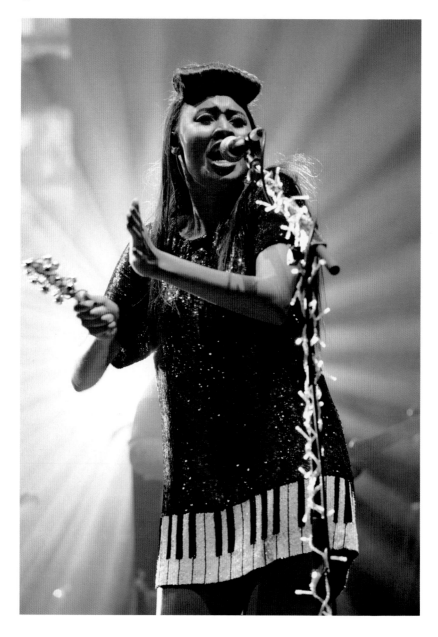

Miss Piano Girl, famed for 'Shark in the Water', wearing a sequined shift dress.
2009 English singer V V Brown performs at the Royal Albert Hall, London.

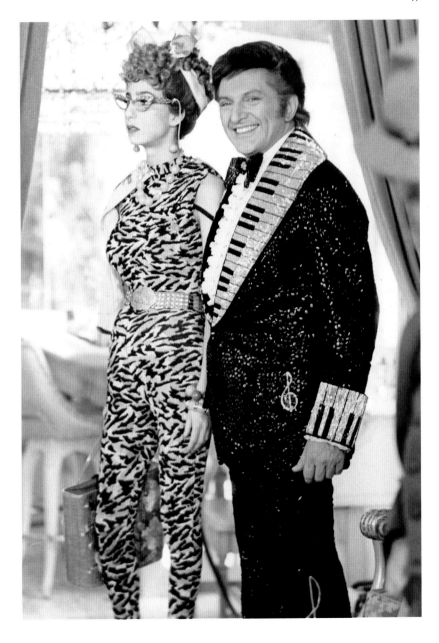

Shrinking violets on TV's *The Sonny & Cher Show*, overdressed to kill.
1970s American singer Cher and famous pianist Liberace, in Hollywood.

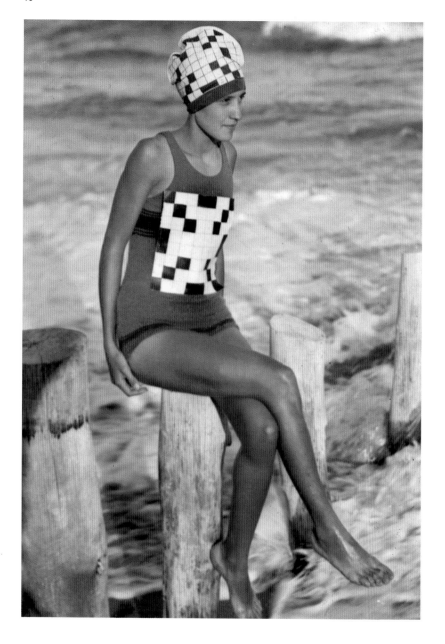

Swimming with the tide, a curious crossword costume with a matching cap.
c.1933 Socialite Verna Lee Fisher at Palm Beach, Florida.

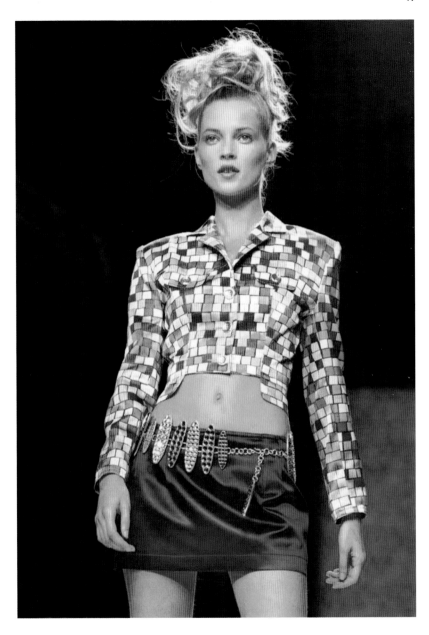

Checkerboard chic, wearing a multicoloured cropped shirt and a minute mini.
1995 Supermodel Kate Moss in the Todd Oldham spring/summer fashion show, New York.

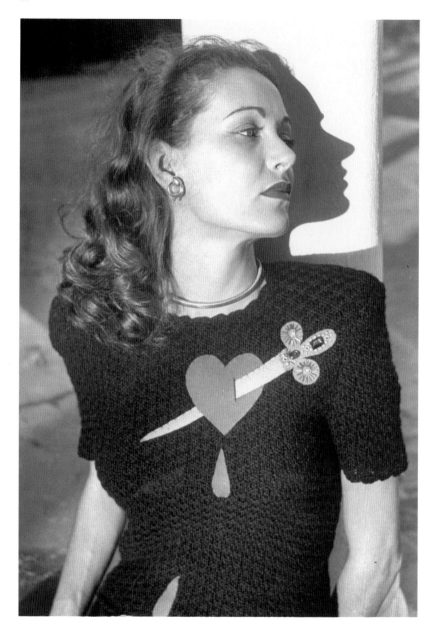

A broken heart is hard to mend, a diva in distress in the latest crocheted fashion.
1947 A model wearing a wool sweater with a heart pierced by a jewelled dagger.

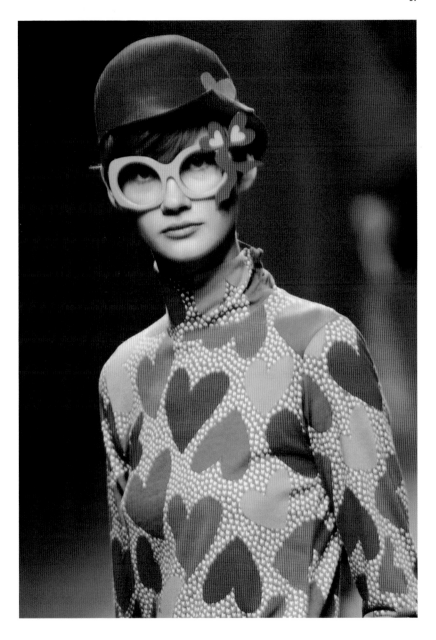

Singularly sixties, aristocratic attire by the 12th Marquise of Castelldosríus.
2010 Spanish designer Agatha Ruiz de la Prada's fashion show, Madrid.

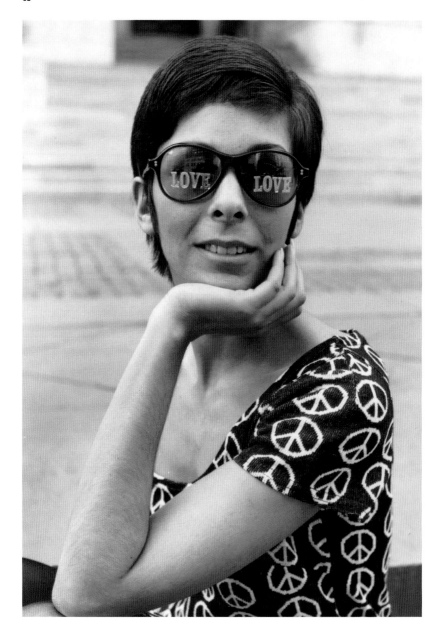

Aldermaston attire, a fashionable frock and sunglasses supporting the cause.
1967 A woman wearing a dress emblazoned with CND peace symbols, New York.

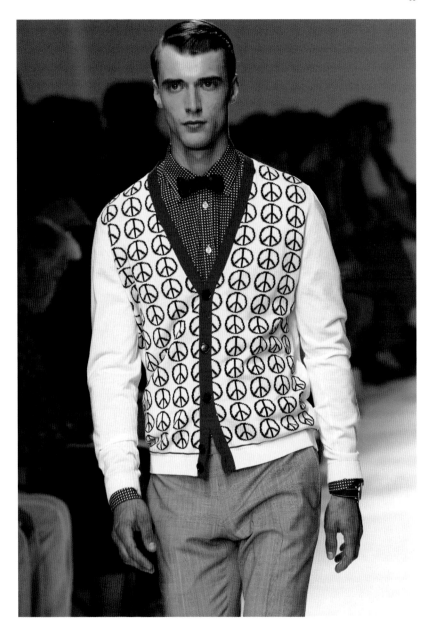

'Ban The Bomb', a cardigan with symbols harking back to protests of the sixties.
2009 Moschino spring/summer men's fashion show in Milan.

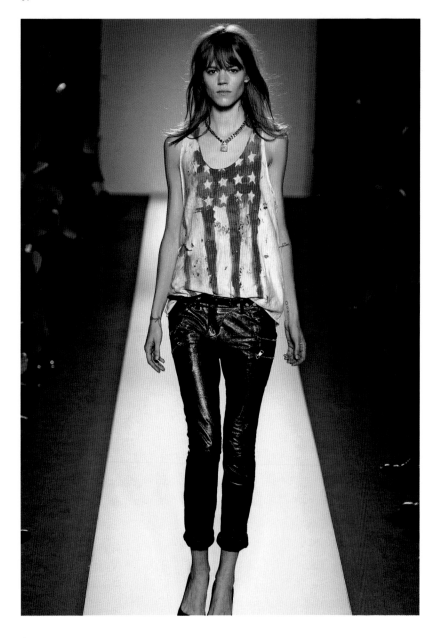

The Stars and Stripes, a trendy T-shirt worn punk-style with black patent pants.
2011 A willowy model strides the catwalk, Balmain spring/summer show, Paris.

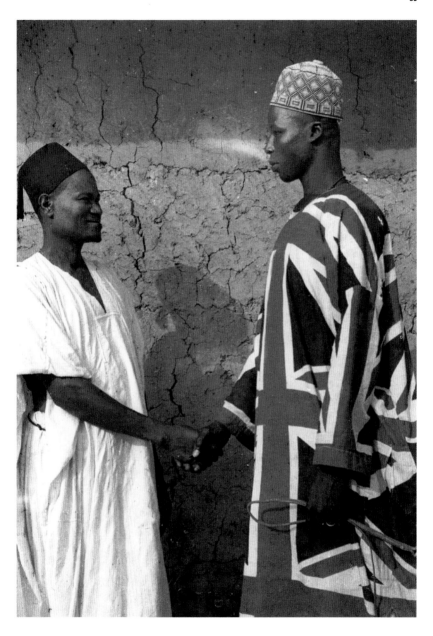

Flying the flag, a fine djellabah cut from several Union Flags worn with a kufi cap.
1941 An uber-patriotic African gentleman greeting a friend in a plain white robe.

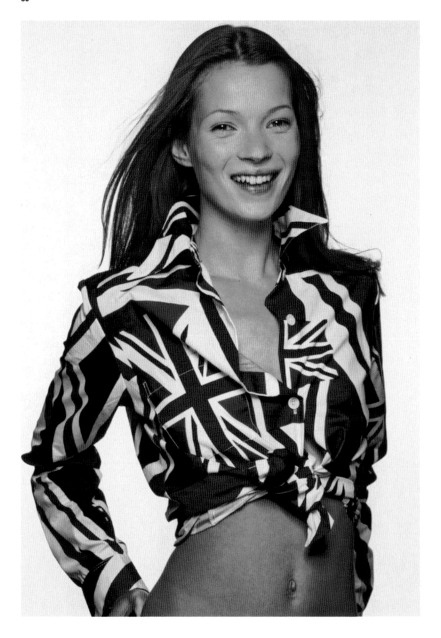

A pretty picture of patriotism, a broad smile, hurrah for the red, white and blue.
c.1995 English fashion model Kate Moss in a shirt printed with Union Flags.

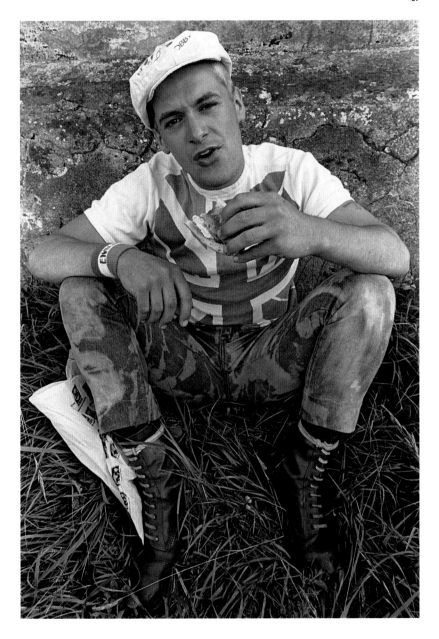

Flagging off-field dressed in a white T-shirt and cap, jeans and bovver boots.
1982 An England football fan at the World Cup Final campsite in Algorta, Spain.

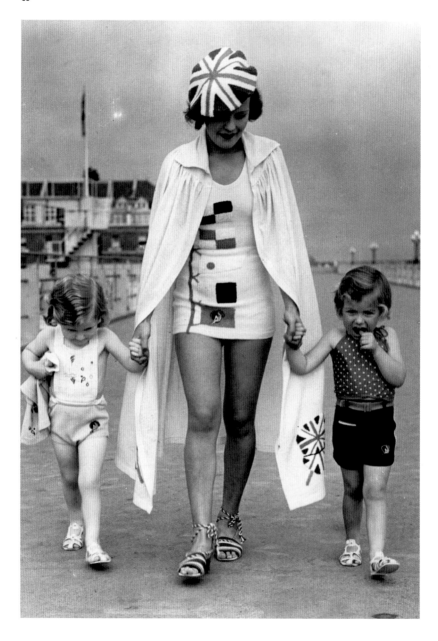

Beauty on the beach, a towelling cape over a swimsuit with flags, and a beret.
1936 The year of the Berlin Olympics, a young family in Hastings, England.

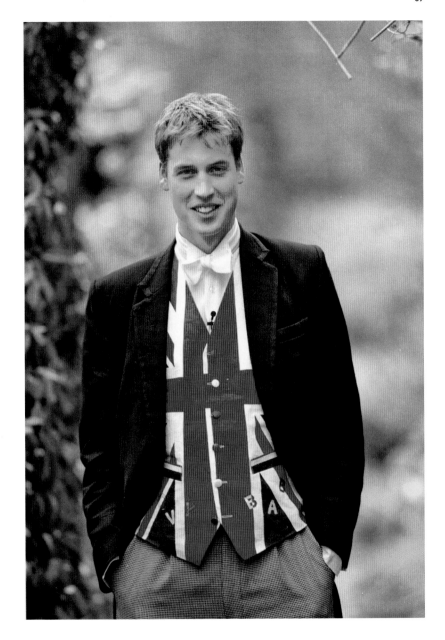

The privilege of Pop in a waistcoat with white tie and tails and checked trousers.
2000 Britain's Prince William at eighteen, one of Eton College's elected prefects.

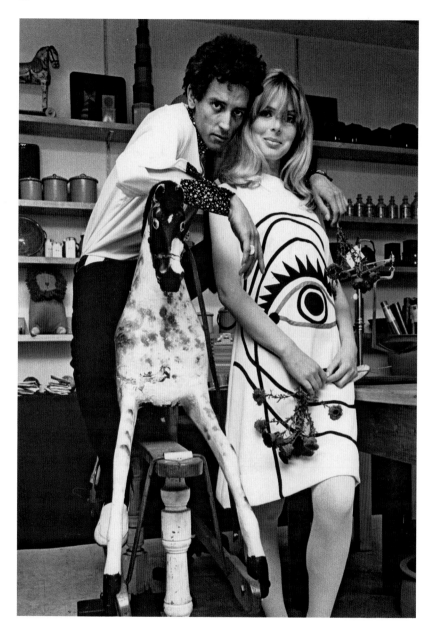

Part of 'The Velvet Underground' in Carnaby Street for *Fab* magazine, London.
1966 German singer Nico and Ben Carruthers, designer and performer.

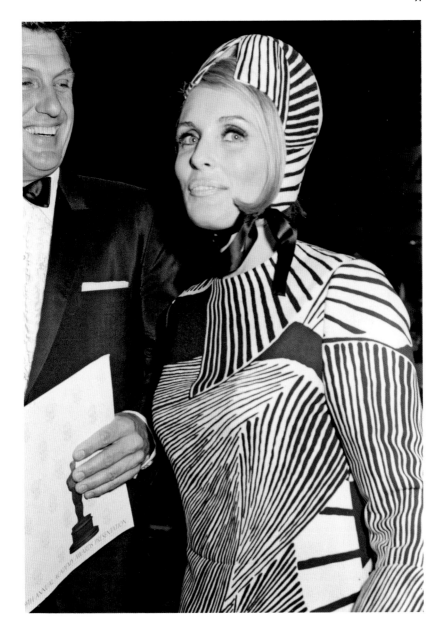

Enter inconspicuously in a graffiti gown with a matching cap, and husband in tow.
1967 American actors Robert and Rosemarie Stack at the Oscars in Los Angeles.

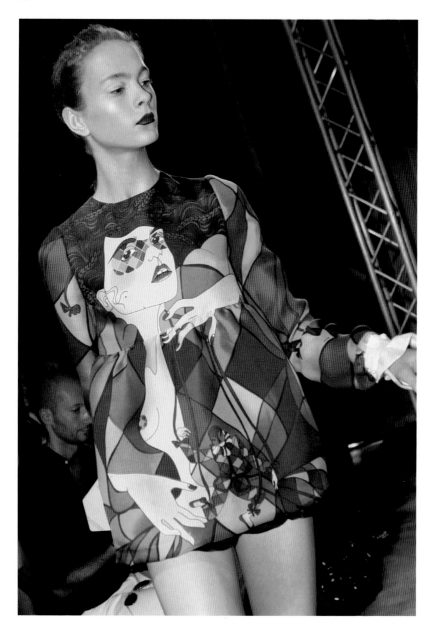

Marionette magic dressed in a tiny tunic with primary coloured harlequin checks.
2008 Miu Miu spring/summer fashion show in Paris.

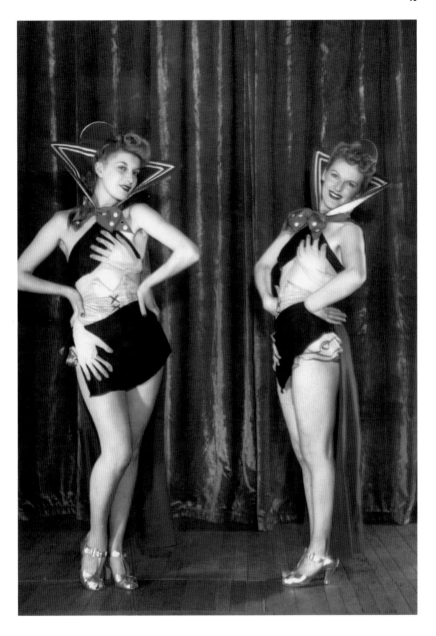

Hands off, curious cropped costumes with sailor collars and spotted bow ties.
c.1930 The Empire Cabaret troupe at the Grosvenor House Hotel in London.

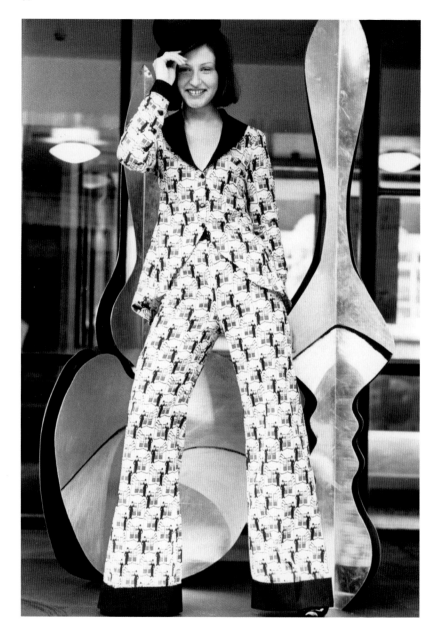

Movie-picture patterns on a jacket with black collar and cuffs, and flared trousers.
1972 American Lynne Bishop in a trouser suit printed with tiny Charlie Chaplins.

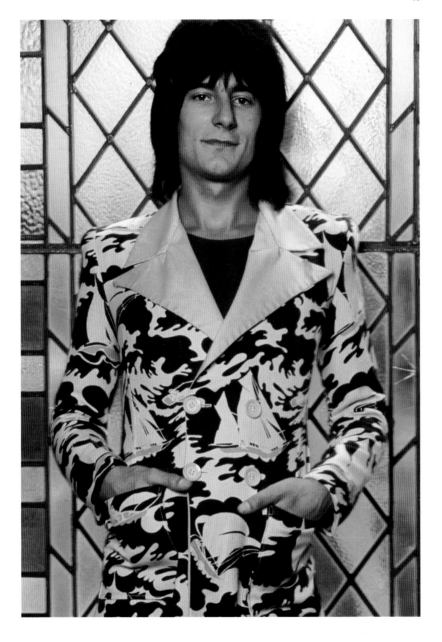

'A Nod is as Good as a Wink' in a loud jacket printed with sagas from the sea.
1971 British rock star Ronnie Wood of The Faces in the early days, in England.

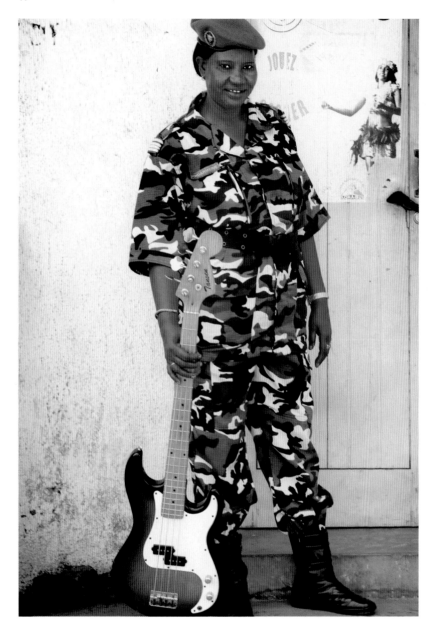

Military music with a difference, a guitarist in fatigues with boots and a beret.
2008 A member of the all-female army band Les Amazones de Guinée in Guinea.

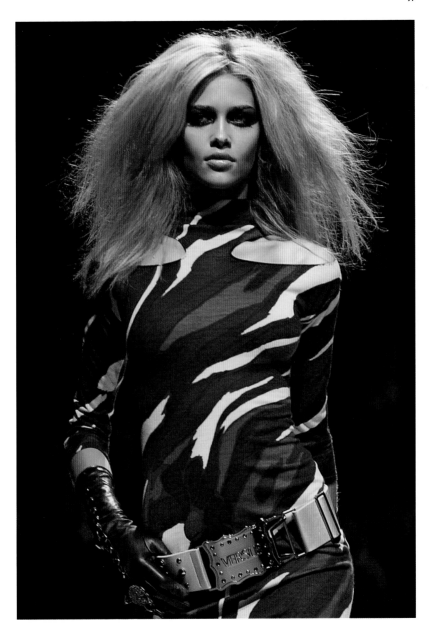

Camouflage chic on the march, a black, khaki and yellow figure-hugging dress.
2003 Versus (a line by Versace) autumn/winter fashion show, Milan.

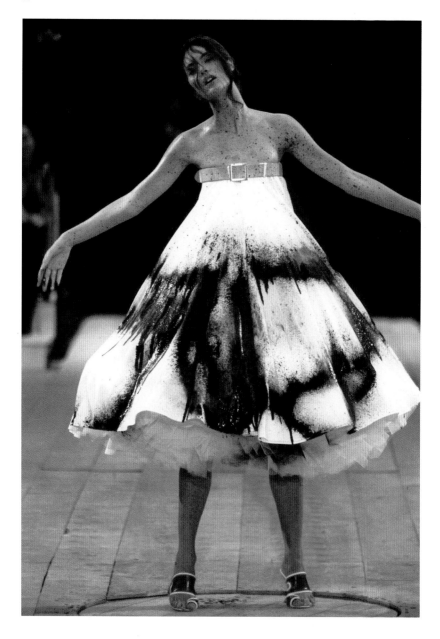

Robotic romance, a strapless white dress sprayed with black and yellow paint.
1999 British designer Alexander McQueen's spring/summer show, Paris.

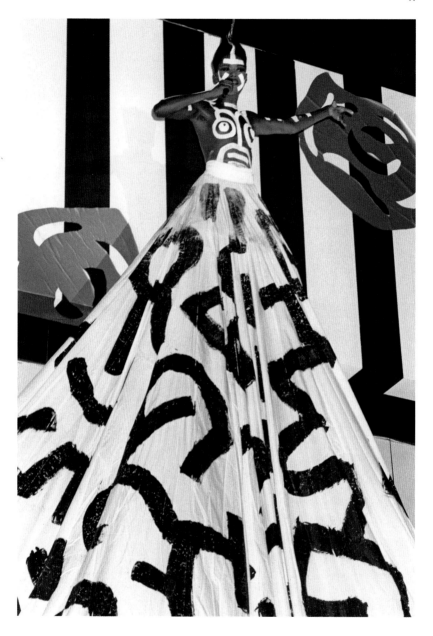

Songstress on stilts in an enormous skirt hand-painted with broad black brushstrokes.
1987 Jamaican singer Grace Jones in the New Year's Eve Concert, New York.

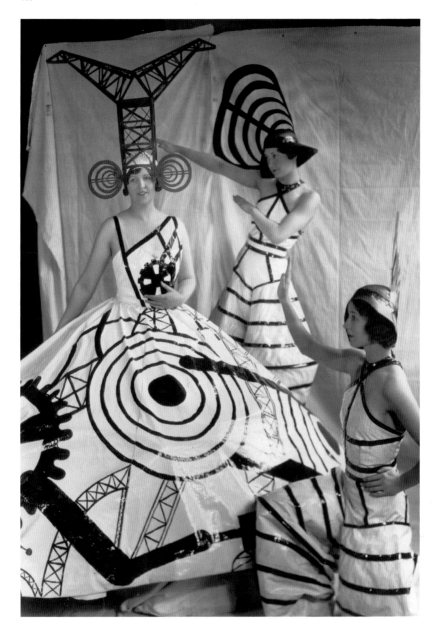

Cogs in a wheel in the 'Pageant of Britain and her Industries', London.
1930 Ladies in themed costumes designed by novelist Barbara Cartland.

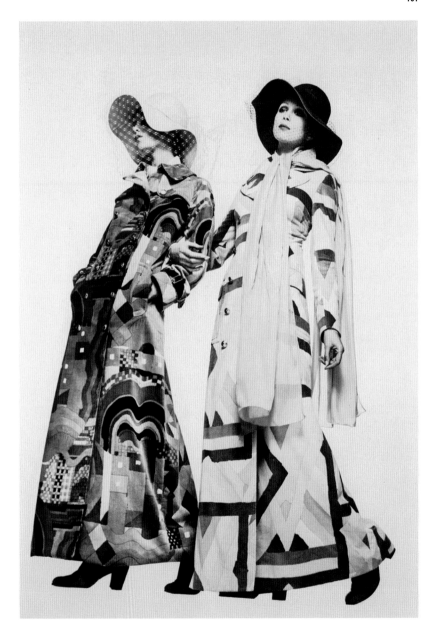

Maximum moments, ankle-length coats in art deco prints worn with floppy hats.
c.1972 British models Twiggy and Patti Boyd in Italian *Vogue* magazine.

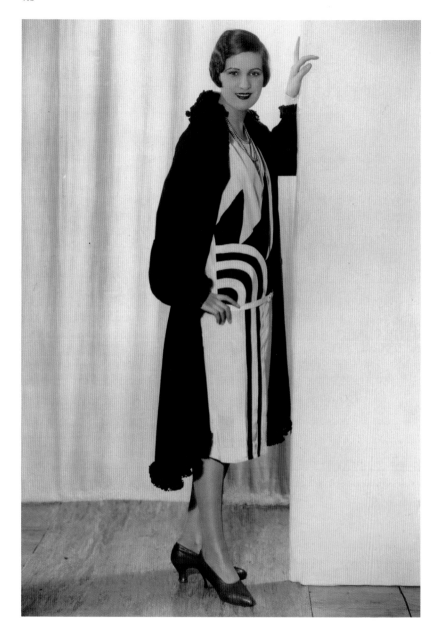

Graphic design, a flapper dress with a black fur-trimmed coat and bobbed hair.
c.1920s A frock with an art deco print in an artificial silk woven in America.

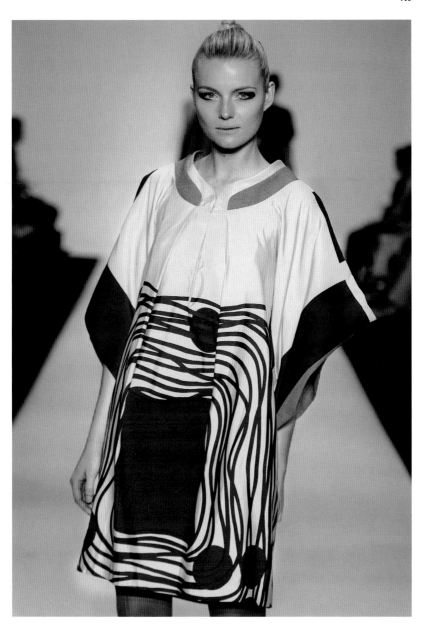

Deco design, in red, black and cream silk with a nod to the Japanese flag.
2008 Japanese designer Kenzo's autumn/winter show in Hong Kong.

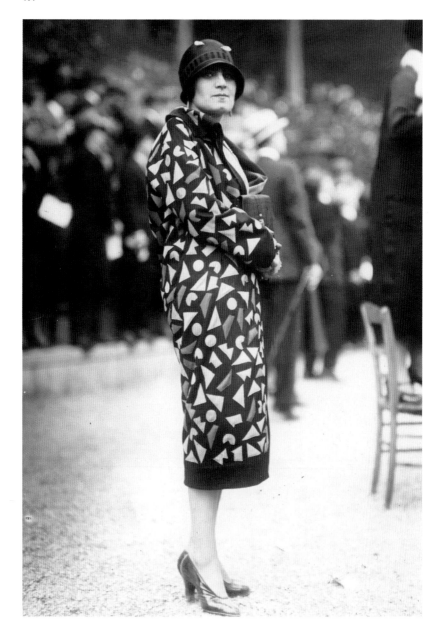

A day at the races, dressed to kill but ladylike, with a bold print and court shoes.
1925 A patterned coat with black trim around the hem and cuffs, and a cloche.

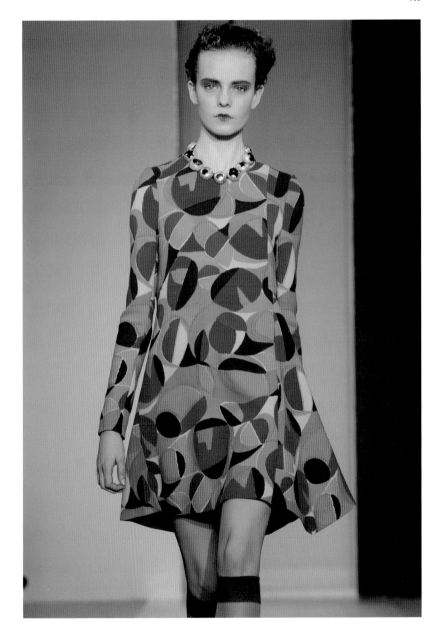

A smock and socks, a trapeze-shaped mini-dress in a bright, block print.
2010 Marni ready-to-wear autumn/winter collection in Milan.

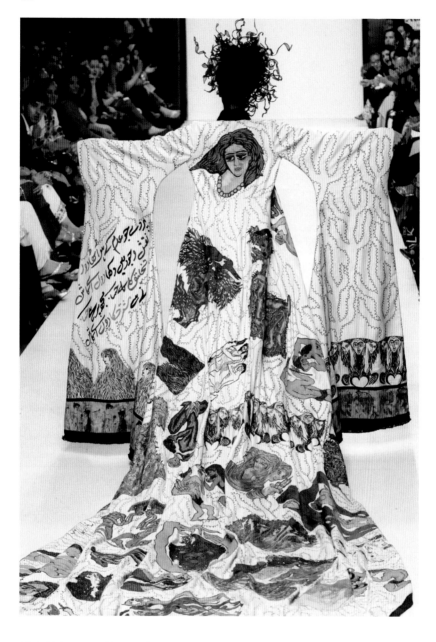

Global influences, a kimono-shaped gown printed with a strange saga.
2010 Pakistani designer Umer Sayeed's show at the second Karachi Fashion Week.

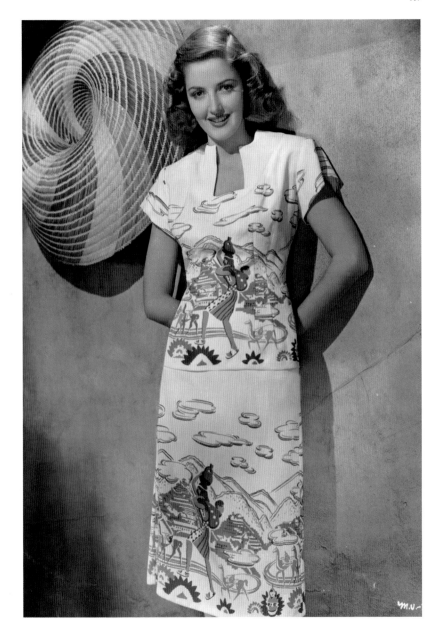

Desert diva, a simple white summer dress printed with camels and pyramids.
c.1946 American television and film actress Martha Vickers in holiday mode.

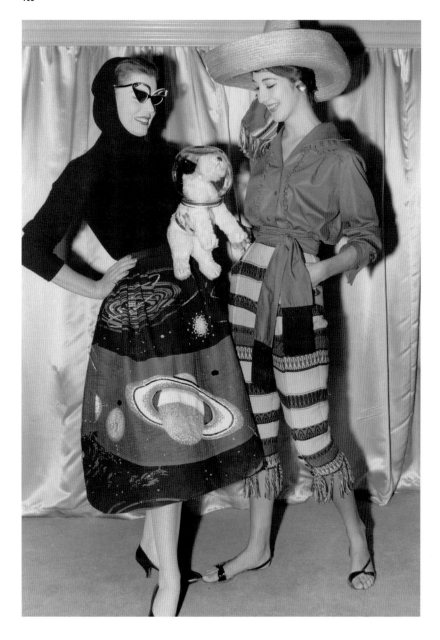

'Beam me up, Scotty', in a space age skirt appliquéd with planets, and a divine dog.
1958 Models in outfits by Teddy Tinling, a tennis player and fashion designer.

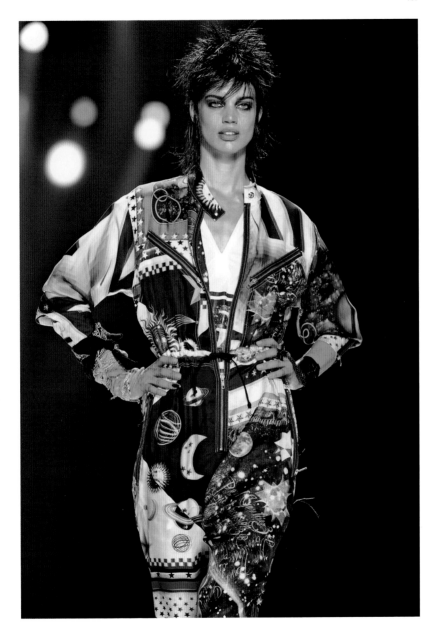

Astrological appeal, 'give me the moon, the stars and the sun, and some stripes'.
2011 French designer Jean Paul Gaultier's spring/summer show, Paris.

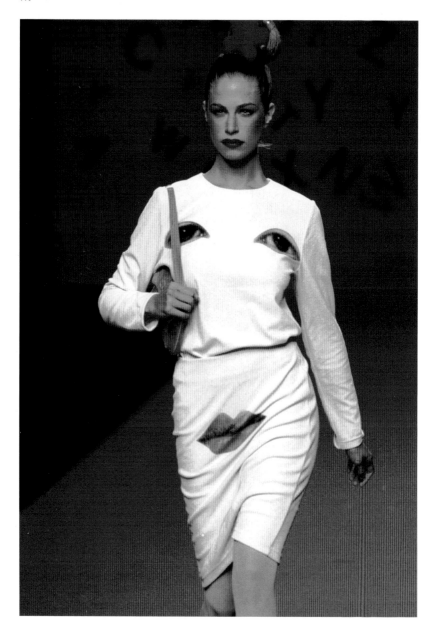

The face of fashion, a dress printed with eyes and a strategically placed mouth.
2001 Spanish designer Agatha Ruiz de la Prada's autumn/winter show, Madrid.

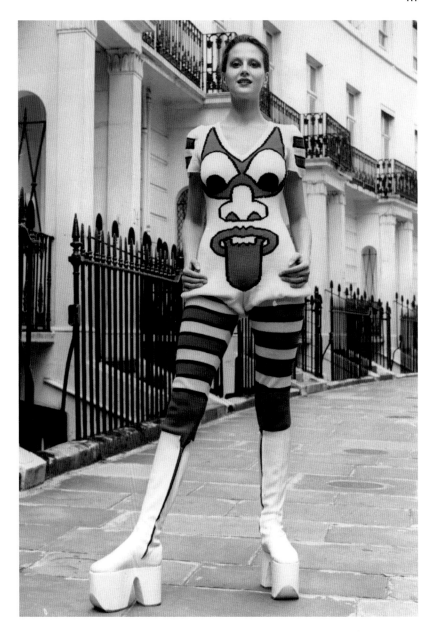

The devil in disguise, a red-and-black face motif and monstrously high boots.
1971 Japanese designer Kansai Yamamoto's hand-knitted jump suit, London.

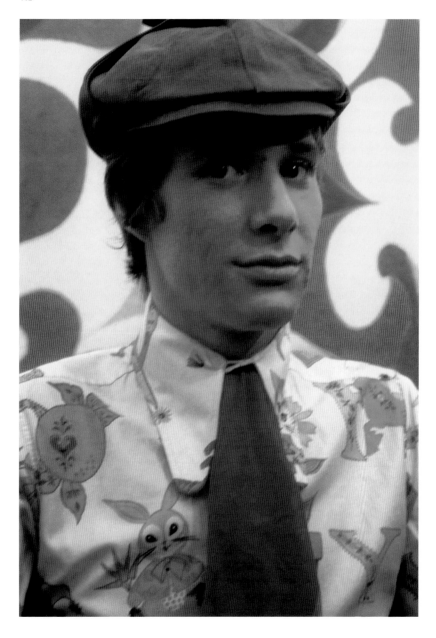

Bunny boy, a funny sixties shirt with a strange tie worn with a baker-boy cap.
c.1960 British singer Paul Jones of the group Manfred Mann in Germany.

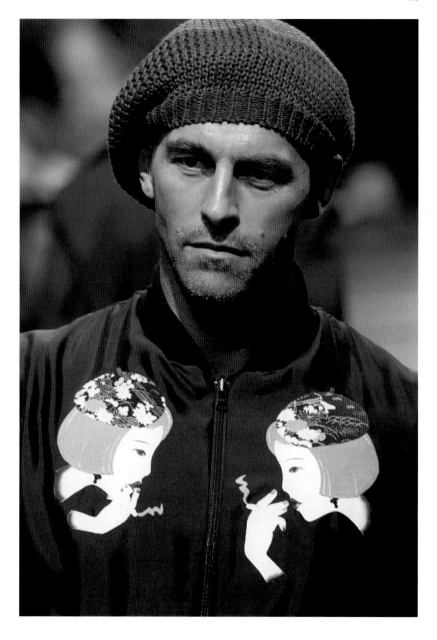

Cigarette break, an appliquéd black bomber jacket and a knitted charcoal beanie.
2004 Japanese designer Yohji Yamamoto's spring/summer show in Paris.

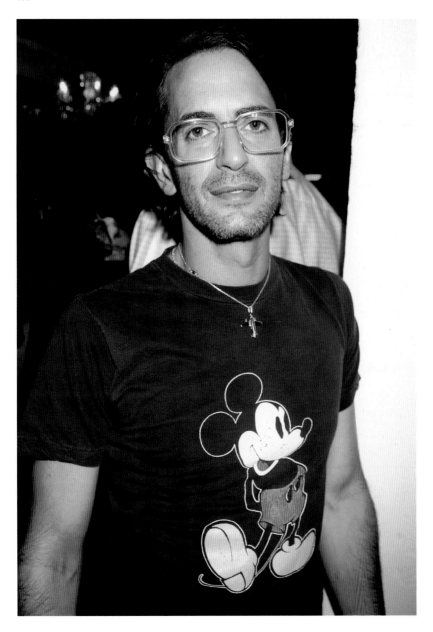

Mister Mouse, with designs on Disney, a simple black T-shirt printed with Mickey.
2006 American designer Marc Jacobs at the 'Fashion Rocks' concert, New York.

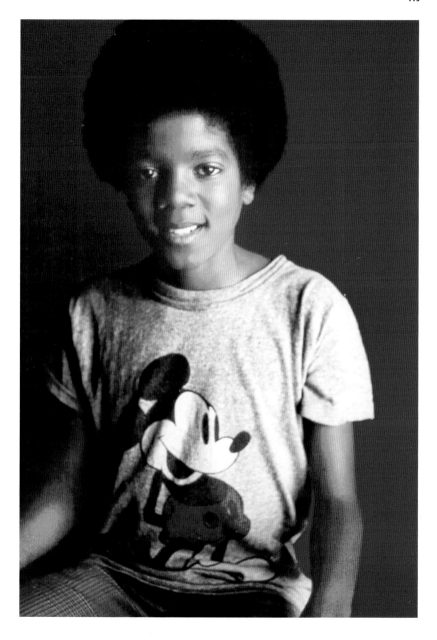

Master Mouse, the youngest member of the pop group The Jackson 5.
1971 American singer Michael Jackson poses for a portrait in Los Angeles.

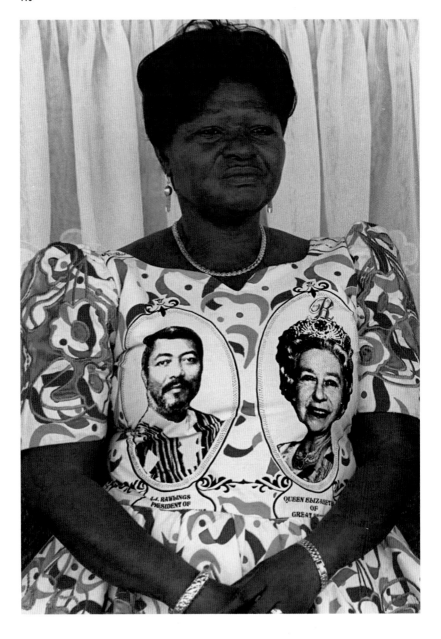

Portraits of President Rawlings and the British sovereign printed on a white dress.
1999 A guest at a ceremony during Queen Elizabeth's visit to Accra, Ghana.

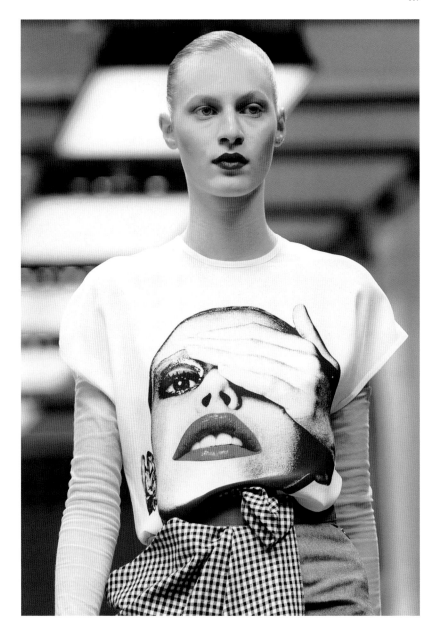

Face of the future, a top with a three-dimensional image and a checked skirt.
2010 British designer Richard Nicoll's spring/summer show in London.

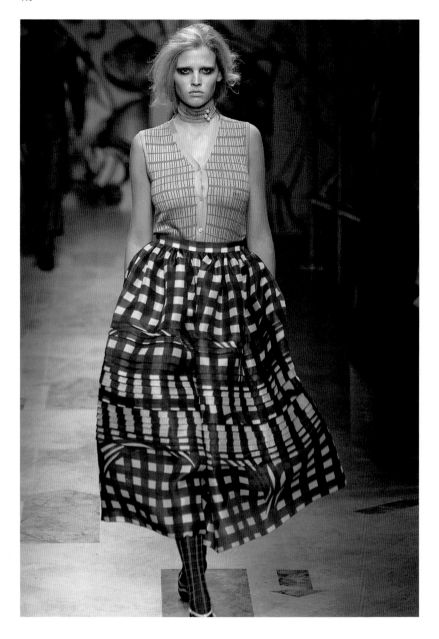

Retro chic in a green checked dirndl skirt worn with a sleeveless top in red and fawn.
2008 Inspired by fifties fashions, Prada spring/summer show, Milan.

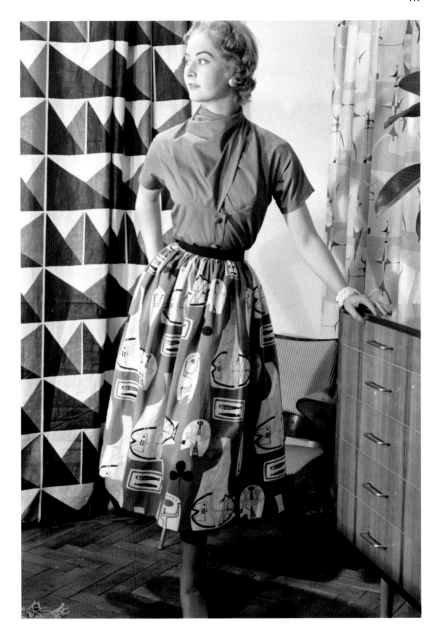

Fashion in the fifties, a fishy print on crisp cotton in a contemporary setting.
1954 A grey, lime, black and white skirt with a grey blouse, by Liberty of London.

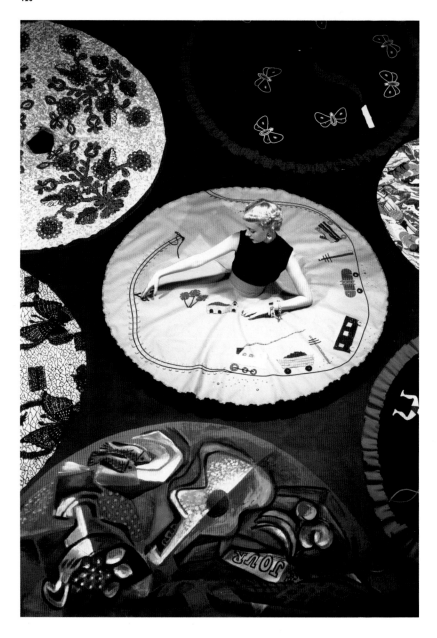

'Toot toot! What shall I pick? An appliquéd train set, a flamenco guitar or flowers?'
1950 A selection of circular skirts; the model is emerging from a hole in the floor.

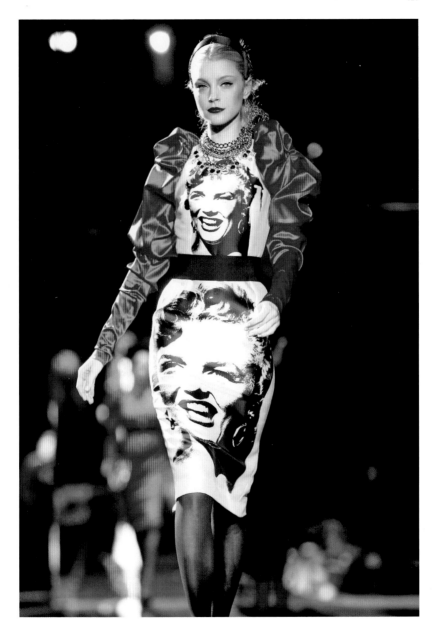

Think pink, a dress with a photoprint of Marilyn Monroe and Schiaparelli pink sleeves.
2009 Dolce & Gabbana autumn/winter show in Milan.

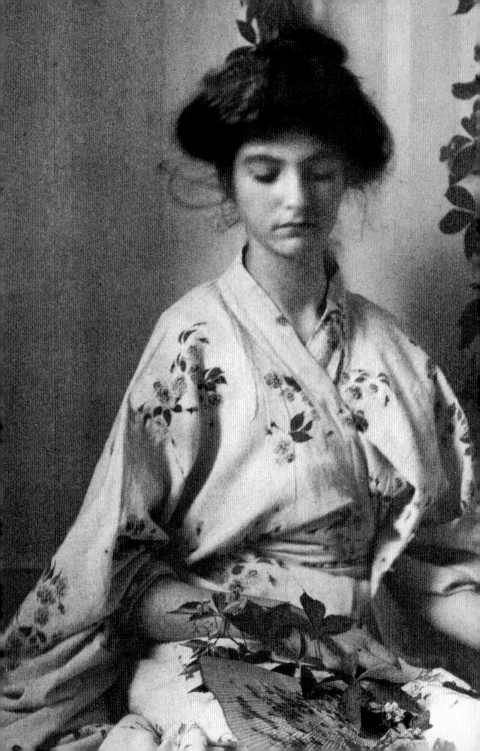

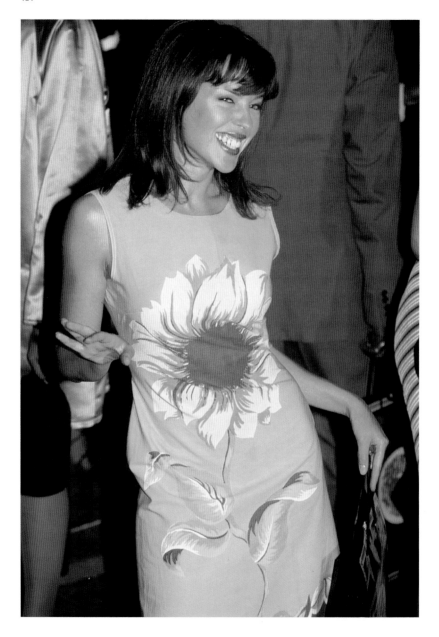

A short, simple shift in emerald green printed with a single enormous flower.
1995 Australian singer Kylie Minogue arriving at a Versace party, Milan.

Previous page Pretty in pink and inspired by Japanese style, a flowered kimono and a vase.
1908 An autochrome portrait of her daughter taken by Etheldreda Janet Laing.

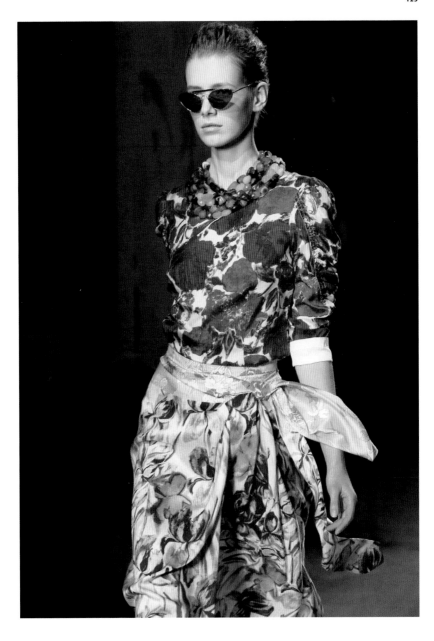

A masterful mélange of prints, a blouse, soft skirt and scarf, all contrasting.
2008 Dries Van Noten's spring/summer show, Paris.

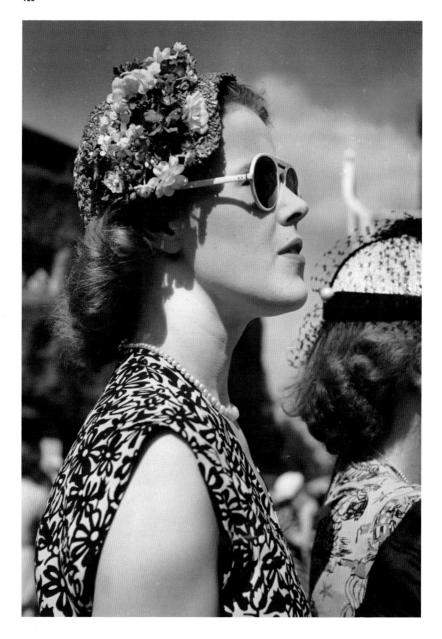

Summer goes to their heads with floral hats, print dresses and sunglasses too.
1951 High society, a portrait of a lady at the races in *Picture Post*, Britain.

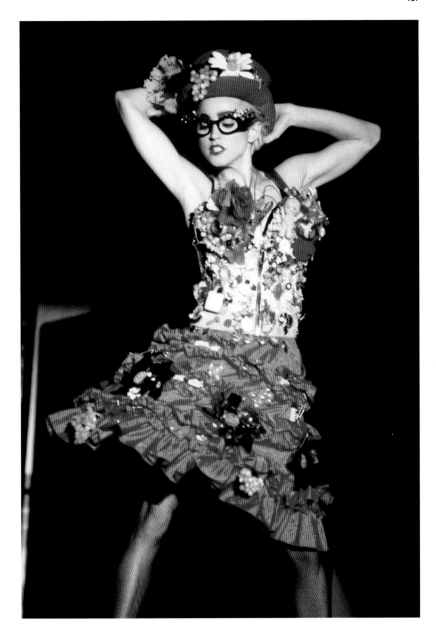

In 'fancy-dress' during her early days, a strange outfit of flowers and specs.
1983 American singer Madonna performs songs from her first album, London.

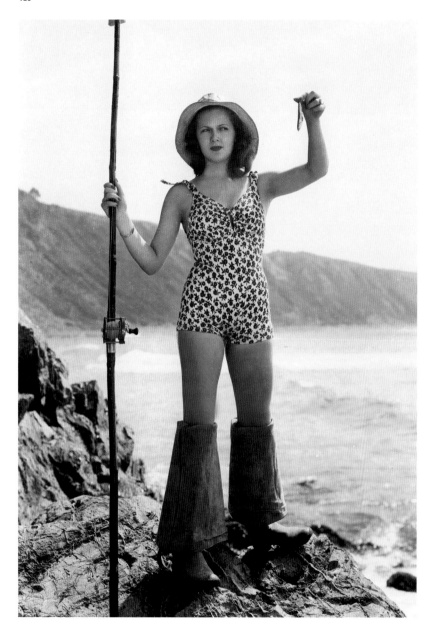

A sprat to catch a mackerel in a floral-sprig costume with waders and a rod.
1937 Hollywood actress Lana Turner shows off her catch dressed in a swimsuit.

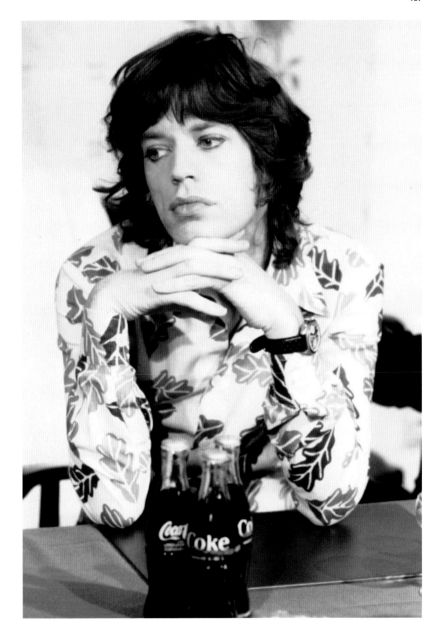

Brooding like a young Byron in a leaf-print shirt, Coca-Colas at the ready.
1973 English rock singer Mick Jagger of The Rolling Stones, Amsterdam.

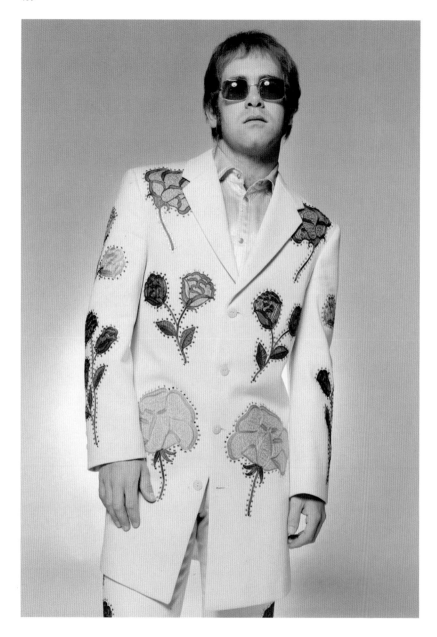

'A rose is a rose is a rose and never a shrinking violet' in a white draped jacket.
c.1975 English pop star and pianist Elton John wearing a floral appliqué suit.

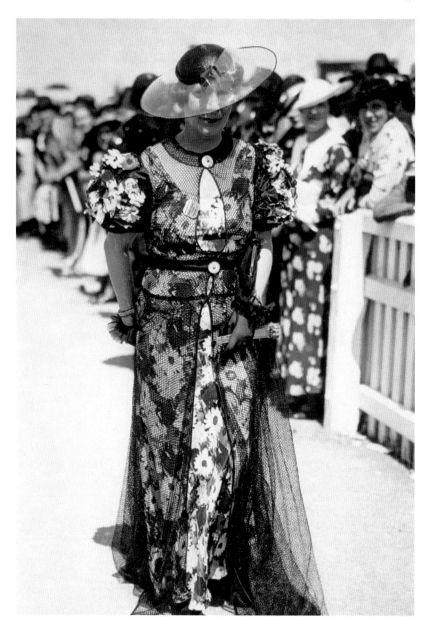

Long but by no means lean, a flowered frock with a dark tulle overdress and hat.
1936 A lady at the Ascot races enjoying the admiring glances, England.

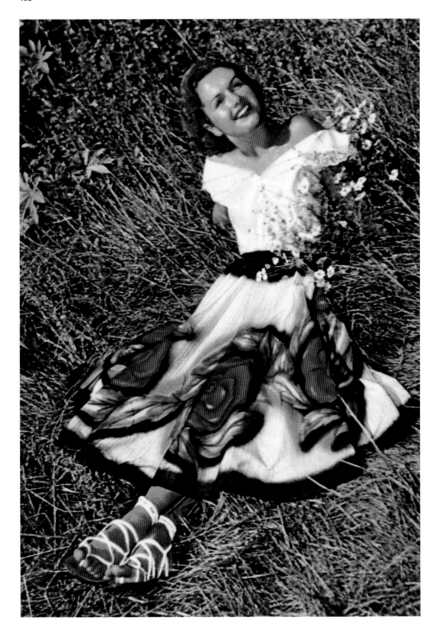

Meadow sweet in a fresh white frock painted with giant red and green blooms.
1957 American actress Debbie Reynolds making the film *Tammy Is A Bachelor*.

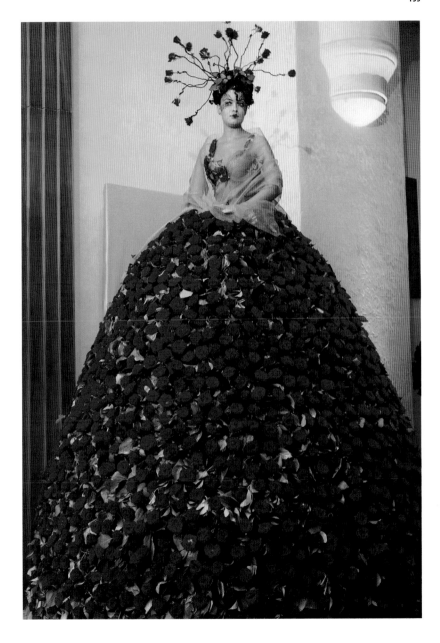

A hundred thousand red roses greeted the guests, only some of them were on skirts.
2009 The grand opening night of the Kerzner Mazagan Beach Resort, Morocco.

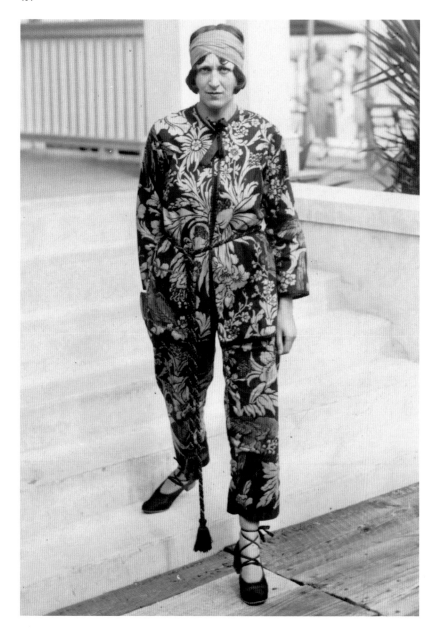

Shock of the new, loungewear previously only seen at home in the bedroom.
c.1924 Palm Beach blinked at Mrs. Herbert in her snazzy beach pyjamas.

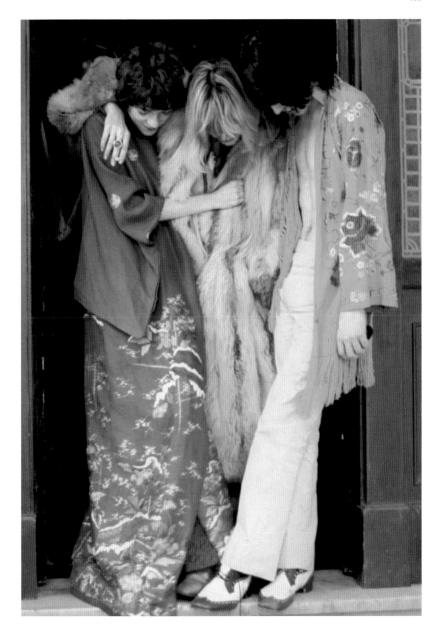

Ménage à trois, in a rock 'n' roll crime thriller dressed in embroidered kimonos.
1968 Michèle Breton, Anita Pallenberg and Mick Jagger in the film *Performance*.

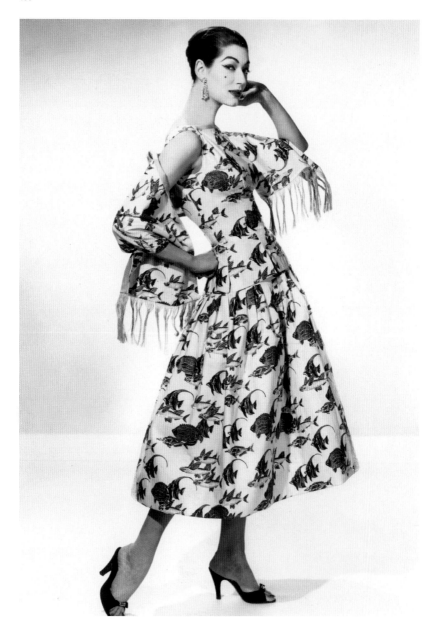

Fishing for compliments in a ladylike outfit printed with swimming fish, and fauna.
c.1950 A model wearing a full skirt with a bodice and a matching shawl.

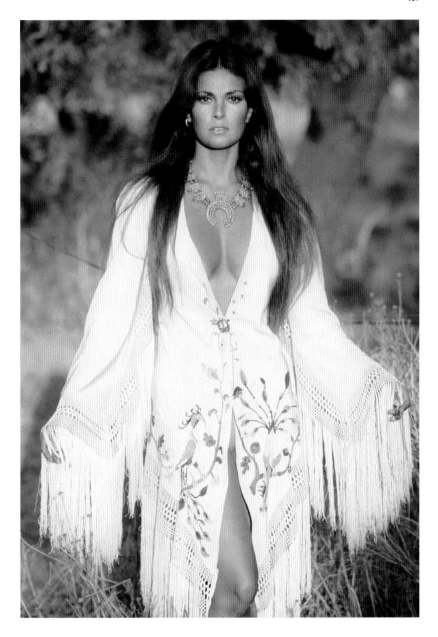

An exotic bird, in a dress made from an antique shawl embroidered with parrots.
c.1970 American actress Raquel Welch emerging from the forest.

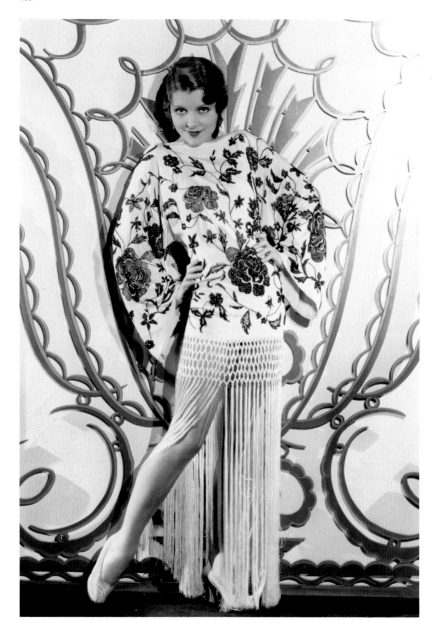

One of the 'It Girls' of her generation posing in an embroidered silk shawl-dress.
c.1930 American actress Peggy Shannon originally in the Ziegfeld Follies.

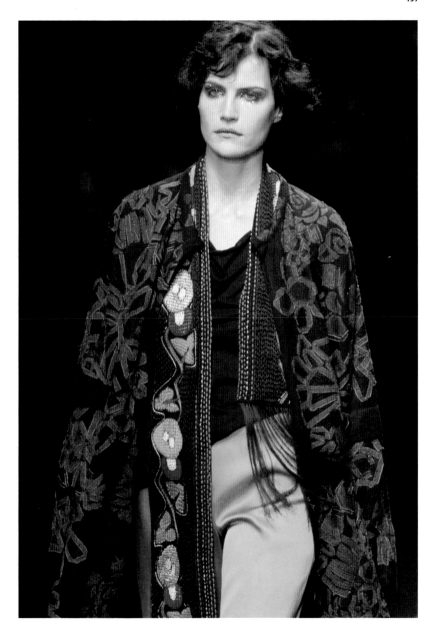

Textile king of the catwalks, a black woven-silk jacket with an appliquéd scarf.
2004 Dries Van Noten's autumn/winter fashion show in Paris.

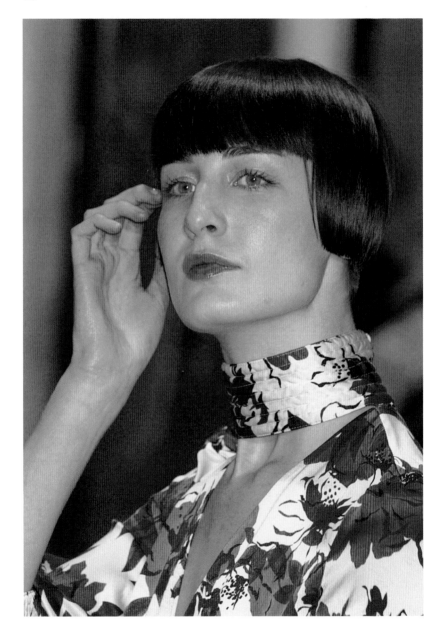

A black-bobbed beauty in a red-and-white flowered silk shirt and matching scarf.
2004 English model Erin O'Connor at the final of 'UK Music Hall Of Fame'.

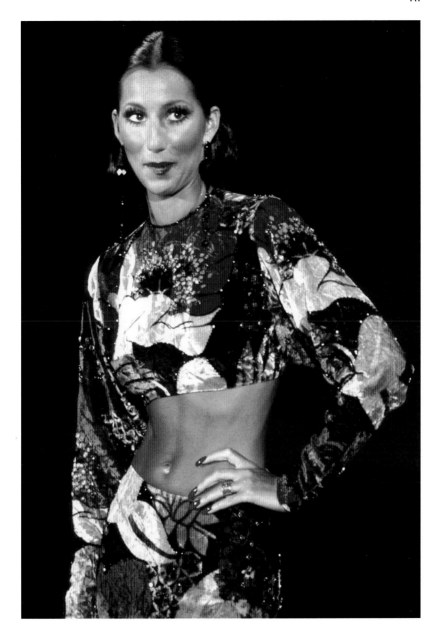

Body beautiful in a rather strange seventies crop-top and flared trousers.
c.1970 American actress and singer Cher posing without her partner Sonny.

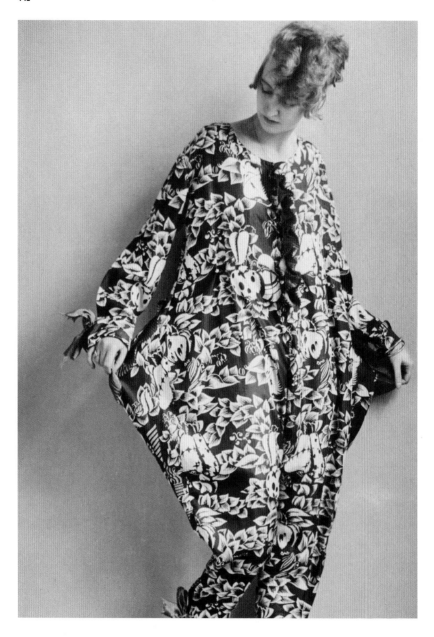

A romper suit in a print influenced by the English Art and Crafts movement.
c.1920 Pyjamas in a fabric by the Viennese company Wiener Werkstätte.

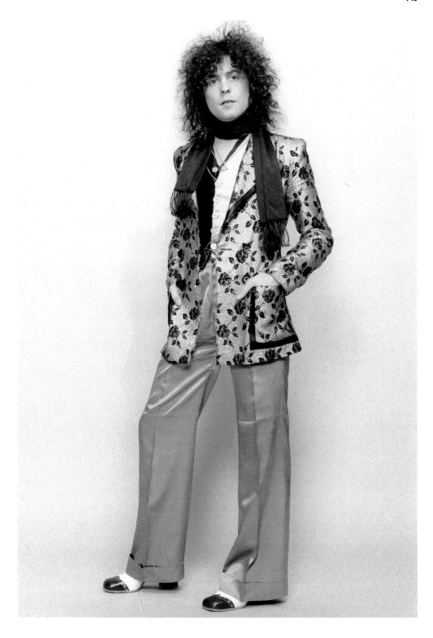

A flowered satin jacket and trousers worn with a scarf and corresponding shoes.
1972 English glam-rock star Marc Bolan, founder of the band T. Rex.

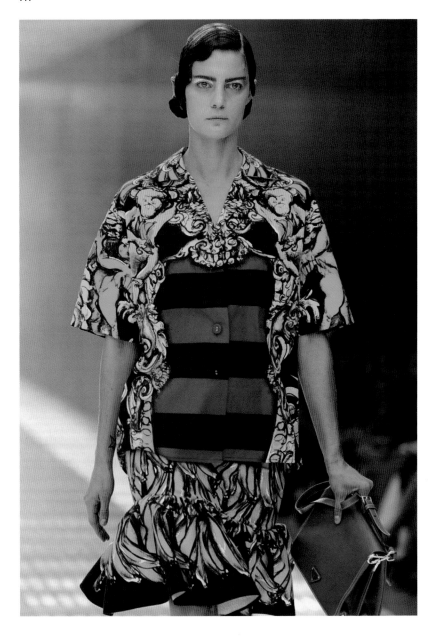

A plantation print with green bananas and leaves, with the odd orchid or two.
2011 Prada spring/summer fashion show, Milan.

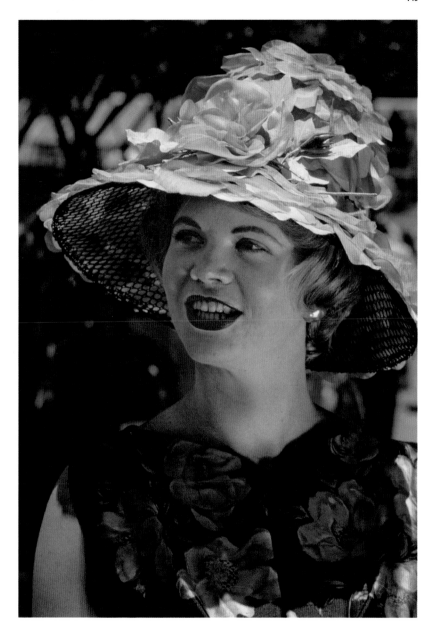

Keeping cool in the heat of the day wearing a leaf-green hat in silk and straw.
1962 A racegoer's hat echoes the print on her dress, Cape Town.

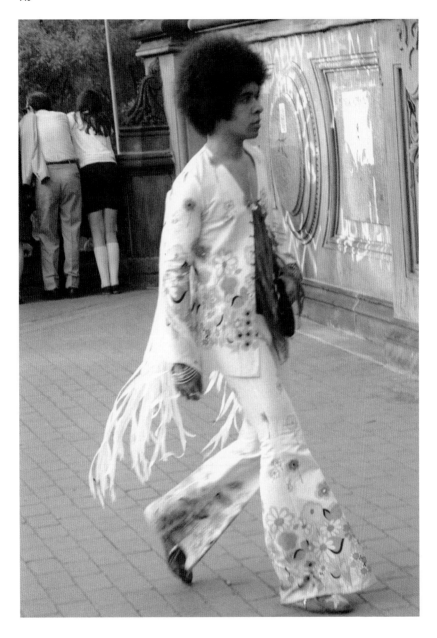

Flower power, all fringed and flared and topped off with an Afro hairdo to boot.
c.1970 A man on a mission, dressed to kill and pristine in white silk.

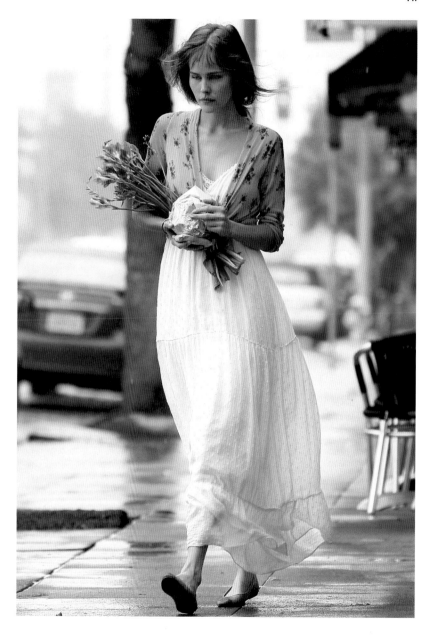

Fresh as a spring daisy on a rainy day, in white cotton with an orange cardi.
2010 Australian actress Isabel Lucas spotted in Los Feliz, Los Angeles.

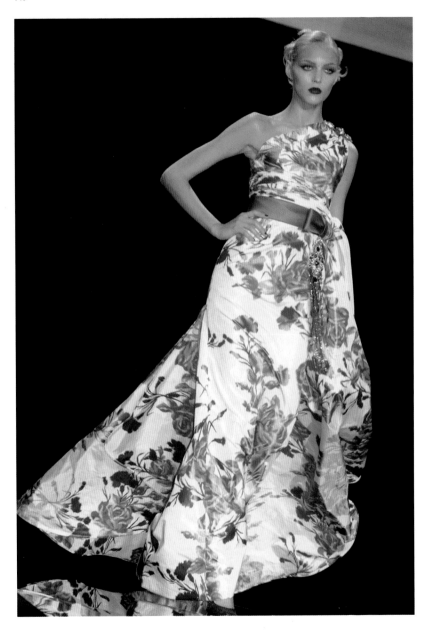

A gorgeous gown in monochrome with a huge train and cinched in at the waist.
2005 Valentino spring/summer haute couture fashion show, Paris.

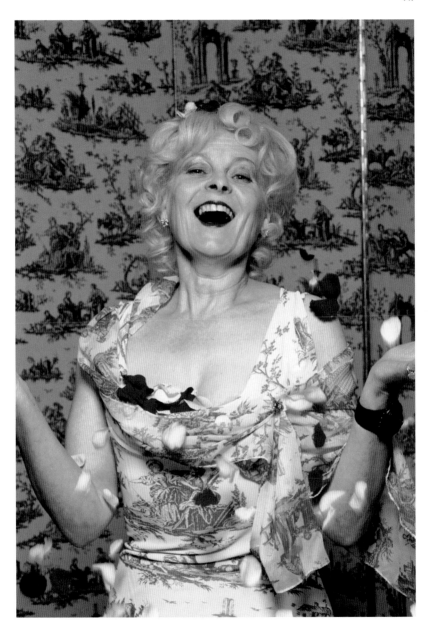

An evening dress in dark red and cream toile de jouy, normally seen on curtains.
c.1990 English fashion designer Vivienne Westwood, after one of her shows.

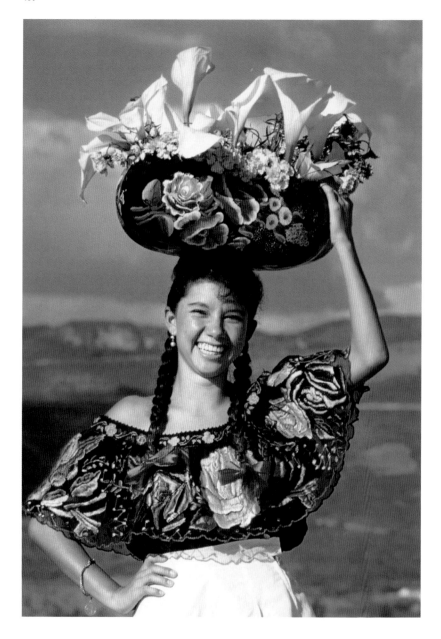

Big blooms and a bright smile on the way to the market, sales should be great.
1961 A girl in an embroidered shirt with a gourd of flowers, Chiapas, Mexico.

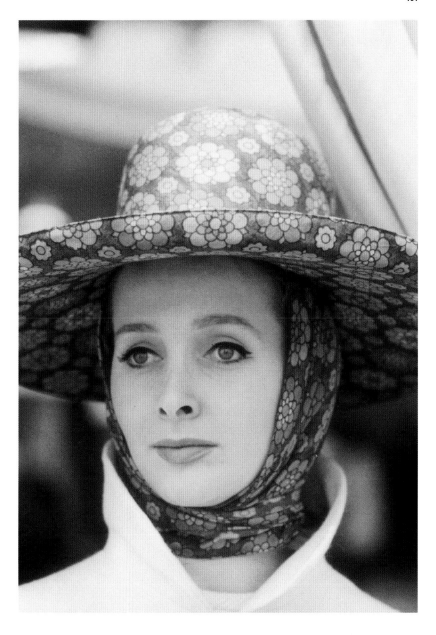

'That Was The Week That Was' and right up-to-date in a sixties-style mackintosh.
1963 British actress Millicent Martin in a patterned hat and matching headscarf.

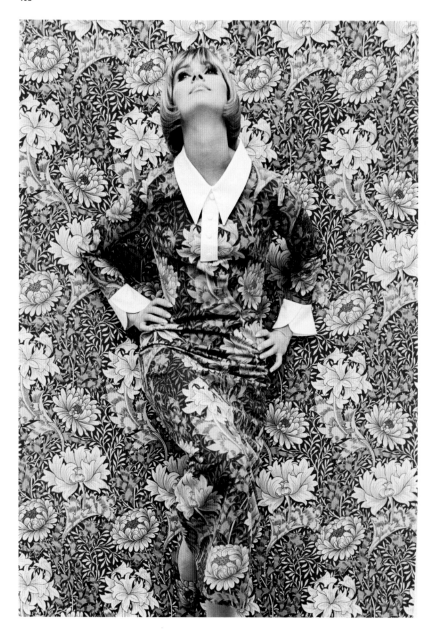

Disappearing act, camouflaged with an identical floral frock and wallpaper.
c.1966 Flower power, a three-quarter-length dress with a prim white collar.

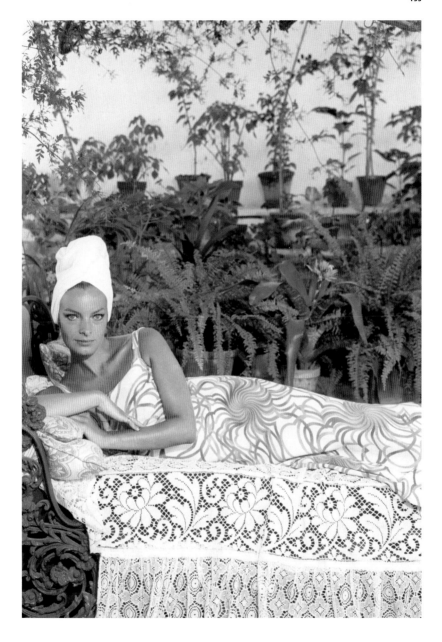

Lounging on lace, surrounded by pot plants, on a terrace overlooking the sea.
c.1980 Actress Brigitte Lapp Fonda reclines amid the foliage in Marbella, Spain.

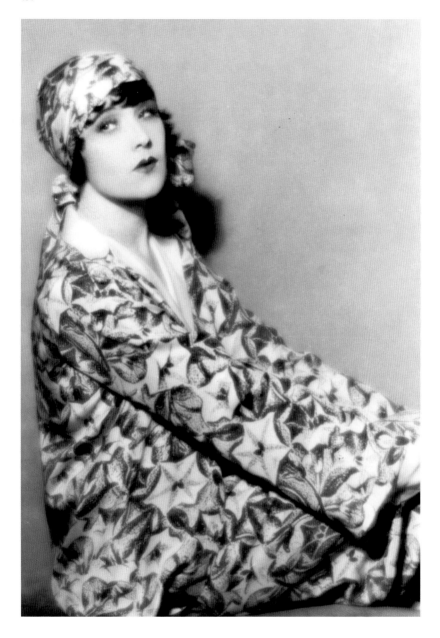

Posing in pyjamas covered in flowers, a white collar and a matching bandeau.
c.1931 American silent-screen actress and leading lady Margaret Livingston.

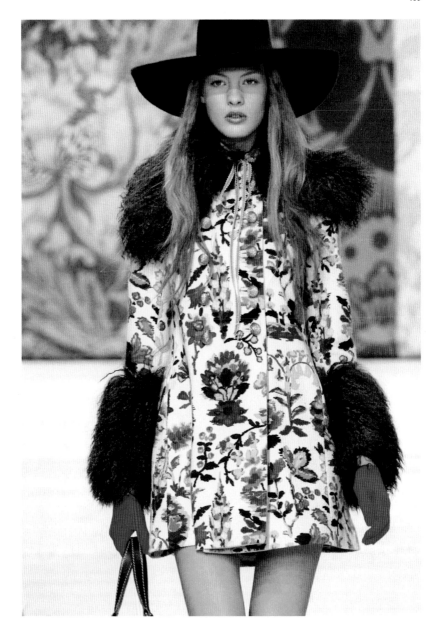

A bright chintz mini-coat, with black fur collar and cuffs, worn with a black fedora.
2005 Antonio Marras' autumn/winter show for Kenzo, Paris.

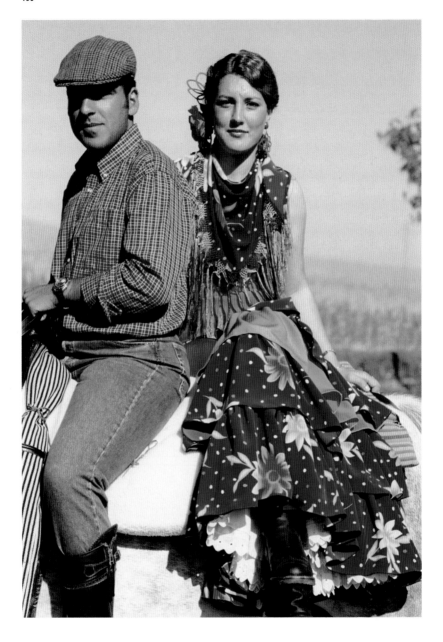

A day off dressed in her best, wearing blue frock with red and yellow flowers.
c.1990 A couple on horseback on their way to a fiesta, Andalucía, Spain.

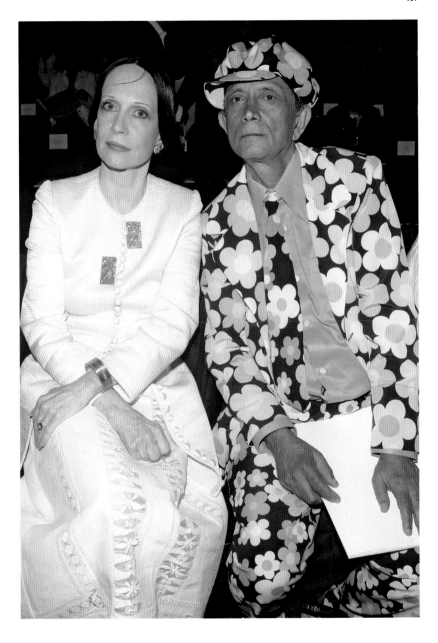

Classy in cream with a date dressed from the sixties in a flower-power suit.
2005 Designer Mary McFadden and Shail Upadhya at the Bill Blass show, New York.

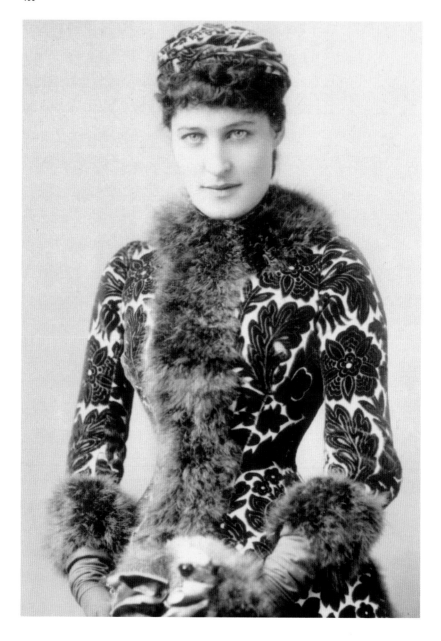

'Jersey Lily' looking lush in a brocade, fur-trimmed coat with a matching little hat.
c.1880 English actress, socialite and racehorse owner Lillie Langtry.

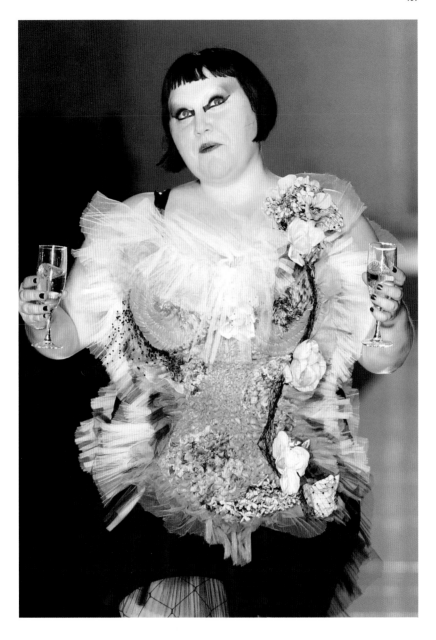

Champagne moll, a cabaret act in layers of tulle, roses and fishnet tights.
2011 American rock-star Beth Ditto at the Jean Paul Gaultier show, Paris.

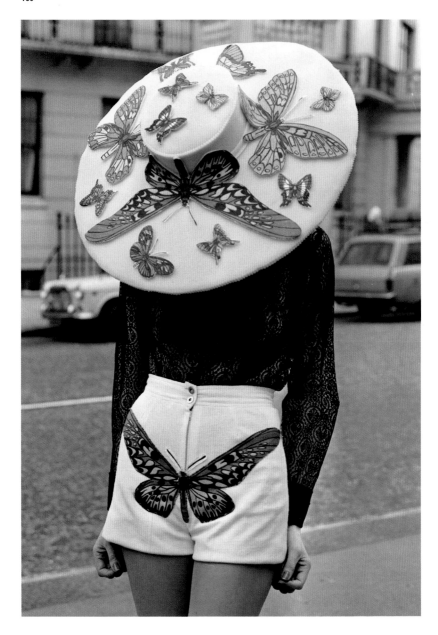

A cartwheel hat covered with butterflies and matching shorts, not really regal.
1971 An outfit by Simone Mirman, milliner to the Queen, London.

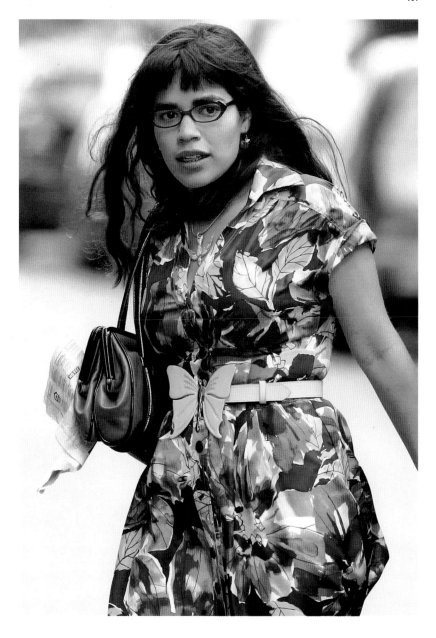

On her way to the fashion magazine in an ugly floral frock with a butterfly belt.
2008 American actress America Ferrera on the set of TVs *Ugly Betty*, New York.

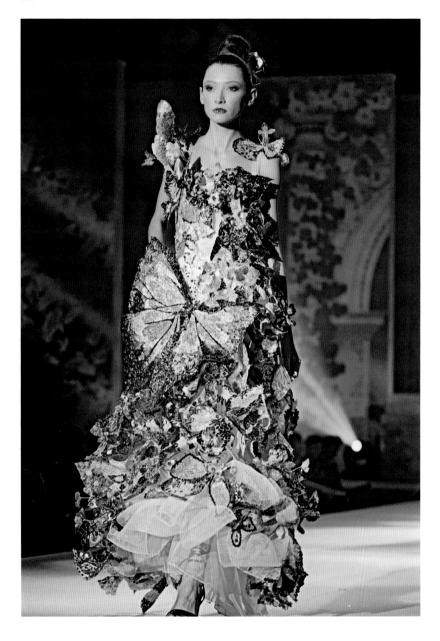

A gown of a thousand butterflies made from fifty thousand fish scales.
2010 An evening dress by Japanese bridal designer Yumi Katsura, Tokyo.

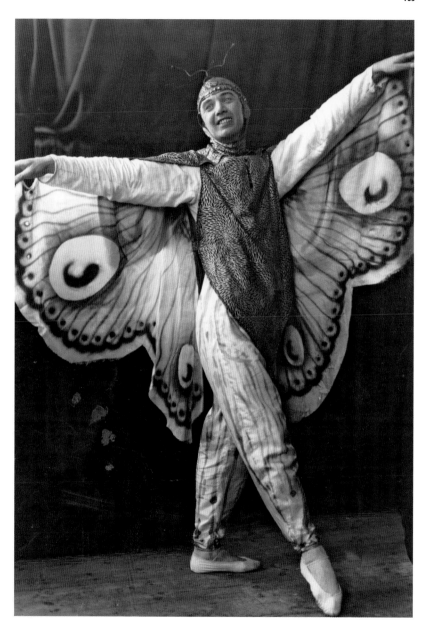

Dancing or fluttering across the stage in a beautiful, hand-painted costume.
c.1910 A member of the Haines Ballet Company dressed as a butterfly.

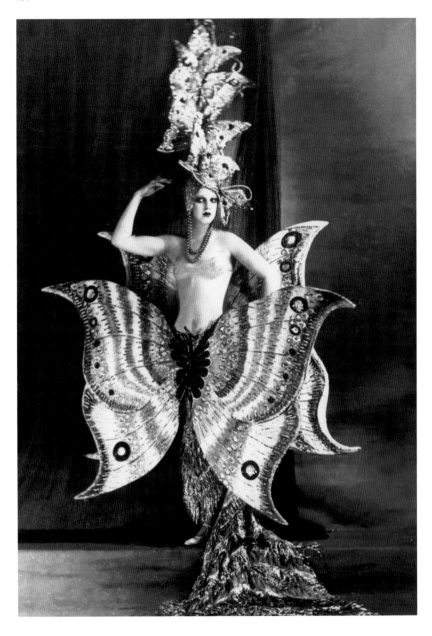

Still as a statue, posing in a fantastic sequined butterfly costume, semi-nude.
c.1910 A cabaret dancer in costume at the Folies Bergère, Paris.

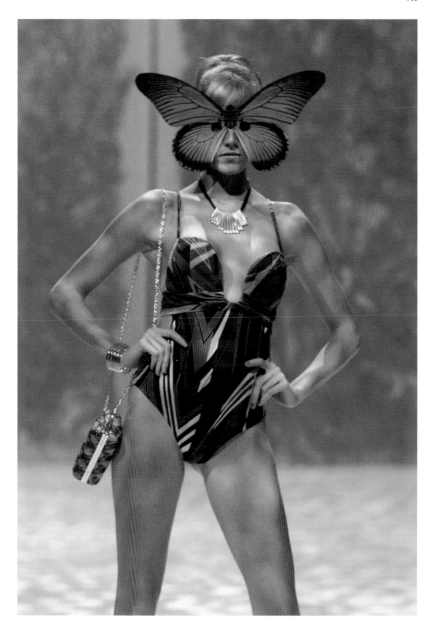

A swimsuit with a bright stained-glass print, a butterfly mask and a handbag too.
2011 Spring/summer fashion show at Copenhagen Fashion Week, Denmark.

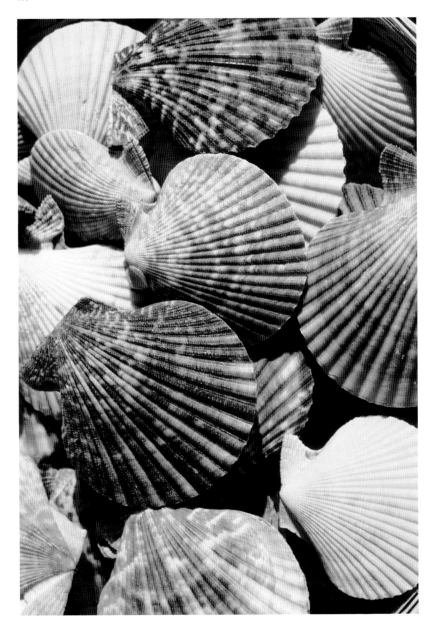

Pretty enough for a picture, shells discarded in a basket on a bright white beach.
20th Century Scallop shells in yellow and coral colours, Cape Town.

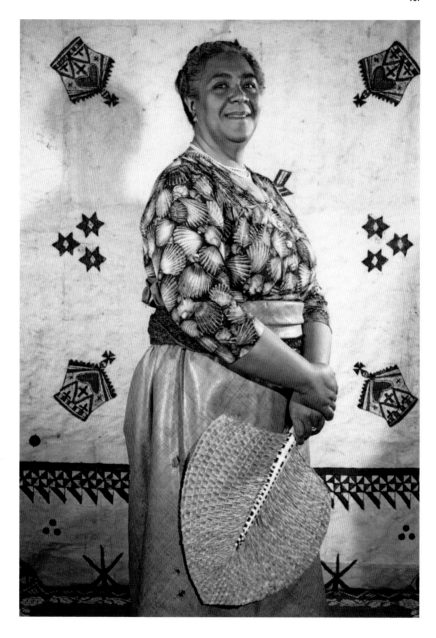

A blouse of shells on a sea-blue shirt against a backdrop of stars and crowns.
c.1950s Tonga's Queen Sālote Tupou III led the islands until her death at 65.

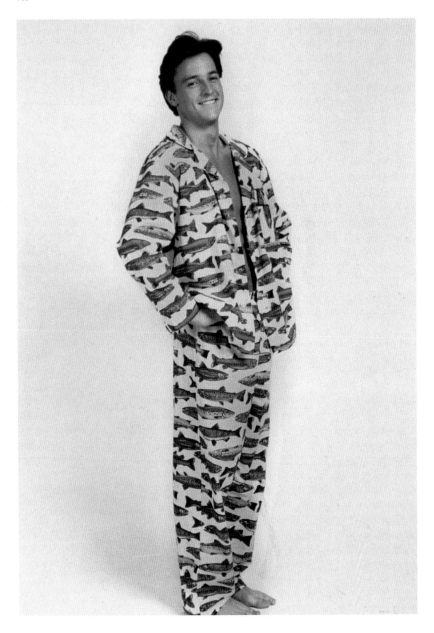

Shark alert, a fishy print in blues on a white background, and off to bed we go.
c.1990s A model in pyjamas by Joe Boxer Co. designed by Nicholas Graham.

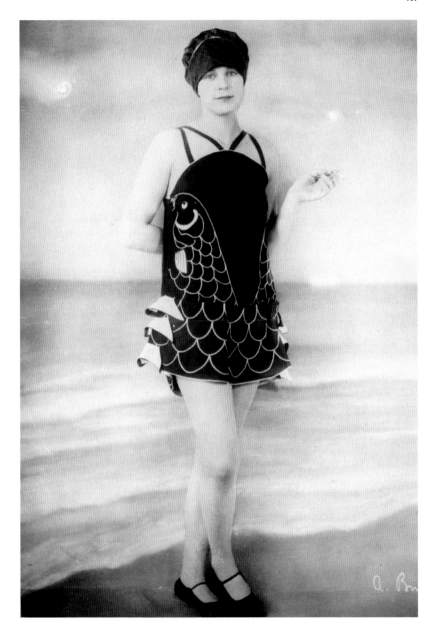

Bathers more for posing against a beach backdrop than for diving into the sea.
1926 A silk swimming costume embroidered with fish and scalloped at the sides.

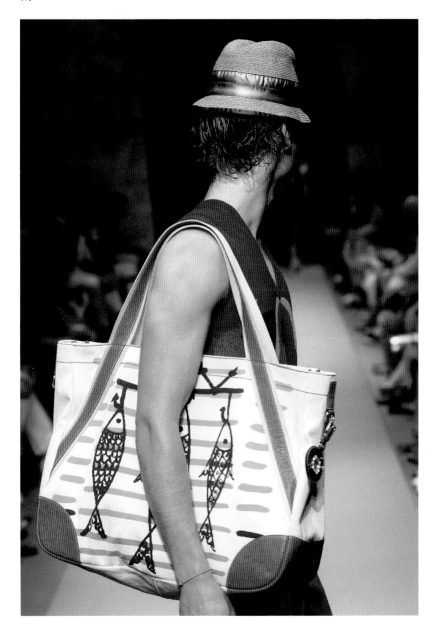

A holiday holdall for the beach in red, white and blue canvas with fish on a line.
2005 Prada men's spring/summer fashion show, Milan.

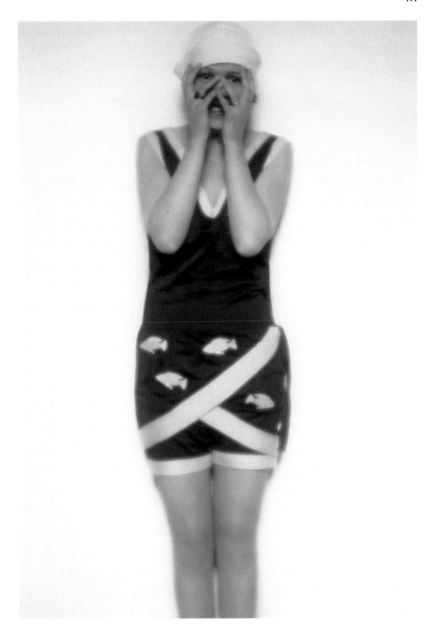

Peek-a-boo, not-the-most-attractive woollen bathers, quite broad in the beam.
c.1920 Beach fashion, black with goldfish and wide stripes knitted in white.

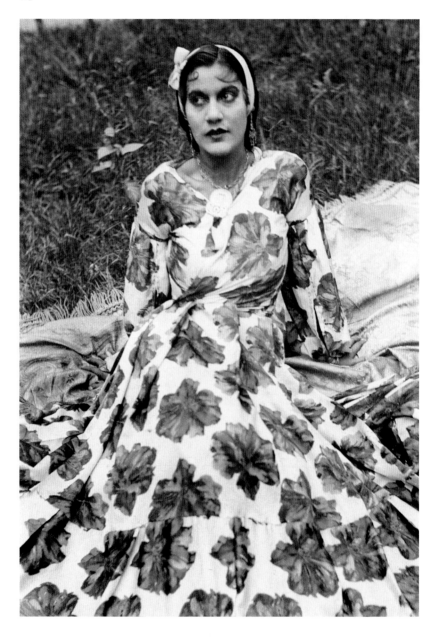

Kohl-black eyes, arched red lips, wearing a full-skirted, flowered frock, fascinating.
1935 A gypsy woman wearing a colourfully patterned dress, Hungary.

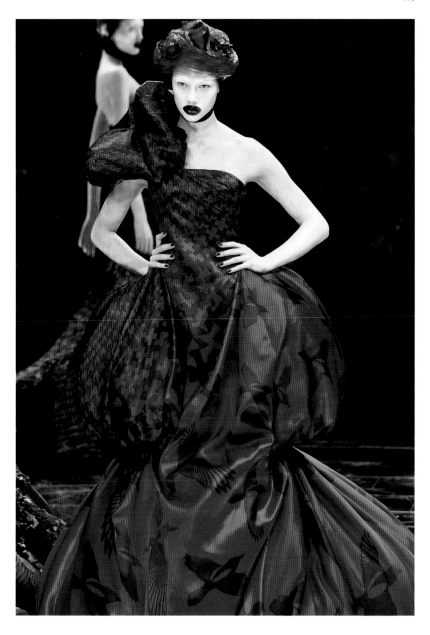

Blackbirds and magpies scudding across a crimson gown with dogtooth checks.
2009 Alexander McQueen's autumn/winter fashion show, Paris.

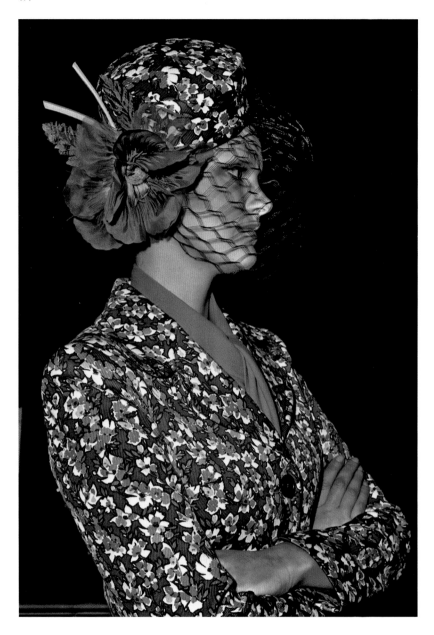

A floral print suit in cornflower blue, poppy red, yellow and white and a net mask.
1973 A Christian Dior outfit in cotton piqué worn with a matching pillbox hat.

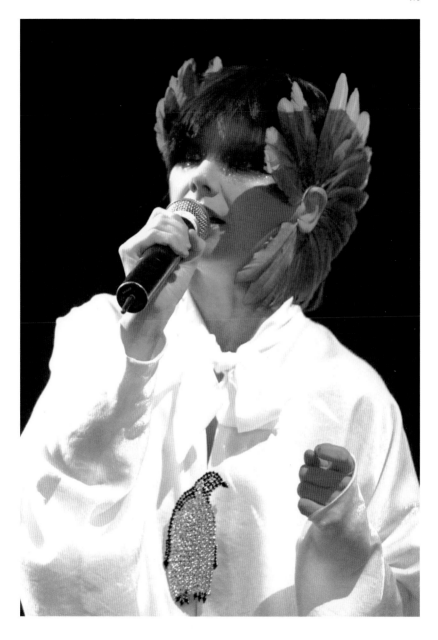

Turquoise feathered earphones, heavy eye make-up and a crisp white shirt.
2003 Icelandic singer Björk live in concert at the Roskilde Festival, Denmark.

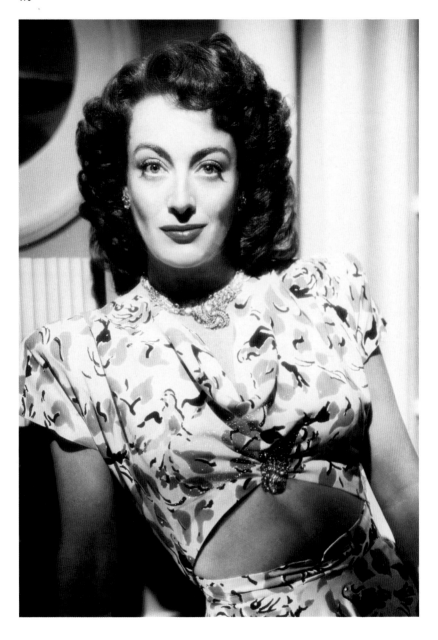

An Academy Award winner in a patterned cropped-top and a matching skirt.
c.1944 American film actress Joan Crawford in her role in *Mildred Pierce*.

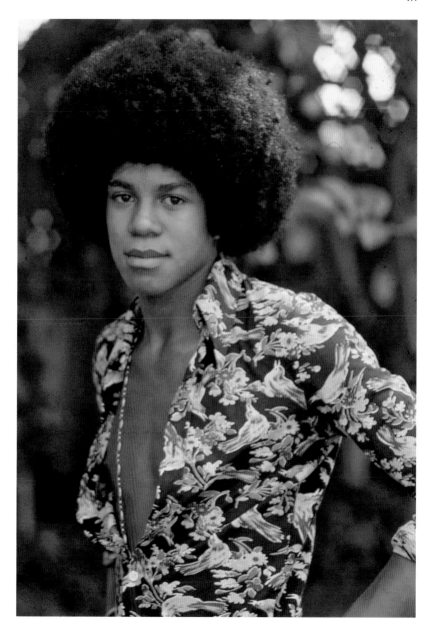

Motown magic, the birds and the bees fluttering over a blue floral shirt.
1972 American singer Jermaine Jackson, one of The Jackson 5, in a pretty pose.

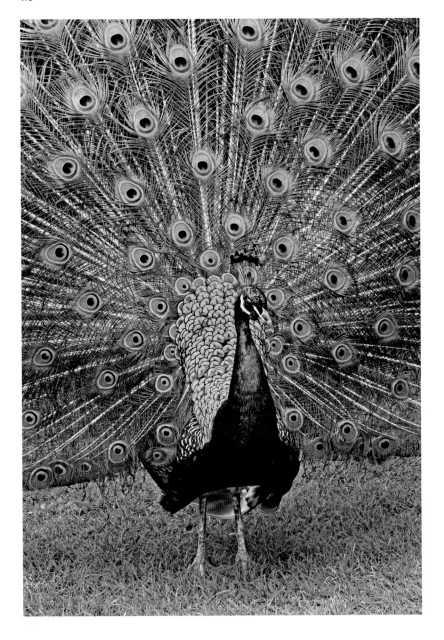

A brilliant bird fanning out its jewel-coloured feathers.
20th Century An Indian blue peacock in a typical courtship display.

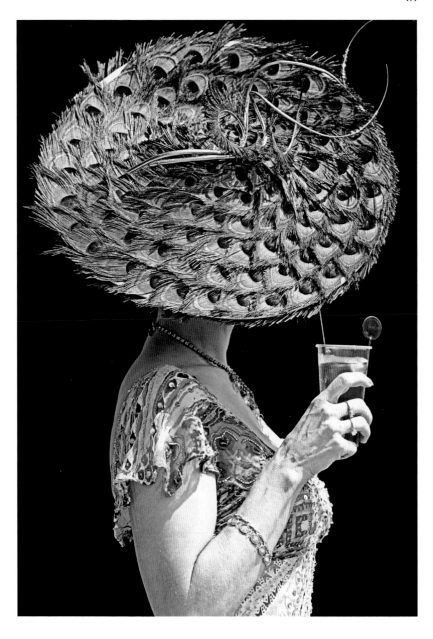

Peacocks were always thought to be unlucky, let's hope she wins her bets.
2010 A racegoer wears a hat made from peacock feathers, Ascot, England.

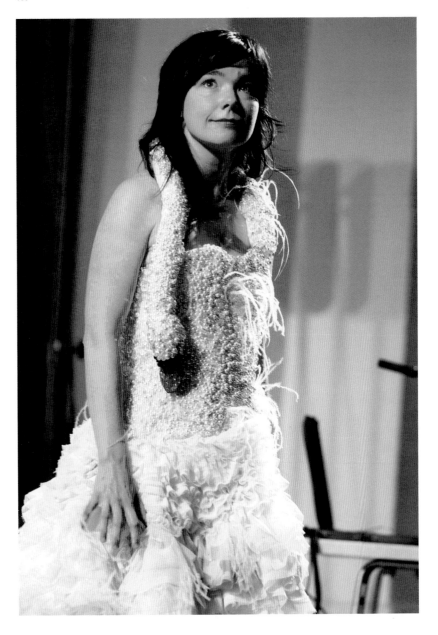

Swan song, wearing a white, feathered frock complete with a head and beak.
2001 Icelandic singer Björk in Alexander McQueen, performing live in London.

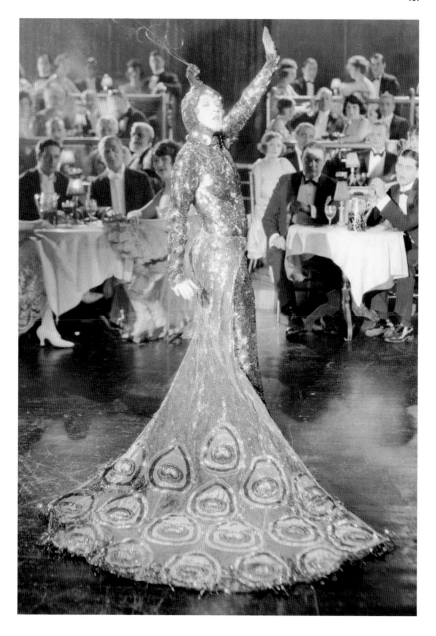

'Peacock Alley', performing in a nightclub clad in an exotic, embroidered gown.
1922 American actress Mae Murray in a film by her husband Robert Z. Leonard.

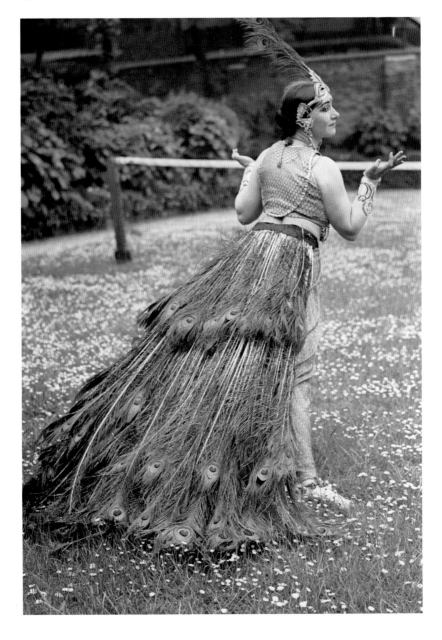

Meadow sweet, wearing an enormously long feathered skirt and Indian jewels.
1938 Dancer Ragina Devi in a peacock costume rehearsing a Hindu ritual dance.

Bal Masqué, in a scary bird headdress by Gareth Pugh and a pristine Pucci dress.
2011 Fashionista Anna Dello Russo at the *Vogue* 90th Anniversary party, Paris.

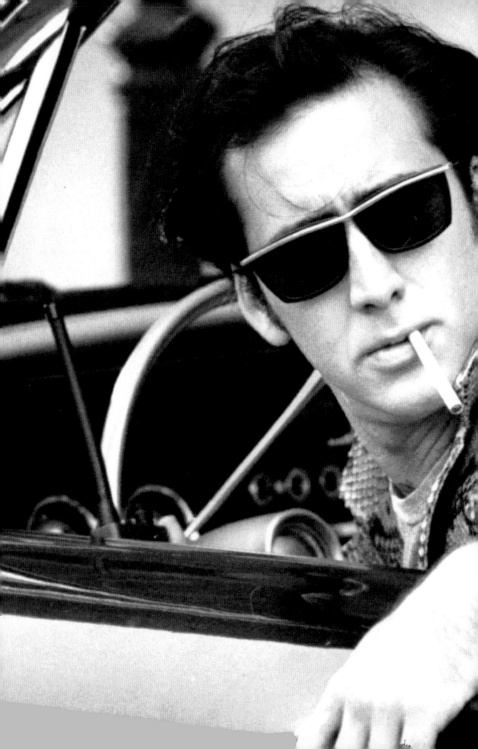

Shedding her skin, a layered chiffon dress in a pretty python print.
2008 Christopher Kane's spring/summer show, London.

Previous page Mad, bad and dangerous to know, filming *Wild At Heart* in his cool convertible.
1990 American actor Nicolas Cage wearing sunglasses and a snakeskin jacket.

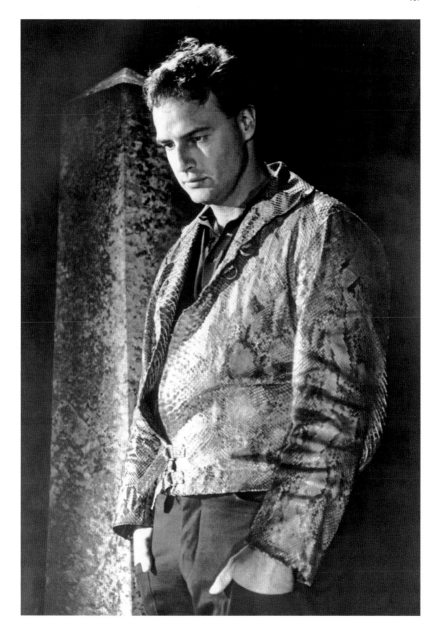

Brooding good looks, in a snakeskin jacket, and a fine Tennessee Williams tale.
1959 American actor Marlon Brando in the movie *The Fugitive Kind*.

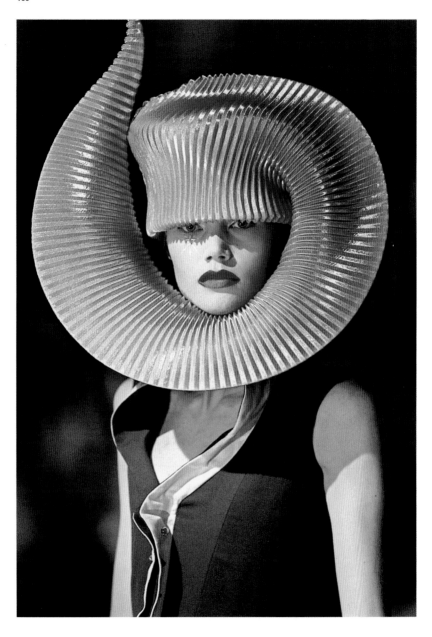

A swirling shell-shaped hat in the palest peach framing a delicate face.
2001 British milliner Philip Treacy's autumn/winter haute couture show, Paris.

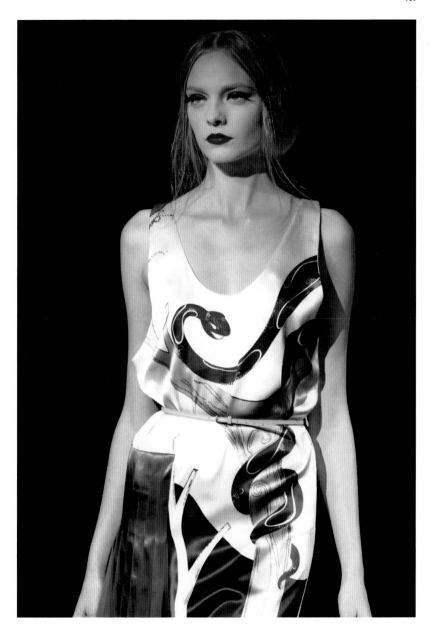

A writhing black serpent on a tree, hand-printed on a white silk shift-dress.
2011 Miu Miu spring/summer show, Paris.

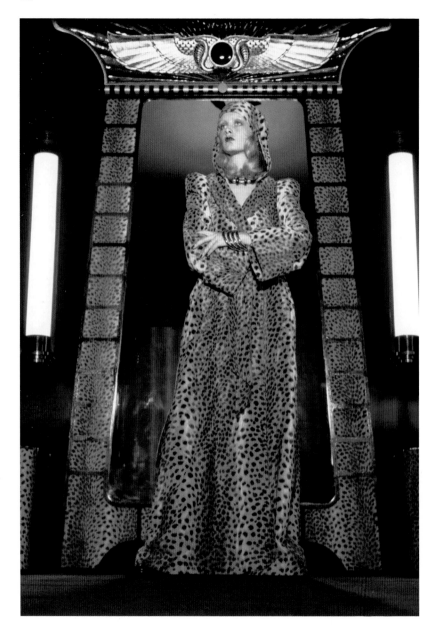

Clad Cleopatra-like in a long faux-leopard gown with a matching headdress.
1971 English model Twiggy in Egyptian mode at the Biba store in London.

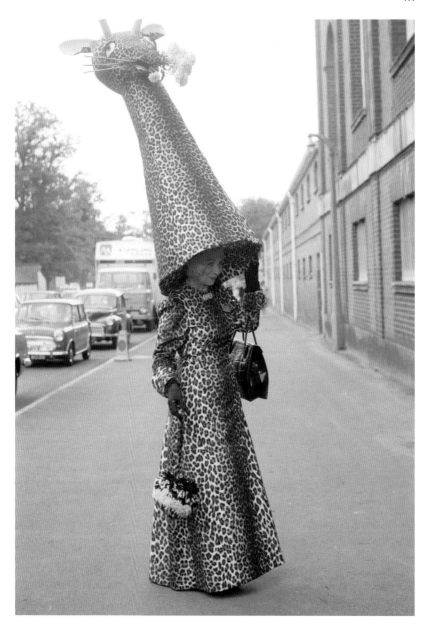

On her way to the Ascot races in a bizarre giraffe hat and a long dress in leopard print.
1971 English eccentric Gertrude Shilling, the mother of milliner David Shilling.

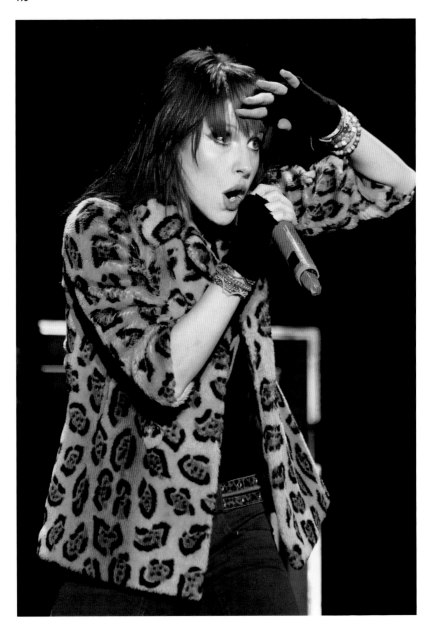

Rock chick with electric red hair, an animal-print jacket and beaded bracelets.
2010 American singer Hayley Williams of Paramore, Reading Festival, England.

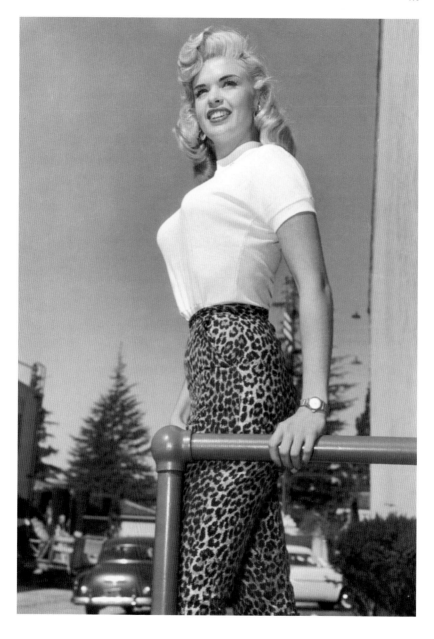

Blonde bombshell and sex siren, curvaceous in a white T-shirt and leopard-print pants.
c.1955 American actress Jayne Mansfield standing outside in the sunshine.

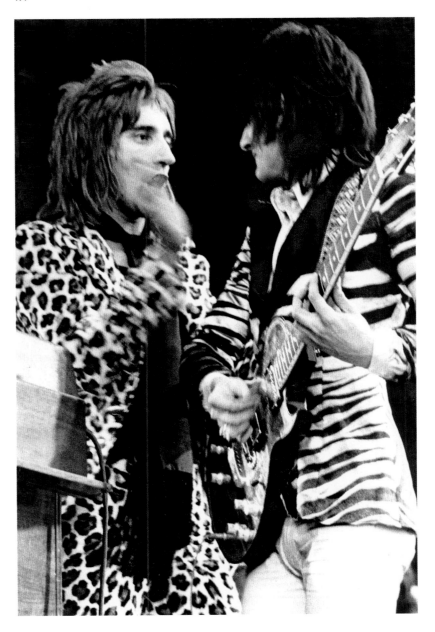

Animal magic, you're a leopard, I'm a zebra, rock 'n' roll jackets live on stage.
1971 Brits Rod Stewart and Ronnie Wood of The Faces at the Oval, London.

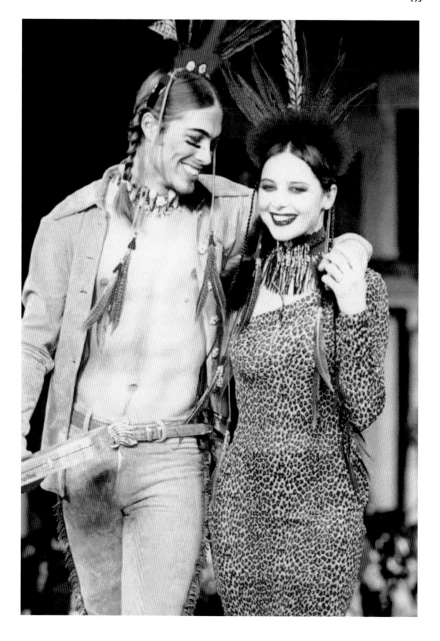

Sioux chic with feathered headdresses and chamois outfits, hers in animal print.
1995 Italian actress Isabella Rossellini in the Betsey Johnson fashion show, New York.

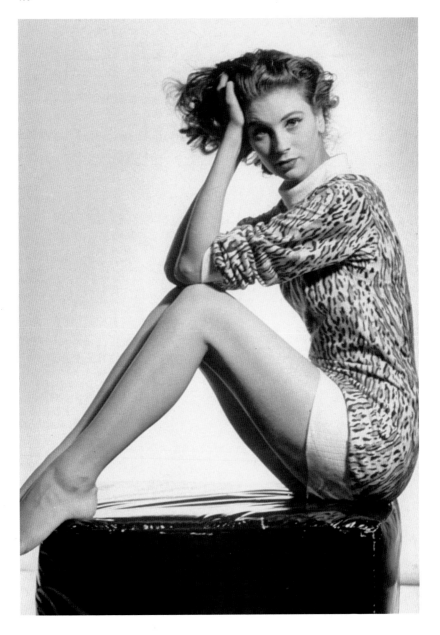

A playsuit by Tiger Lil in animal print with a white trim, perched on a PVC pouffe.
1951 American model and actress Suzy Parker on the cover of *Life* magazine.

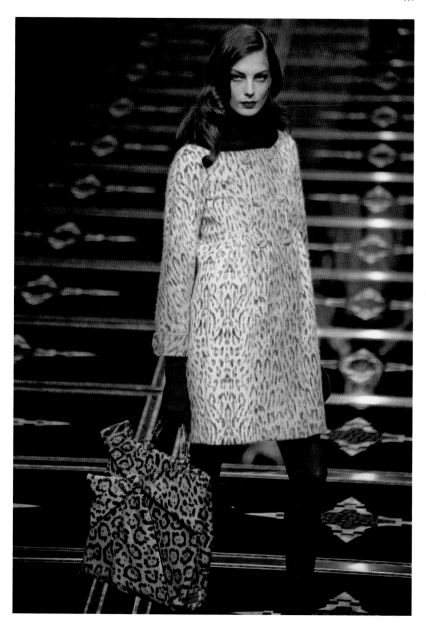

Never knowingly out of fashion, an animal-print coat with a fur collar and a bag.
2001 Valentino autumn/winter fashion show in Paris.

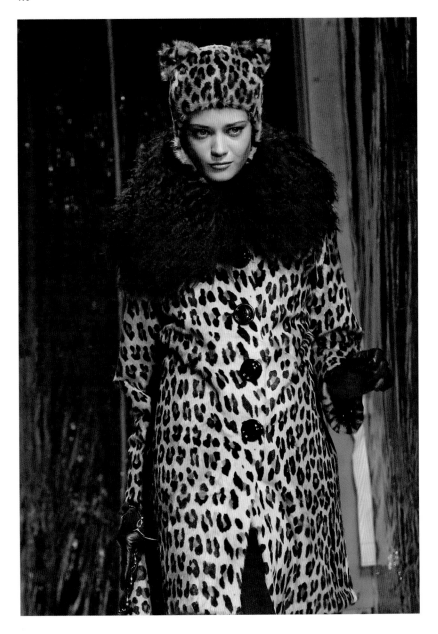

Grrr, a big-cat coat with a large black fur collar, and a hat with little ears.
2010 Moschino Cheap & Chic autumn/winter show, Milan.

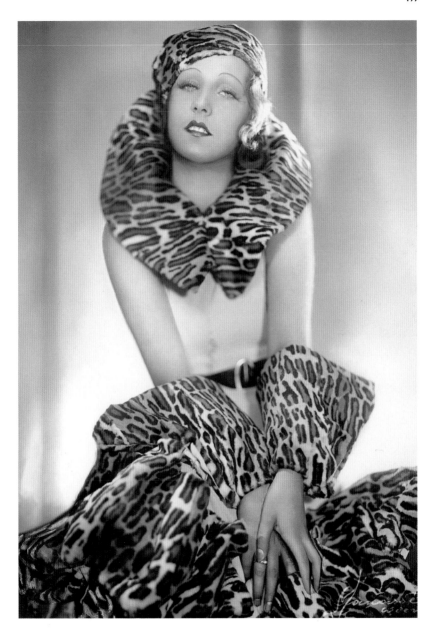

A leopard-print coat with detachable collar and cuffs, and a small matching hat.
1932 American actress and entertainer Gerty Gert posing for a picture.

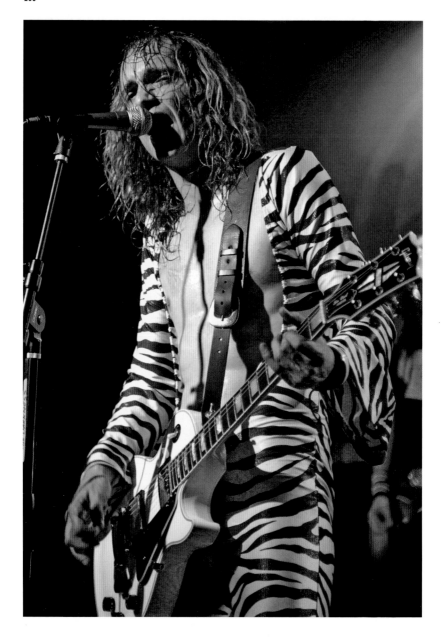

Lithe in lycra, glam rock in the tightest zebra-print body suit with flared sleeves. 2005 Justin Hawkins of the British band The Darkness, Los Angeles.

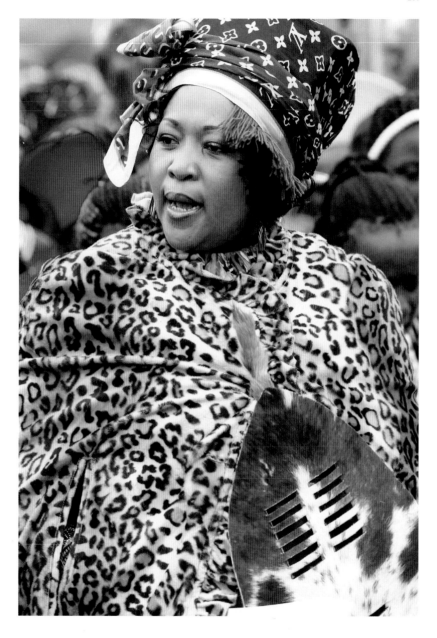

Bride number five in traditional Zulu leopard skins and a Louis Vuitton scarf.
2010 Thobeka Madiba at her marriage to South African President Jacob Zuma.

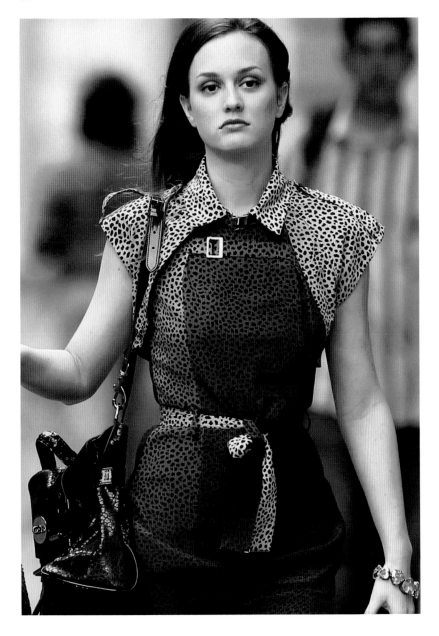

Striding the mean streets, wearing an animal-print dress in browns.
2010 American actress and singer Leighton Meester spotted in New York.

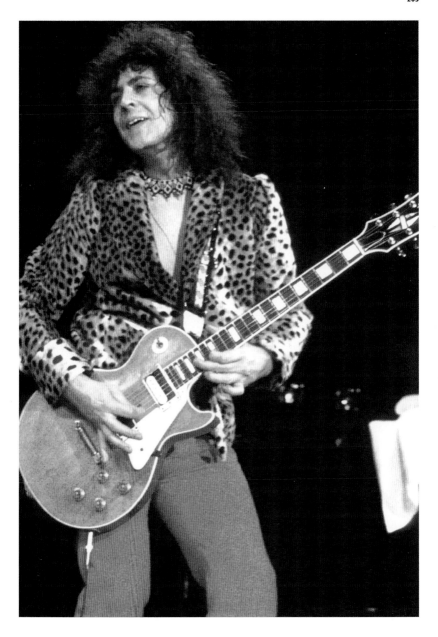

Always a bit of a fashion icon in a fake-fur jacket, red jeans and a necklace.
1973 British glam rock star Marc Bolan of T. Rex in concert, Denmark.

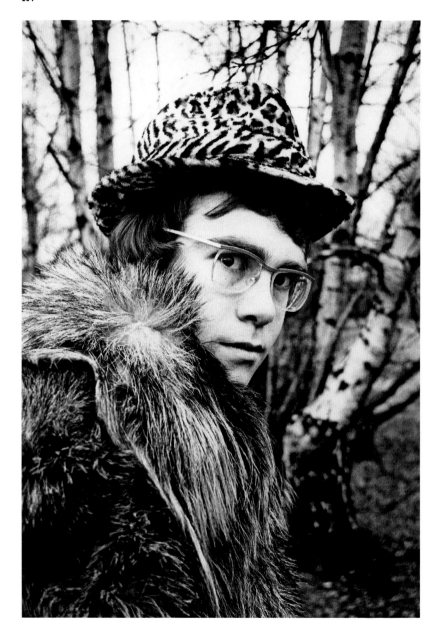

On his stellar rise to rock royalty wearing furs and a leopard-print titfer.
1968 Singer Elton John in his first publicity photos, Hampstead, London.

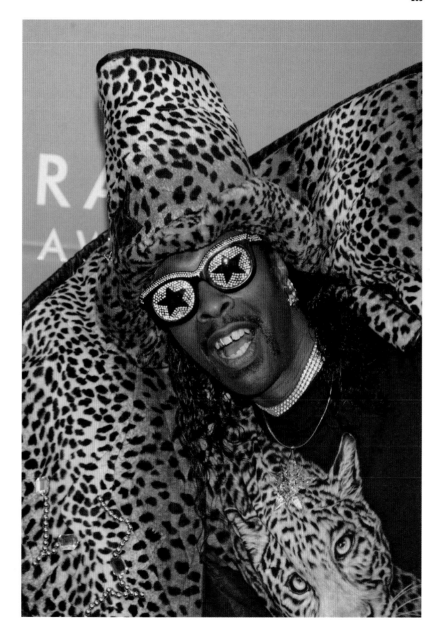

'Standing in the Shadows of Motown' with stars in his eyes and in leopard-print.
2002 American funk bassist Bootsy Collins at the Grammy Awards, Los Angeles.

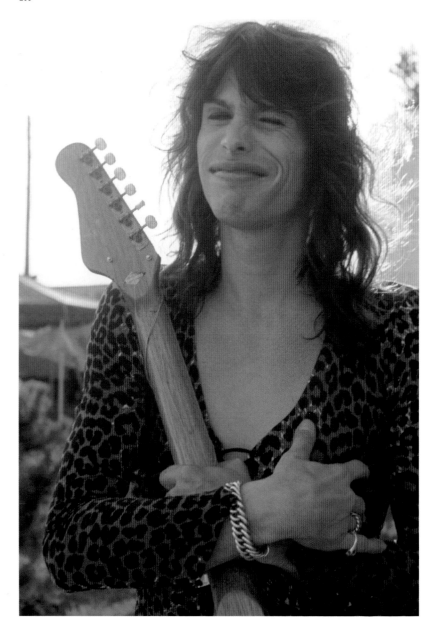

'One of the Bad Boys of Boston' in their heyday, the lead guitarist wears red leopard print.
1976 American singer Steve Tyler of the heavy-metal band Aerosmith.

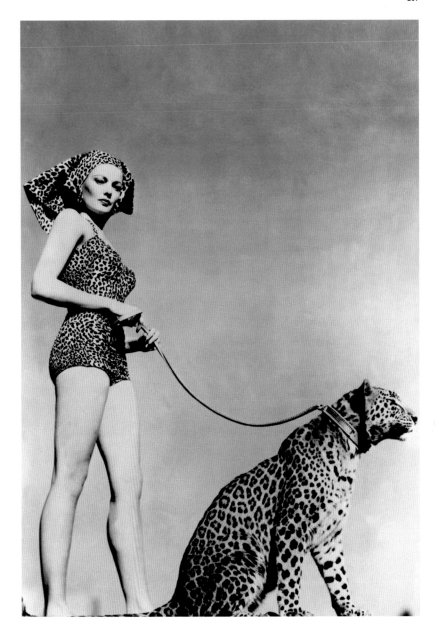

With very long legs, a leopard on a leash, oh what shall I wear? A divine swimsuit.
1954 American actress Gene Tierney with her matching pet in California.

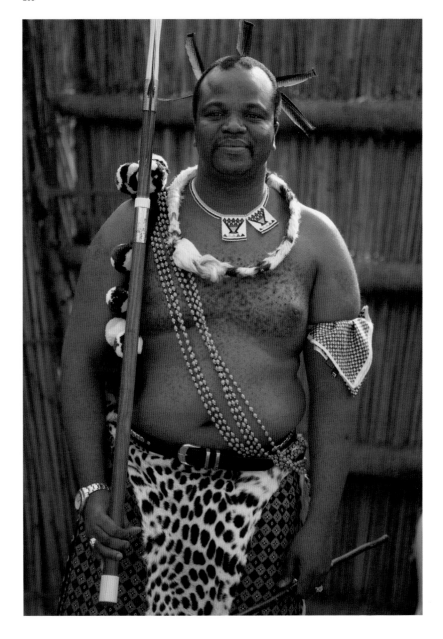

One of the richest and last absolute monarchs, who already has fourteen wives.
2009 King Mswati III of Swaziland watches virgins at a traditional ceremony.

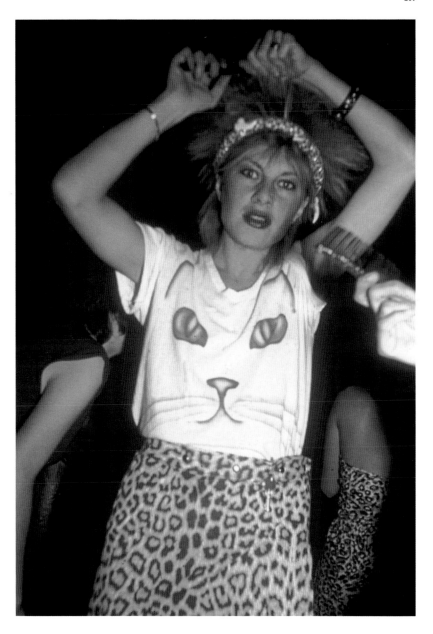

Cat woman bopping around in a white T-shirt and a leopard-print straight skirt.
1970s A party girl at the fashionable nightclub Studio 54, New York.

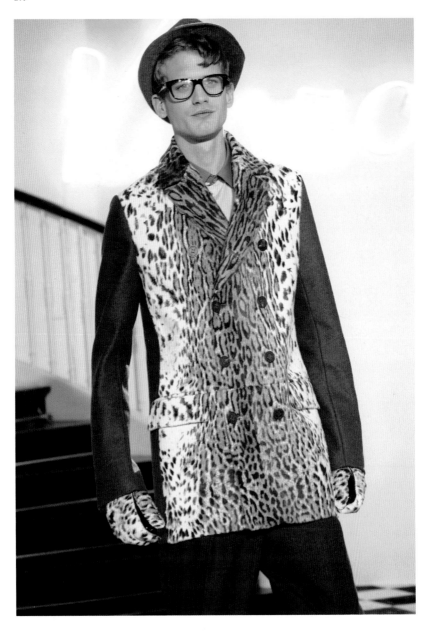

Geek chic in spectacles, a suit with an animal-print front and matching mitts.
2010 Kenzo autumn/winter men's show, Paris.

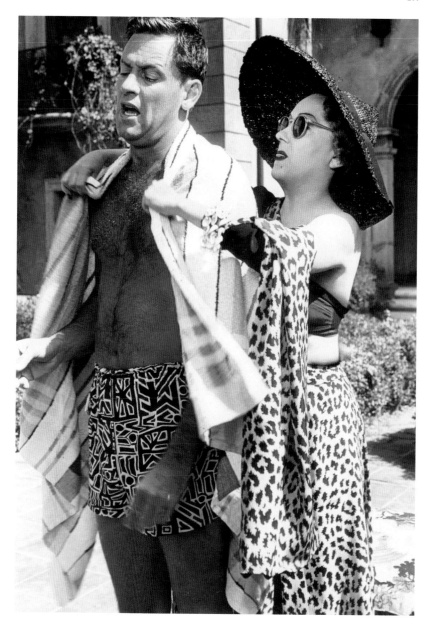

Hoorah for Hollywood, dressed for a cool pool party in designer bathers.
1950 American actors William Holden and Gloria Swanson in *Sunset Boulevard*.

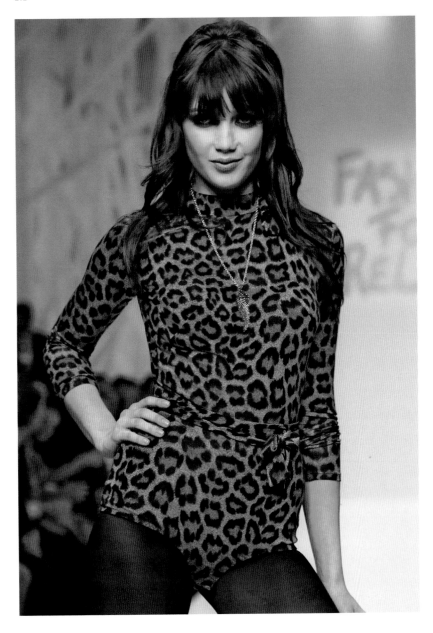

Lovely in a leotard, more for the catwalk than the gym, in leopard print.
2009 English model Daisy Lowe in 'The Fashion For Relief' charity show, London.

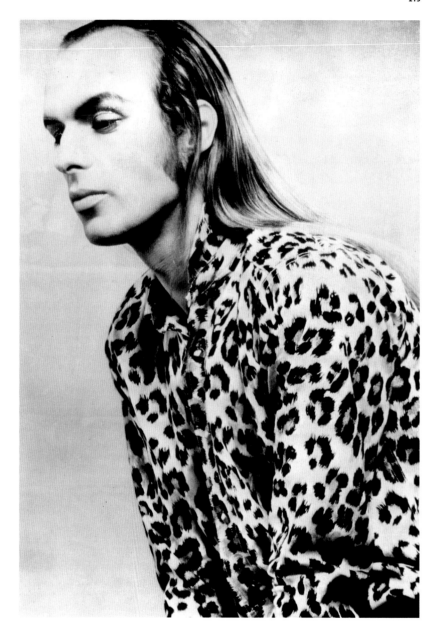

'Taking Tiger Mountain', in a leopard's spots, at the beginning of his solo career.
1974 English electronic rock musician Brian Eno, formerly of Roxy Music.

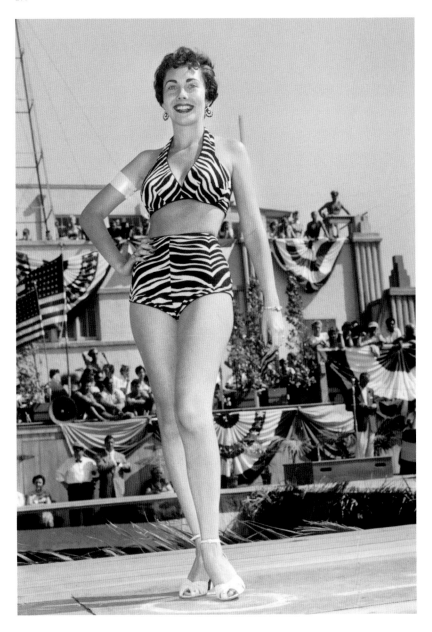

A very generous bikini in zebra print, not really suitable for surfing.
1954 A contestant in 'Miss Surfestival' on stage in a two-piece bathing suit, USA.

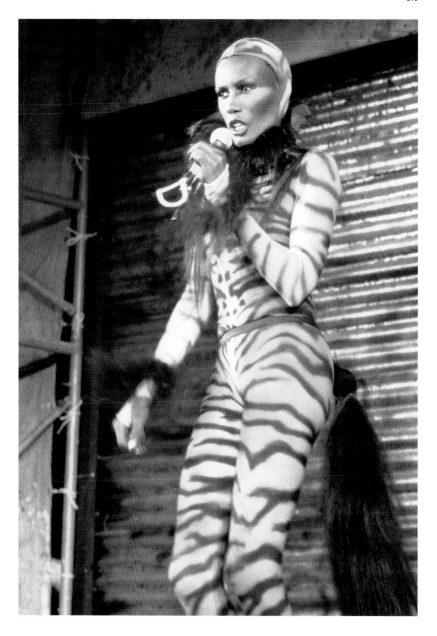

Singing her solo album *Warm Leatherette*, clad in tiger print from top to toe.
1980 Jamaican model and singer Grace Jones, both sexy and androgynous.

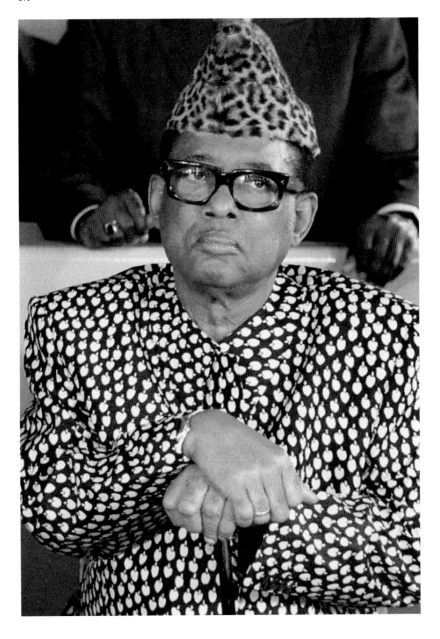

The final curtain, clad in his customary leopard-skin cap and a fruit-print shirt.
1997 Zairean President Mobutu at summit talks near the end of his rule.

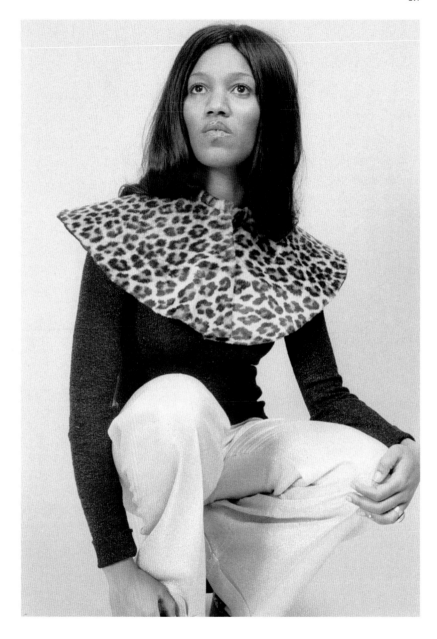

'Light of Love', very glam rock in a large leopard collar over a black sweater.
1974 American singer Gloria Jones, the then girlfriend of Marc Bolan, London.

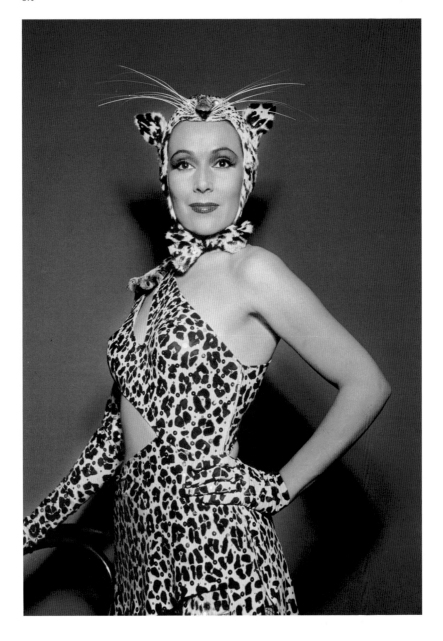

A real pussycat in *Journey Of Fear*, dressed in a saucy leopard costume.
c.1942 Mexican film star Dolores del Río, ex-girlfriend of Orson Welles.

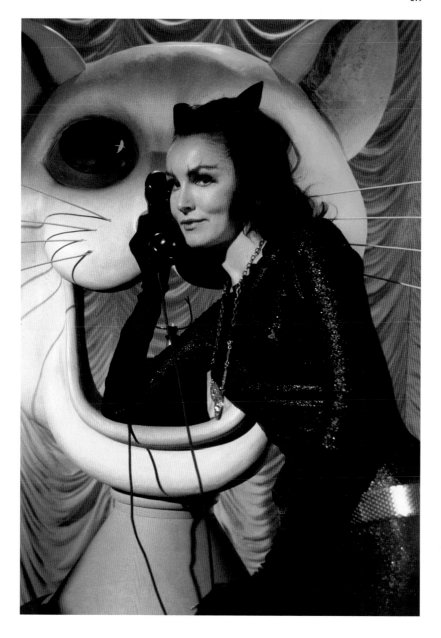

Catwoman, 'the purrfect villainess', on the telephone to Batman or Robin?
c.1966 American actress and dancer Julie Newmar, in the TV series *Batman*.

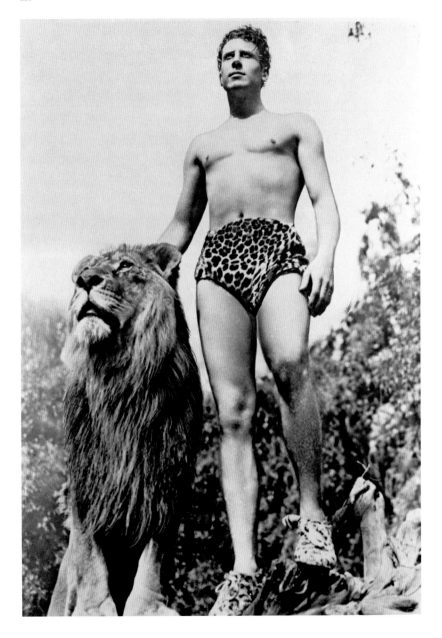

A hero's pose in matching leopard-print shorts and shoes, with a very large lion.
1938 American actor Glenn Morris in the film *Tarzan's Revenge*.

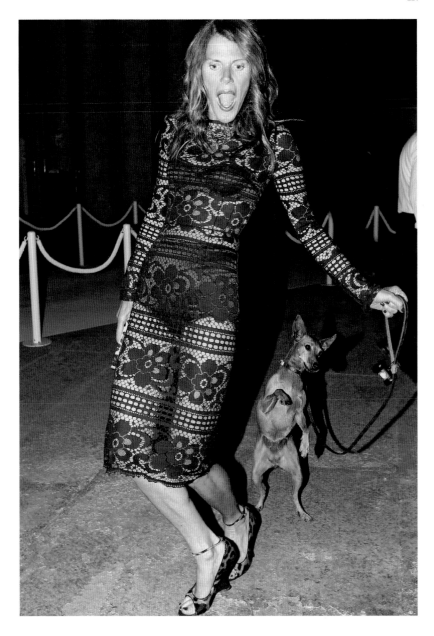

Scarlet woman in a lace over-dress and leopard-print wedges, with a tiny dog.
2011 Italian fashion director Anna Dello Russo at the Burberry show in Milan.

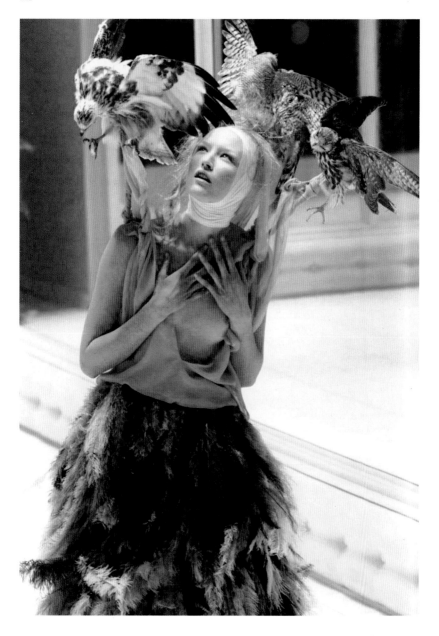

Inspired by Hitchcock's film *The Birds*, an eagle headdress and a feathered skirt.
2001 Alexander McQueen's spring/summer show, London.

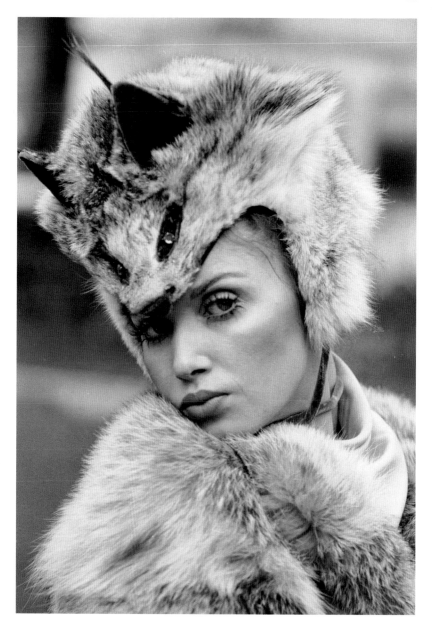

Cat's-eyes, a helmet complete with ears and paws, and a matching coat too.
1970 A hat made from lynx fur designed by the milliner Mitzi Lorenz, London.

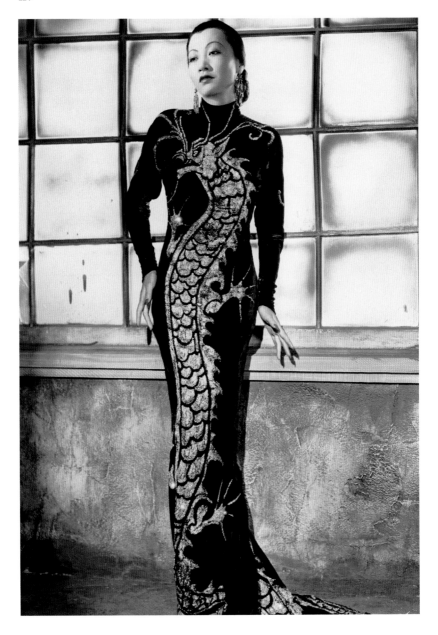

Dragon lady in a long lean black dress with a chignon and chandelier earrings.
1934 Chinese-American film star Anna May Wong in *Limehouse Blues*.

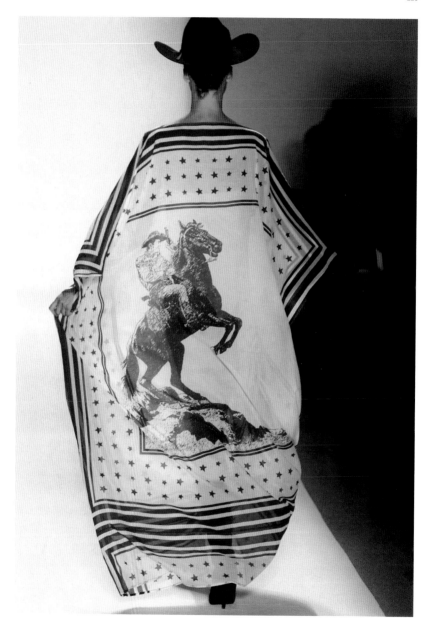

From the Thai border to Texas, a print of a cowboy in black on white silk.
2011 Malaysian designer Zang Toi's spring/summer show in New York.

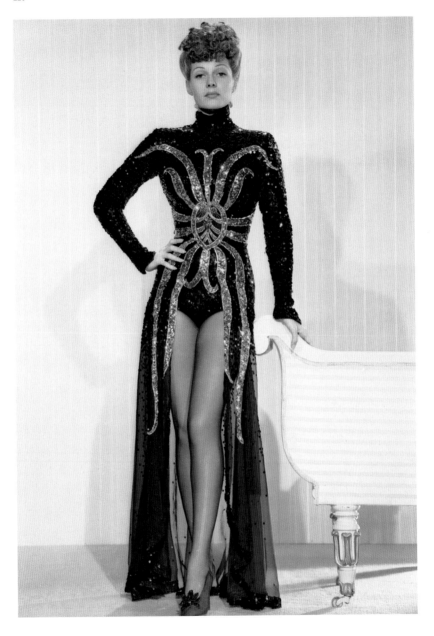

'The Love Goddess' in a gown slashed to the waist, sequined with a spider.
1942 American actress Rita Hayworth in the film *My Gal Sal*.

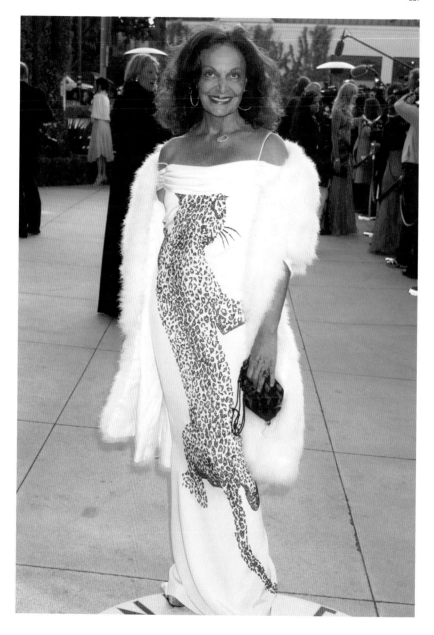

Feline but friendly, in Hollywood, wearing a white gown with a prowling leopard.
2005 American designer Diane von Furstenberg at the *Vanity Fair* Oscars party.

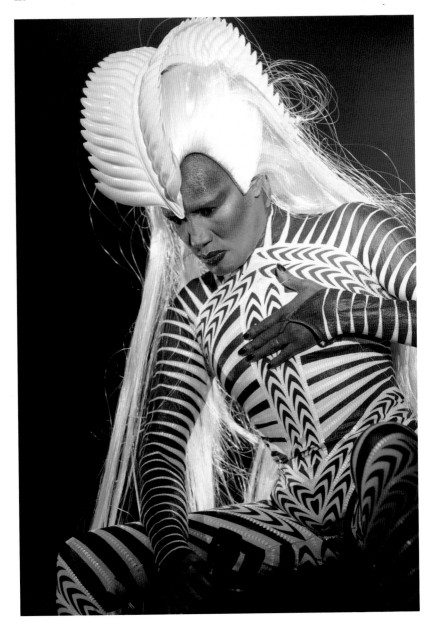

'Slave to the Rhythm', animal magic in a zebra-print bodysuit with an exotic headdress. 2010 Jamaican singer Grace Jones performs at the Royal Albert Hall, London.

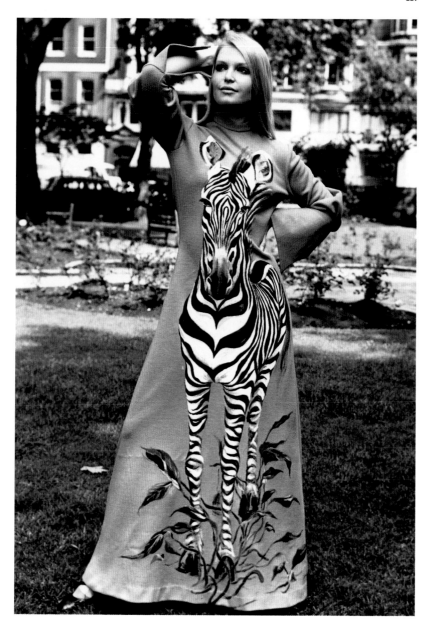

Wildlife in a London park, a maxi-dress with a polo-neck and a zebra.
1971 Austrian actress Eva Rueber-Staier, former Miss World, in England.

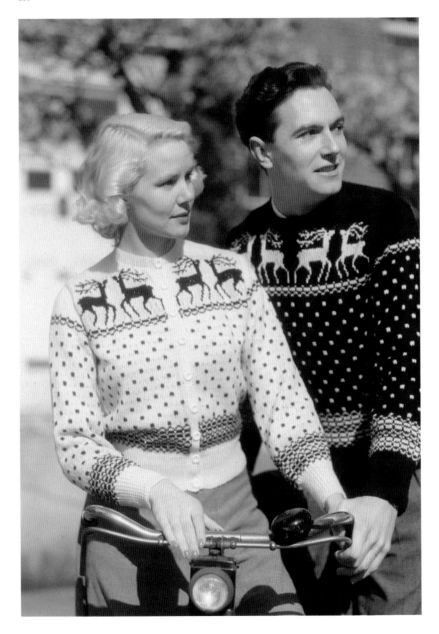

Positive and negative, his and hers, Norwegian knits with romping reindeer.
c.1955 A young couple cycling in matching black-and-white wool cardigans.

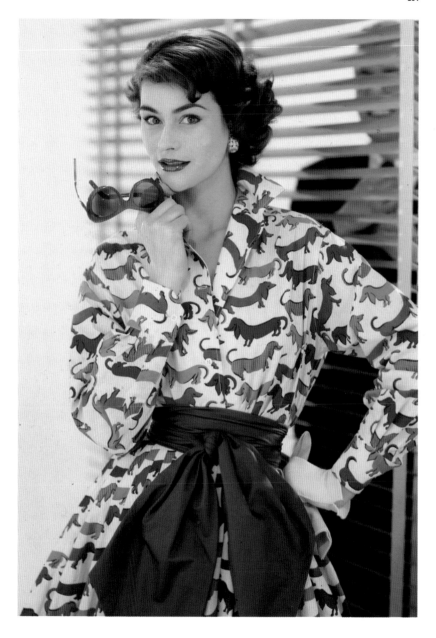

All the rage, sausage-dog chic, a summer dress in red, green and cream cotton.
c.1955 A woman in a shirtwaister with a dachshund print and a wide sash.

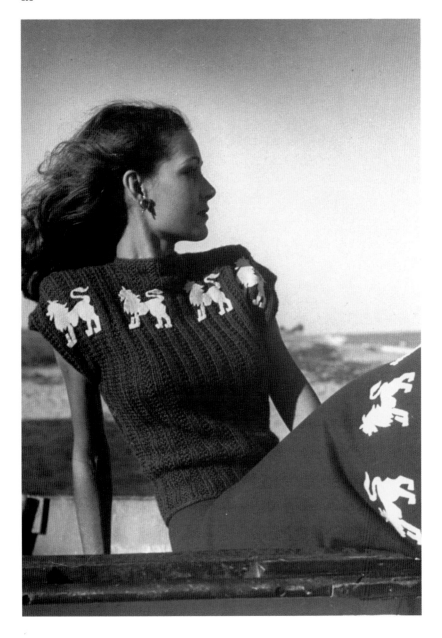

Knit one, purl one or two, lions rampant on a slash-neck top with a straight skirt.
1947 A model wearing a ribbed sweater and skirt decorated with roaring lions.

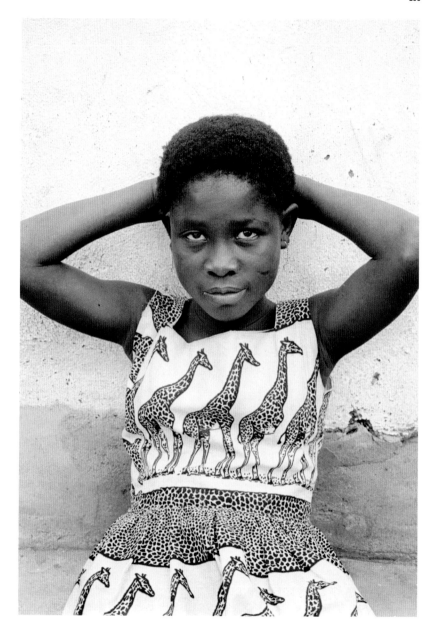

A little lady with very tall giraffes printed in black on a white cotton frock.
c.1956 A young Ghanaian girl posing in her Sunday best.

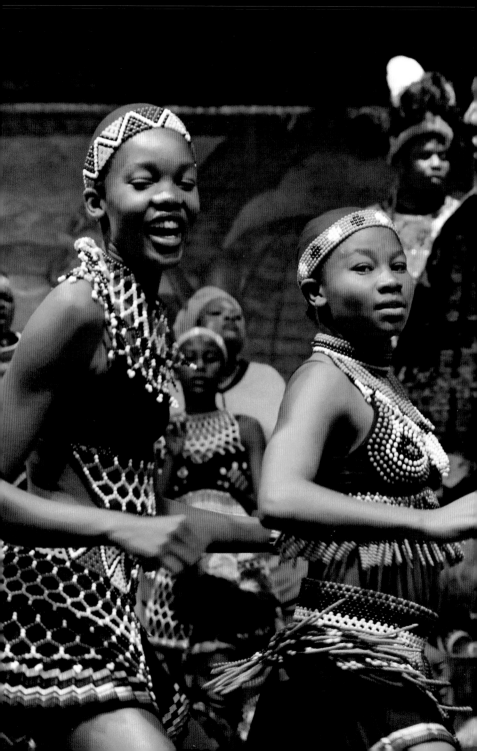

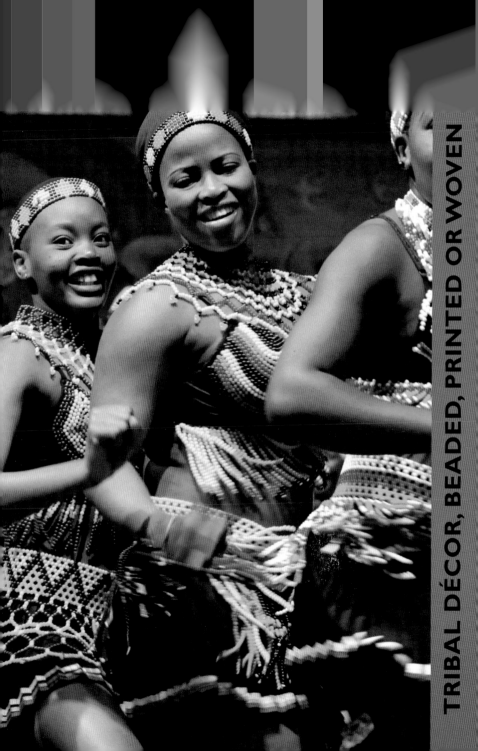

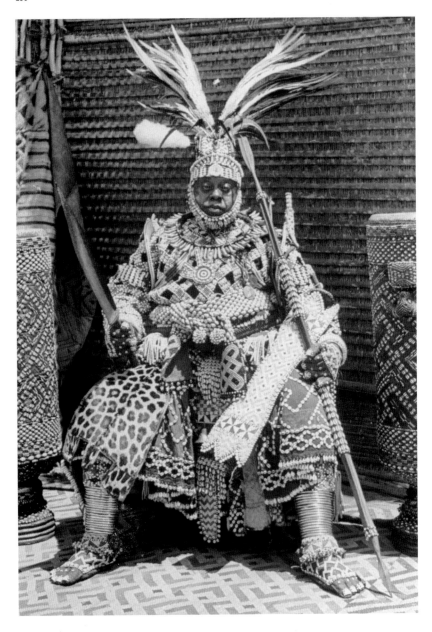

A despotic chief, with eight hundred wives, clad in exotic beaded armour.
1947 King Bope Mabinshe of the Bakuba tribe, sitting on a throne, Congo.

Previous page Dancing a fine conga in bright beads and traditional woven costumes.
2010 Girls in Johannesburg, during the South African World Cup.

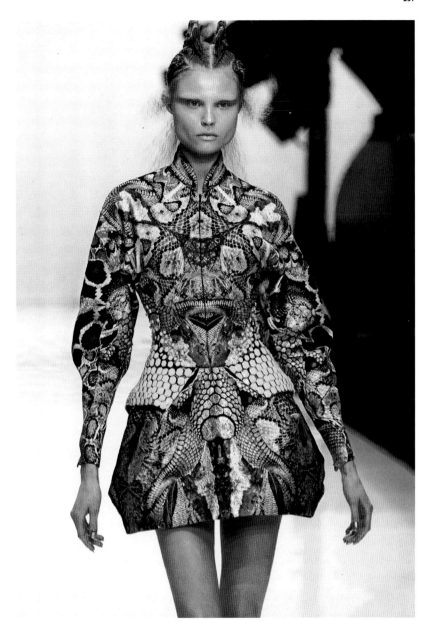

The final curtain, a print inspired by nature and slithering snakes on the catwalk.
2010 Alexander McQueen's spring/summer fashion show, Paris.

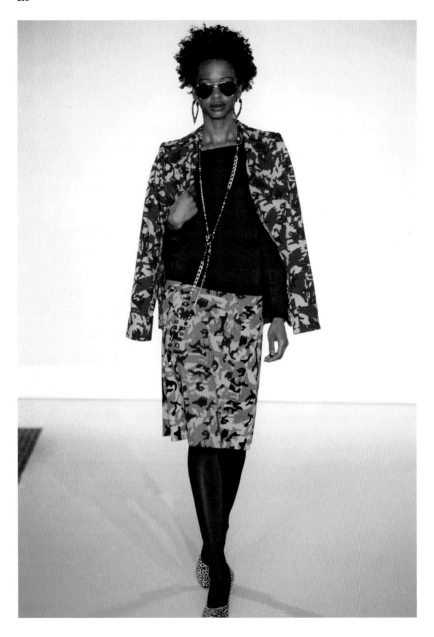

An African-inspired suit, half camouflage greens, half bright red flowers and blue sky.
2008 Nigerian-born Duro Olowu's autumn/winter fashion show, London.

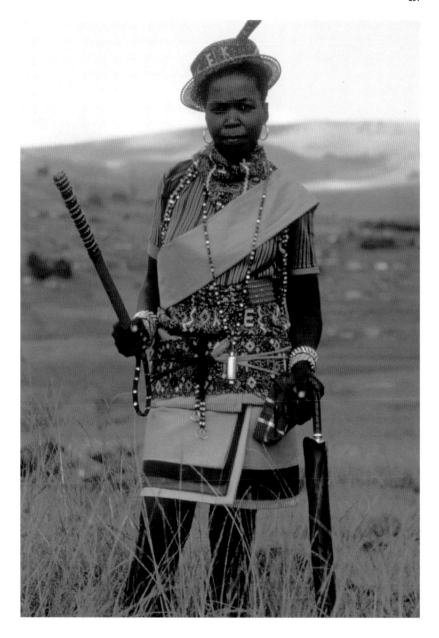

A handmade costume of beaded embroidery with a jaunty hat and an umbrella.
c.1975 A young Zulu woman in her Sunday best en route to a wedding.

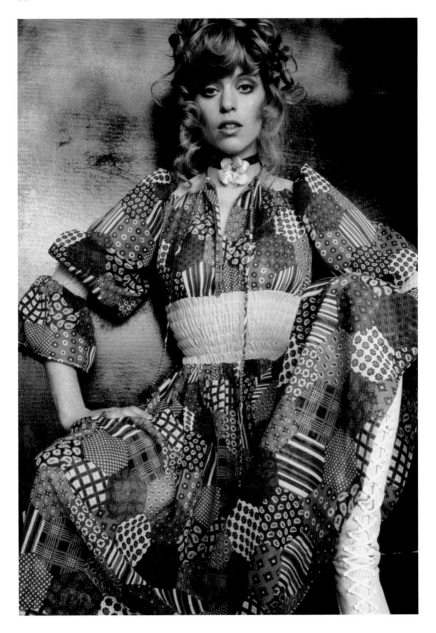

Cut from an old bedspread in autumnal shades with a beige shirred waist.
c.1975 A model wearing a patterned patchwork dress with white laced boots.

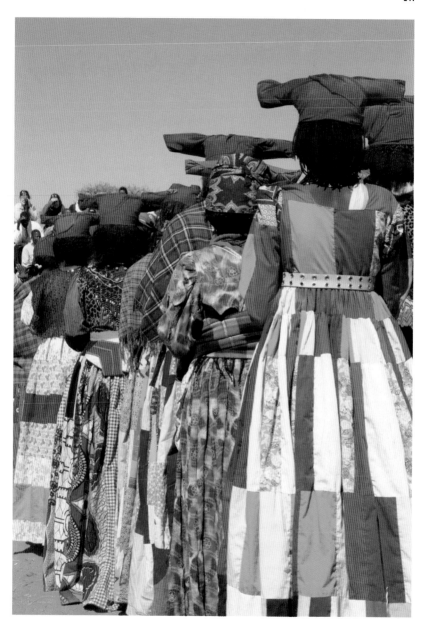

Dancing in the Kalahari Desert, dressed in a cacophony of colour and pattern.
20th Century Women in national costume for the Kuru Festival, Botswana.

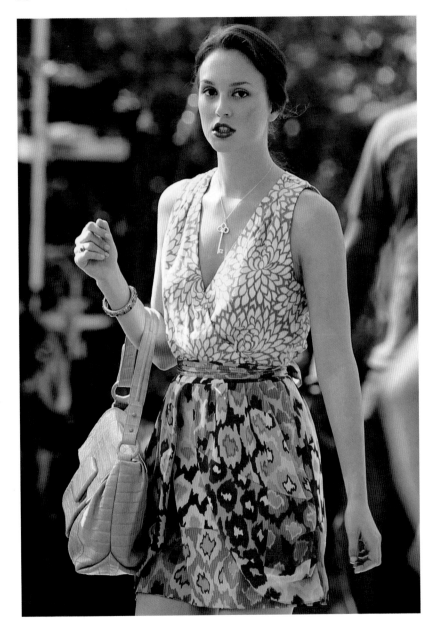

The 'Gossip Girl' in a dress of brilliant yellows and oranges with an ikat print skirt.
2010 American actress Leighton Meester spotted at General Grant's tomb, New York.

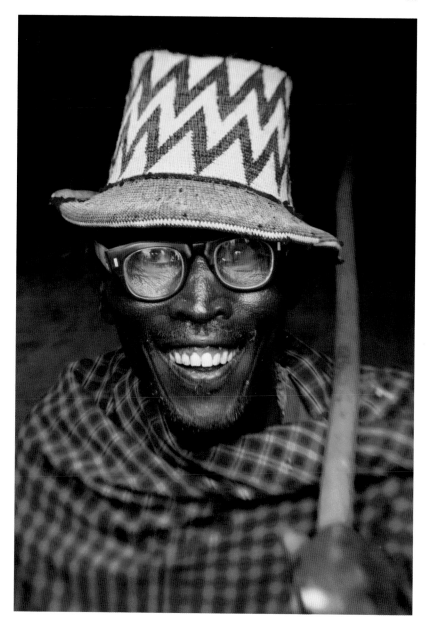

Cheerful chappy in a zigzag patterned and beaded hat, a check shawl and specs.
20th Century An Arbore man from the Omo Valley in Ethiopia.

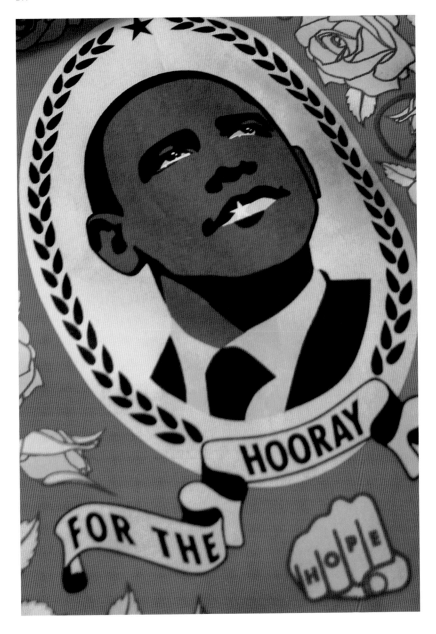

Hurrah, hurrah, a screen-printed kanga in brilliant colours and covered in roses.
2009 A cloth celebrating American President Barack Obama in Cape Town.

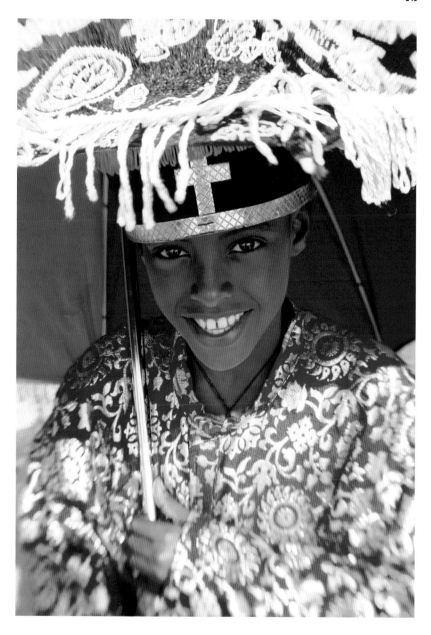

Celebration clothes, virginal vestments in red with silver, and a gold coronet.
20th Century A girl in a procession for Epiphany in Addis Ababa, Ethiopia.

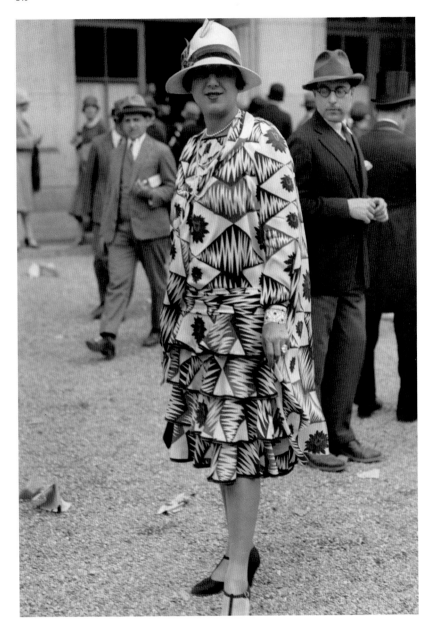

Stand out amid the sober suits in a strong graphic print, very up-to-date.
c.1926 Fashion at the races in Auteuil, a dress with flounces, Paris.

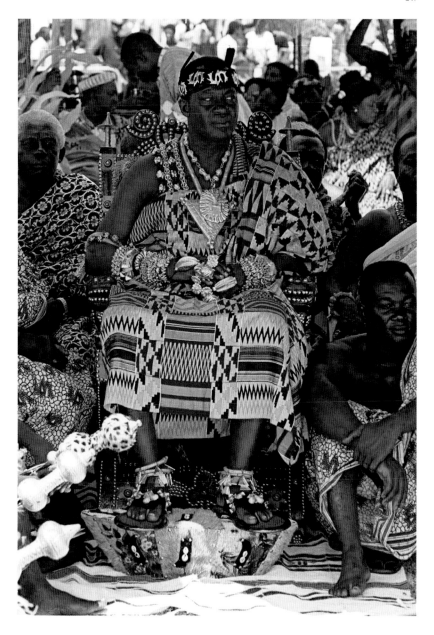

Finery with feet on a footstool, a mountain of a man in his robes of state.
1999 Tribal chiefs at a durbar during Queen Elizabeth II's visit to Accra, Ghana.

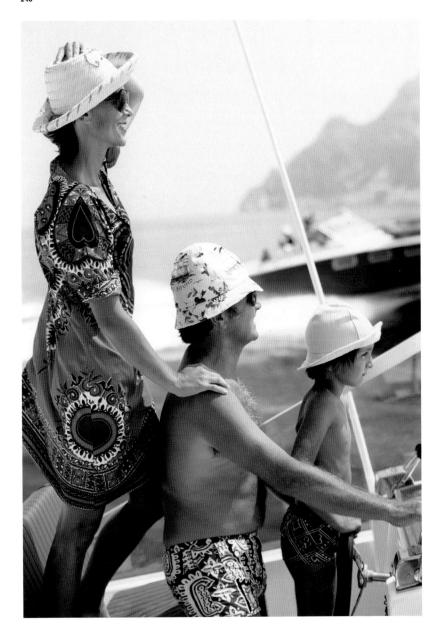

A pretty cotton dress and jaunty bathers cut from printed kanga cloths.
c.1975 A family outing in a motorboat off Porto Ercole, Tuscany, Italy.

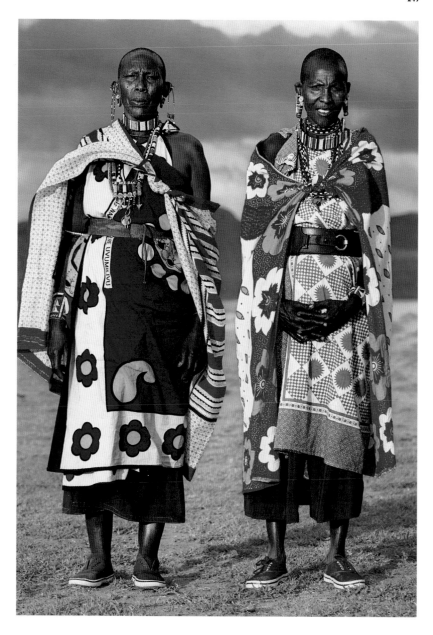

Happy Valley, layers of traditional coloured kangas worn with modern plimsolls.
2006 Masai women in traditional clothing close to Soysambu Farm, Kenya.

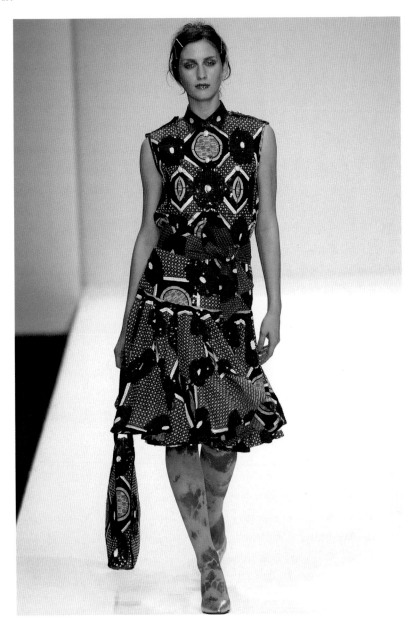

Mustard, red and olive print dress and matching bag worn with curious tights.
2005 Ashish, an Indian designer, shows his spring/summer collection in London.

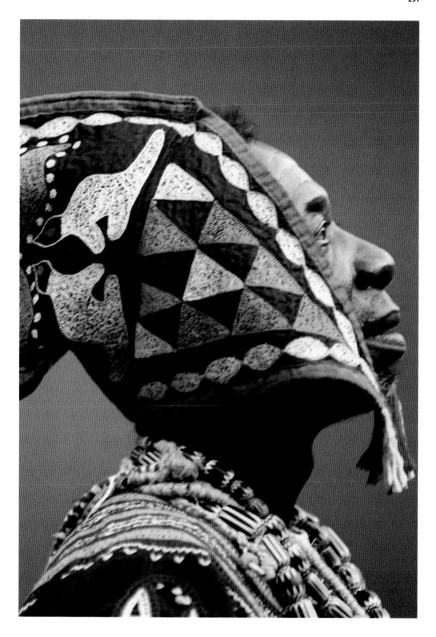

Profile of a diamond geezer in a brightly coloured woven helmet and robe.
20th Century An African man from the Cameroons in traditional Meta tribal dress.

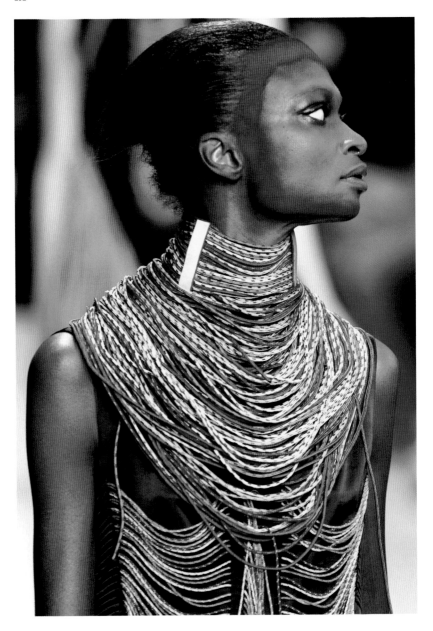

A beautiful bead dress, multicultural and multicoloured, perhaps in the Masai Mara style. 2006 Naoki Takizawa for the Issey Miyake autumn/winter fashion show, Paris.

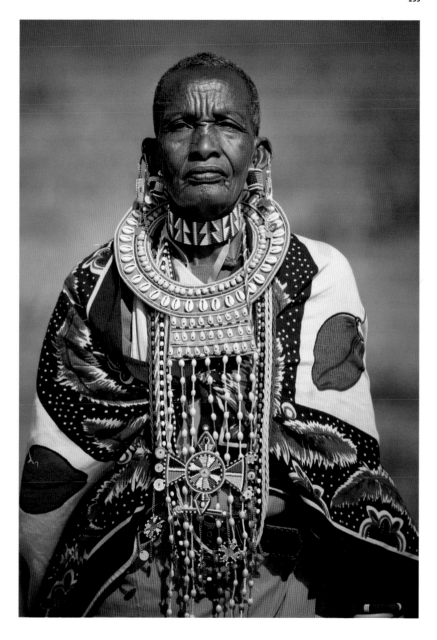

Bejewelled in all her finery, wearing layers of kangas printed with fruit and leaves.
20th Century A Masai woman in traditional ceremonial dress, Kenya.

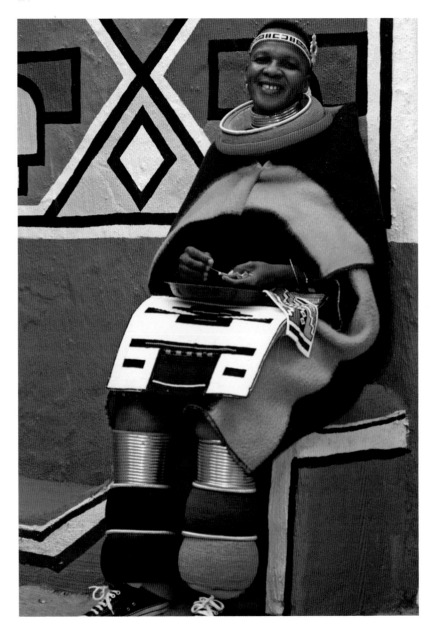

A descendant of one of the Zulu tribes embroiders outside her bright mud house.
20th Century A traditional Mapoch Ndebele village, Gauteng Province, South Africa.

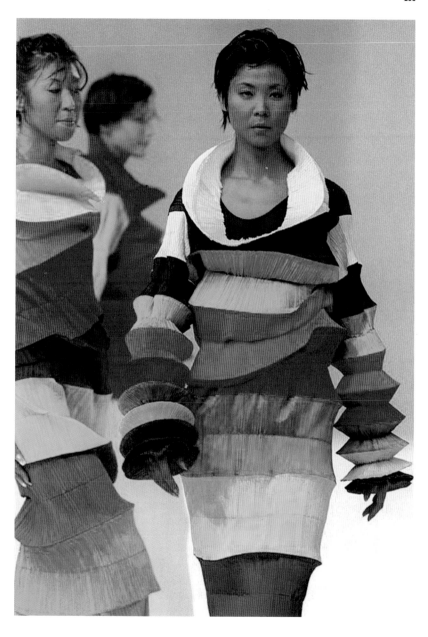

Tubular belles in multicoloured striped dresses with pleats like Chinese lanterns.
1994 Issey Miyake's Flying Saucers in his spring/summer fashion show, Paris.

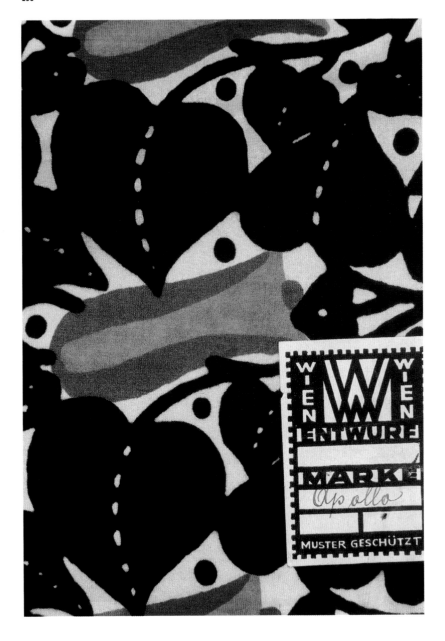

Hand-painted and influenced by English Arts and Crafts and art nouveau.
c.1910 Fabric sample by Wiener Werkstätte named 'Apollo', Vienna.

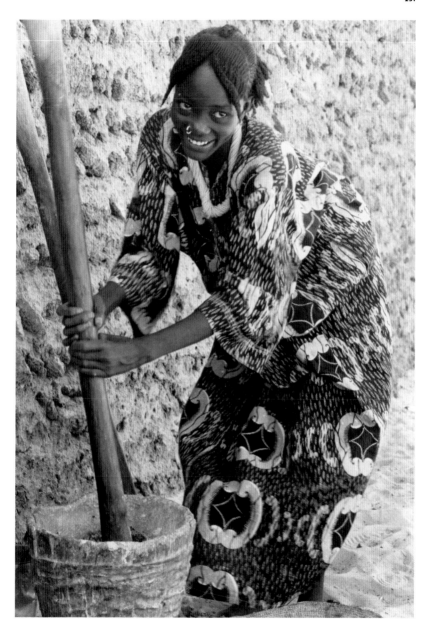

Princess charming in a printed cotton dress with a bead necklace and a nose-ring.
c.1955 A woman pounding millet in the Bilma Republic of Niger.

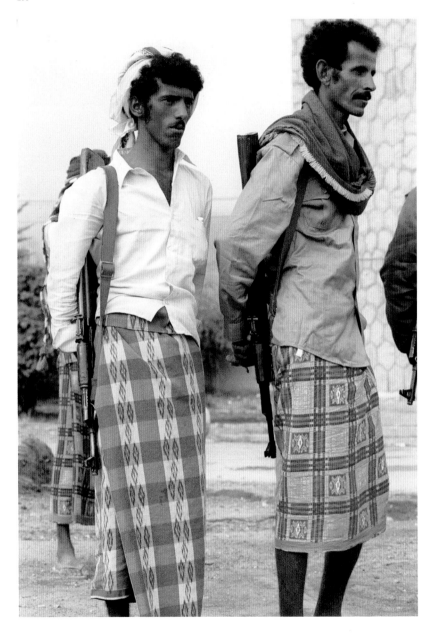

Civil war, wearing mufti, checked sarongs and sandals, and one military shirt.
1986 Militiamen, with their Kalashnikovs, near a checkpoint in Aden, Yemen.

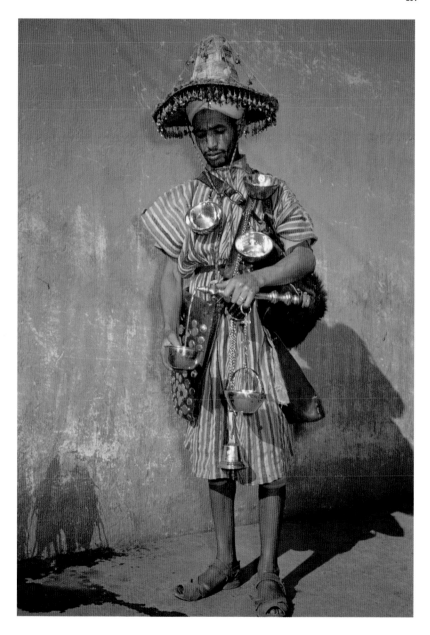

Copper cups, a large metal container and a bag, with a wide-brimmed hat for shade.
1955 A water vendor in a tasselled hat and striped clothes, Marrakech, Morocco.

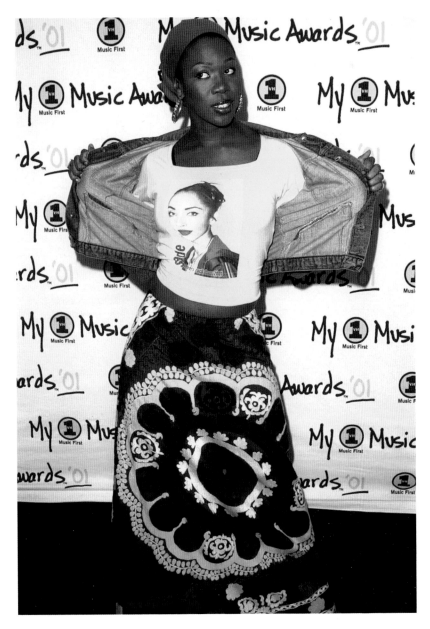

An African print skirt in red, yellow and black, a yellow T-shirt and denim jacket.
2001 American soul singer India Arie arriving at the My VH1 Music Awards, Los Angeles.

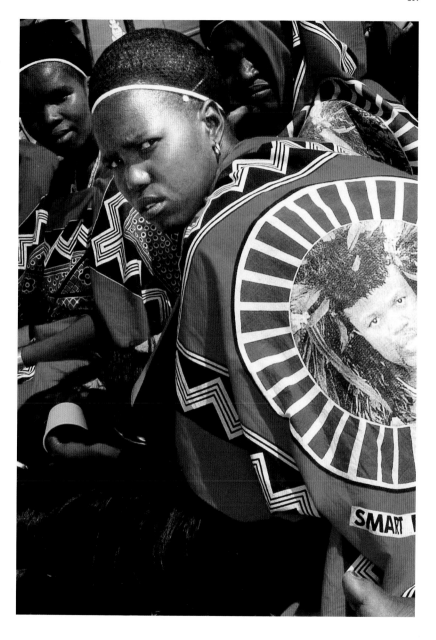

Celebrations for the 37th birthday of one of a thousand grandchildren of the last king. 2005 Women wearing cloths with the portrait of King Mswati III of Swaziland.

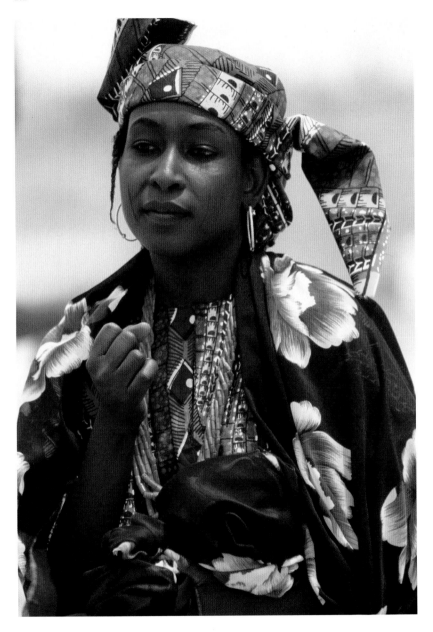

Ropes of beads, big gold hoop earrings, and a dress in dark blue with yellow flowers.
1990 A Nigerian woman with bright clothes and traditional face markings.

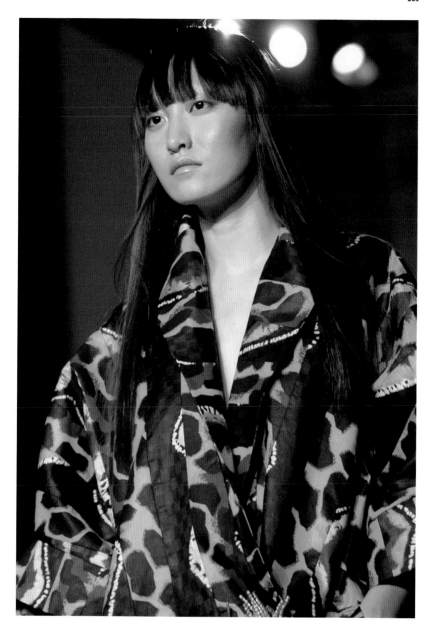

Taking inspiration from his roots, a leopard-print dress with flashes of sky blue.
2008 Duro Olowu's autumn/winter fashion show, London.

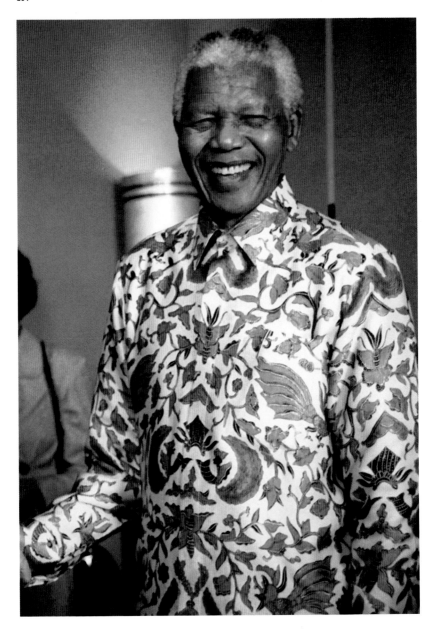

A beautiful man in a perfect print shirt strewn with orange butterflies and leaves.
1998 President Nelson Mandela during a visit to New York.

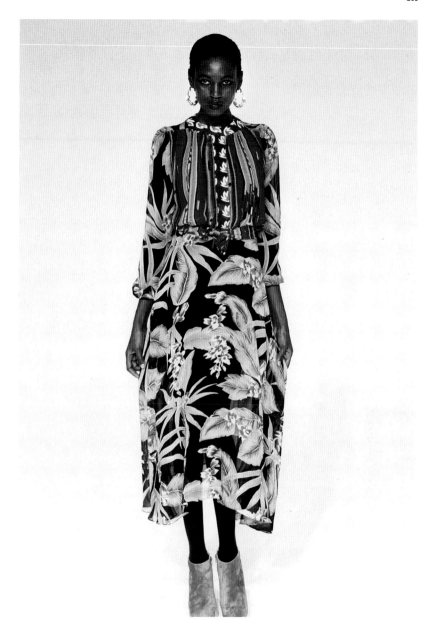

A botanical print of green leaves on a black background with a striped waistcoat.
2011 Duro Olowu's autumn/winter fashion show, New York.

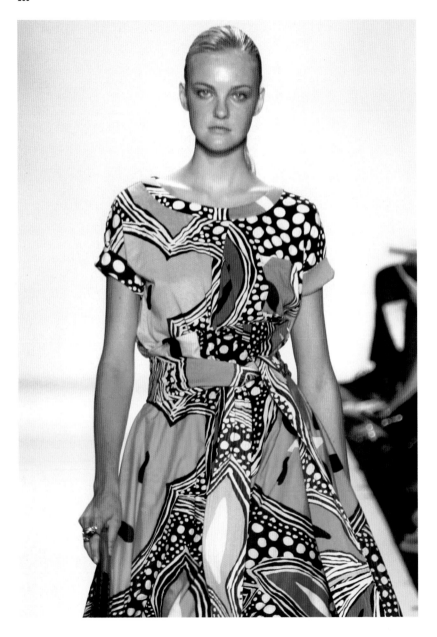

A simple cotton frock with a vibrant print of greens and terracottas, with spots.
2008 Diane von Furstenberg's spring/summer fashion show, New York.

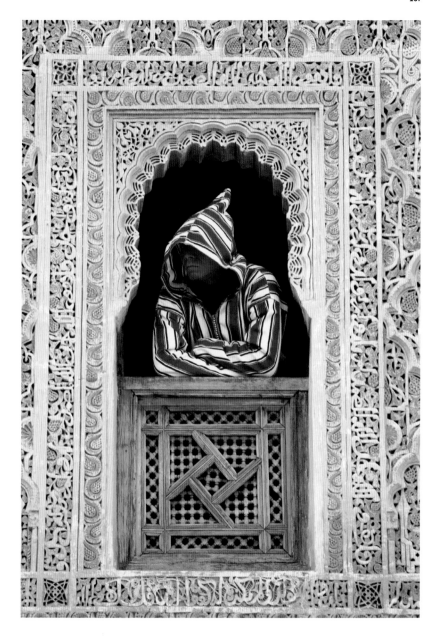

A contemplative moment in a mosque wearing a striped, hooded djellabah.
20th Century A Muslim man in a carved fretwork window, Marrakech.

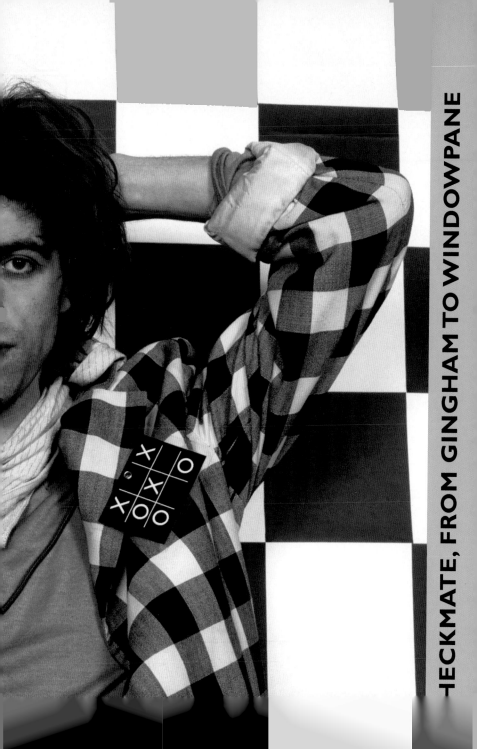

HECKMATE, FROM GINGHAM TO WINDOWPANE

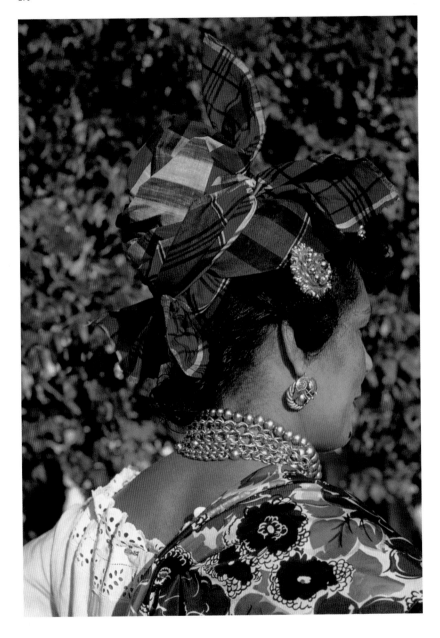

Caribbean chic, a blouse and a flowered shawl, bejewelled with gold and pearls.
1959 A madras kerchief traditionally worn by widows, Fort-de-France, Martinique.

Previous page Noughts and crosses, a checked jacket, coolly casual with tousled hair.
1979 Irish singer and activist Bob Geldof, lead singer of The Boomtown Rats.

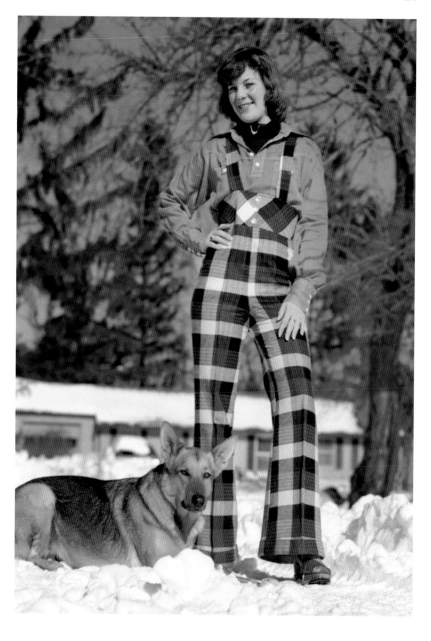

Autumnal tones in a winter wonderland, posing in front of the essential log cabin.
c.1960 A woman in plaid wool dungarees in the snow with her German Shepherd dog.

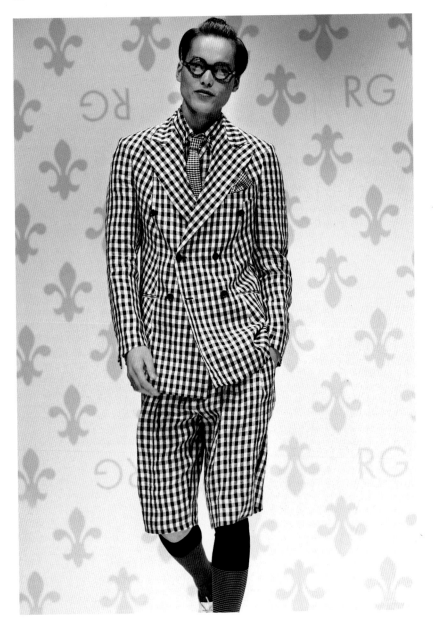

Too long for shorts, too short for trousers, a checked suit with checked shirt and tie.
2009 Romeo Gigli's spring/summer men's show, Milan.

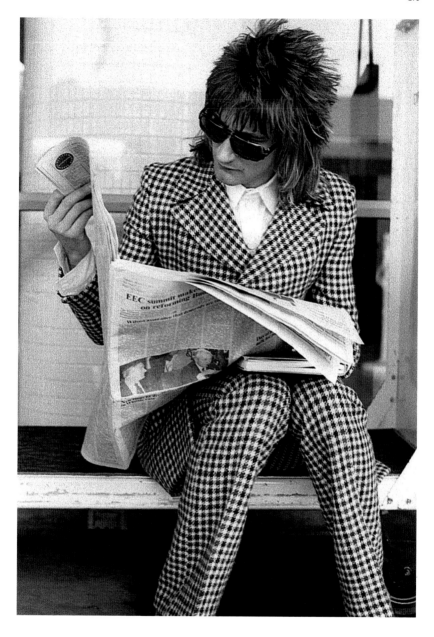

'Every Picture Tells A Story' and 'You Wear It Well' in a dogtooth-check suit.
1973 British singer Rod Stewart of The Faces on a tour of the United States.

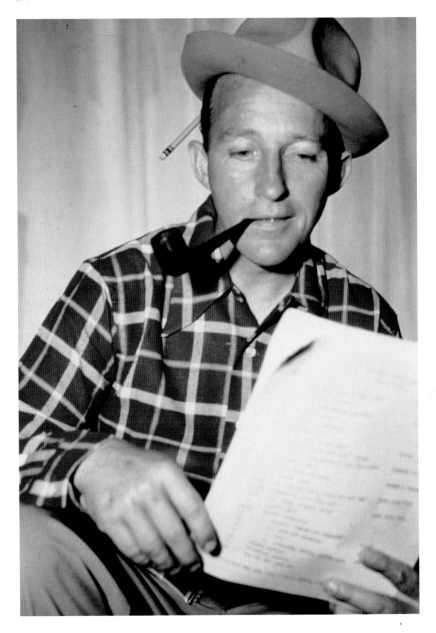

Studying the script and jaunty as ever, a crooner in checks with a pipe and a hat.
c.1950 American singer Bing Crosby with a pencil tucked into his hat.

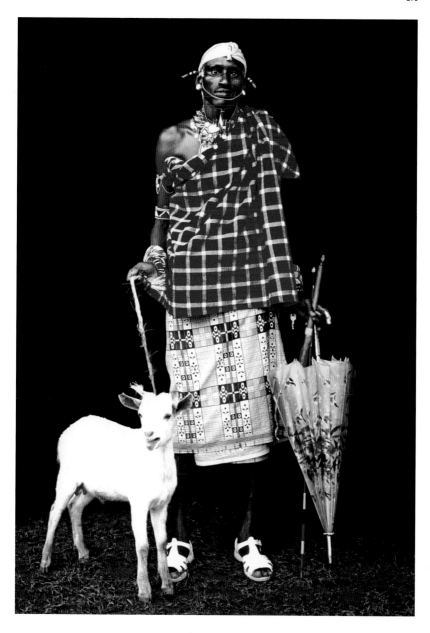

Dressed in his best, checked cloths, beads, a painted cane and a floral umbrella.
20th Century A Samburu moran (warrior) from Kenya with a little snowy white goat.

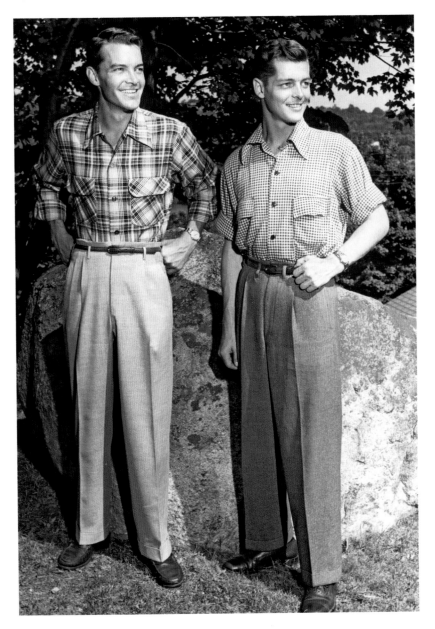

'Ain't I smart in my groovy gear', posing with film-star looks and slim waists.
c.1955 Two young American men in checked shirts and pleated-front slacks.

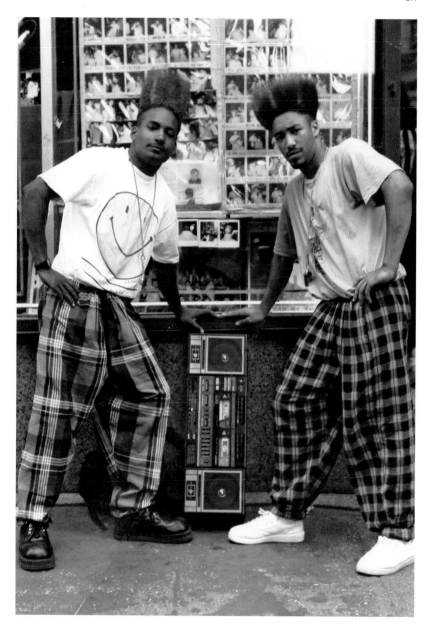

Manhattan moments, a ghetto blaster, plaid pants, plimsolls and scary hairdos.
1991 American rap duo Twin Towers outside the Astor Place barbershop, New York.

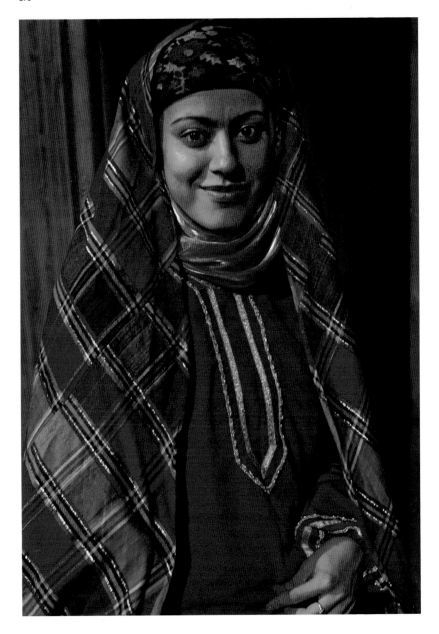

In a costume of red and green, never to be seen except upon an Iranian queen.
2007 A woman in the 'Women From My Homeland' fashion festival, Tehran, Iran.

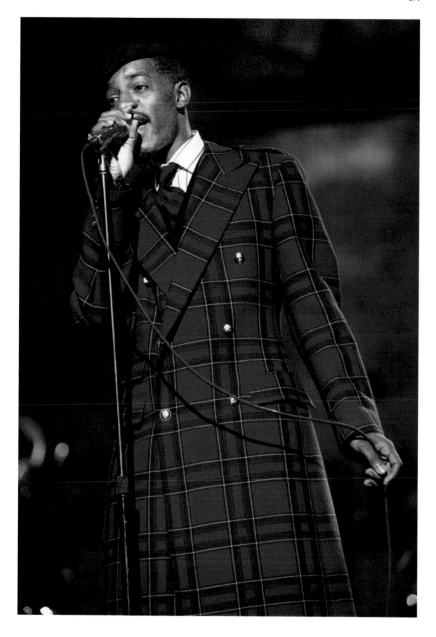

A very dapper rapper in a show-stopping red-and-black double-breasted overcoat.
2004 American singer André 3000 of Outkast, at the 'Fashion Rocks' concert, New York.

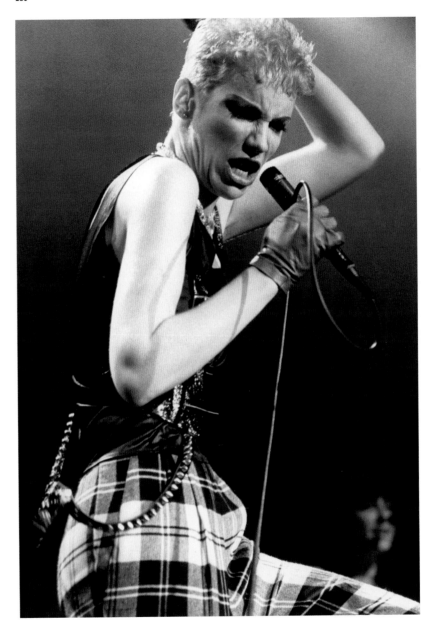

Tartan trews from the homeland, leather gloves for golf and a biker's vest.
1983 Scottish singer Annie Lennox of the Eurythmics, strutting her stuff.

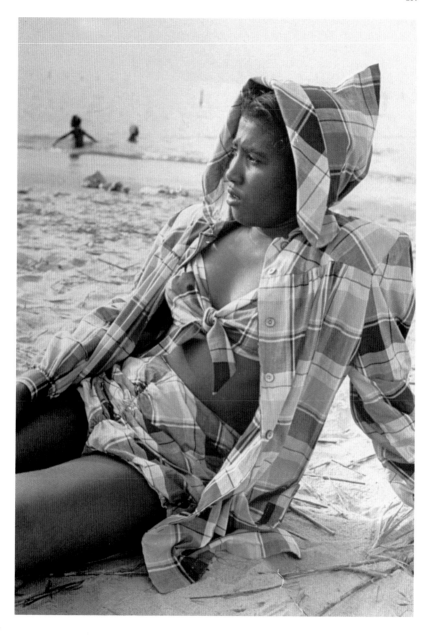

Deep contemplation, shielded from the sun in clothes cut from a tablecloth?
1940 A girl sitting on the beach wearing a plaid bra-top with shorts and a jacket.

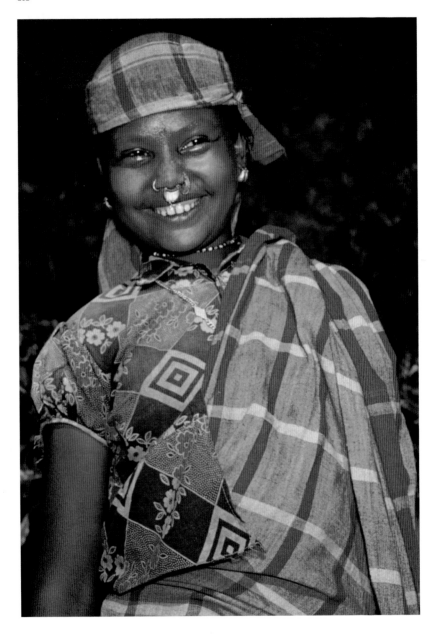

A stunning smile, wearing silver jewellery and a cheerful red checked shawl.
1955 A young Hindu girl with a pierced nose and ears, East Pakistan.

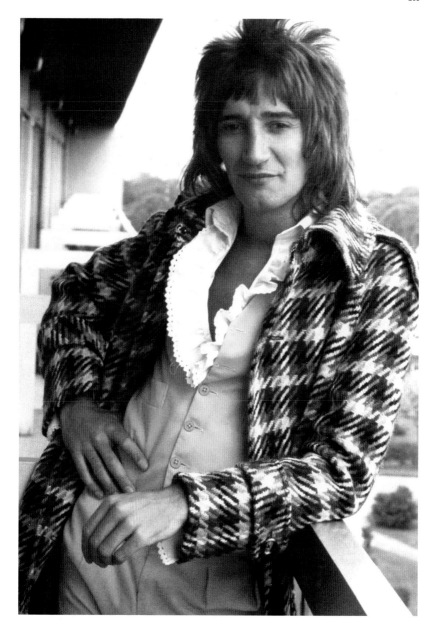

A wonderful wardrobe, rock chic wearing a frilled shirt and a bold checked jacket.
1974 British singer and songwriter Rod Stewart of The Faces, London.

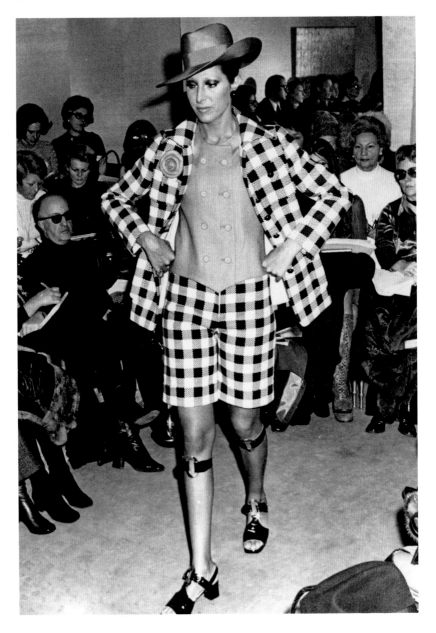

Strange patent sandals, a stylish fedora and a flower all accessorize a strong suit.
1971 Long shorts and a jacket by Italian designer Heinz Riva, Rome.

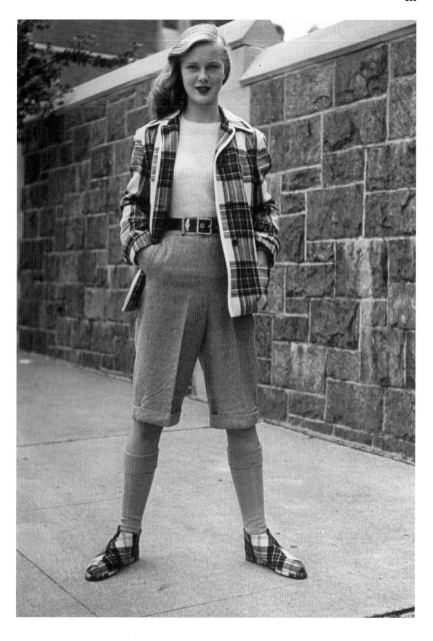

Collegiate chic in Empire-building knee-length shorts, socks and a broad belt.
1948 A model in plaid bootees by Best and Company with a matching jacket.

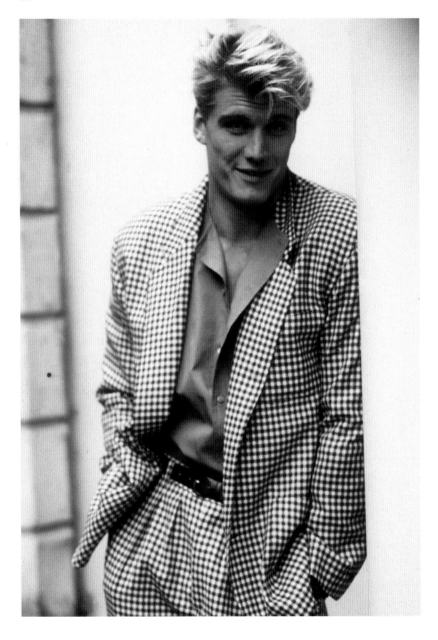

Action man, with brooding blond looks, dressed to kill in black, white and grey.
1986 Swedish actor and martial artist Dolph Lundgren sporting a checked suit.

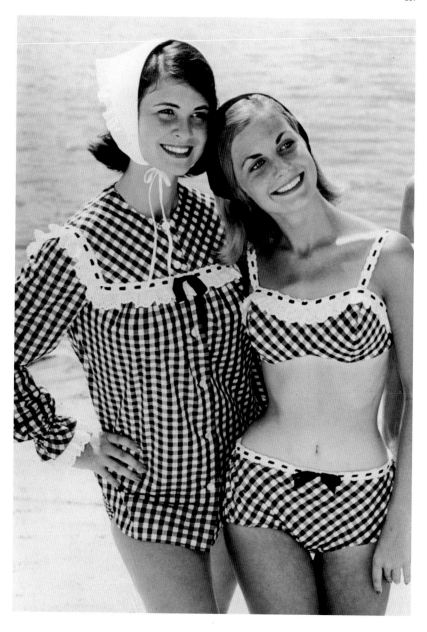

Mix and match, trimmed with white broderie anglaise and little black bows.
c.1963 Beauties on the beach, wearing a checked bikini and a blouse and headscarf.

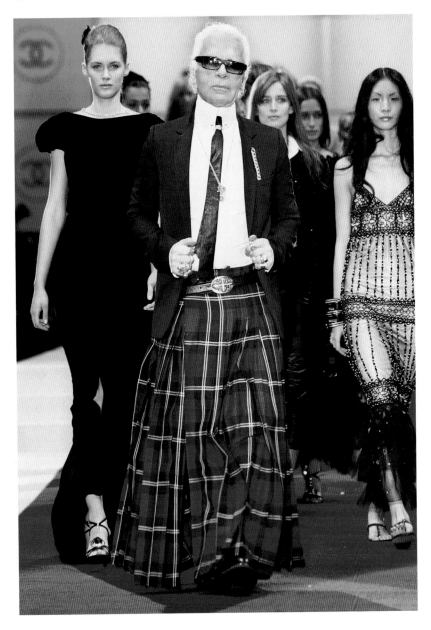

Celebrating the biggest boutique in the world, clad in a sweeping 'Scottish skirt'.
2005 German Karl Lagerfeld's spring/summer show for Chanel, Tokyo.

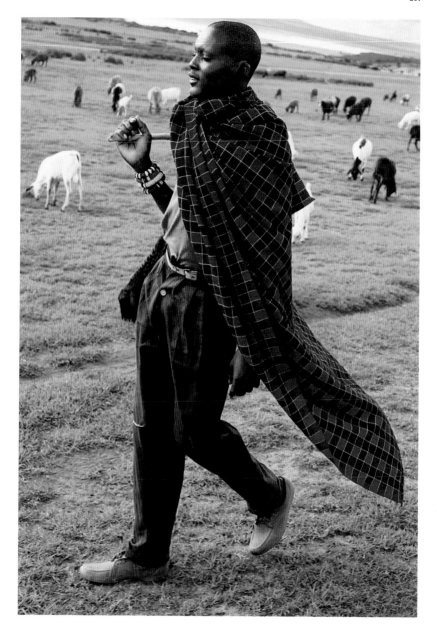

A stylish shepherd with a red-and-black shawl, a beaded bracelet and a fly whisk.
2006 A Masai man walks along Lake Elementeita near Soysambu Farm, Kenya.

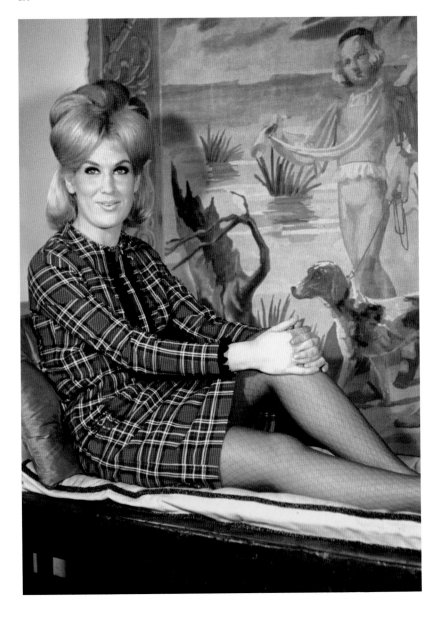

'I Only Want To Be With You', 'The White Queen of Soul' is terrific in tartan.
1963 British pop singer Dusty Springfield with her hugely high hairdo, England.

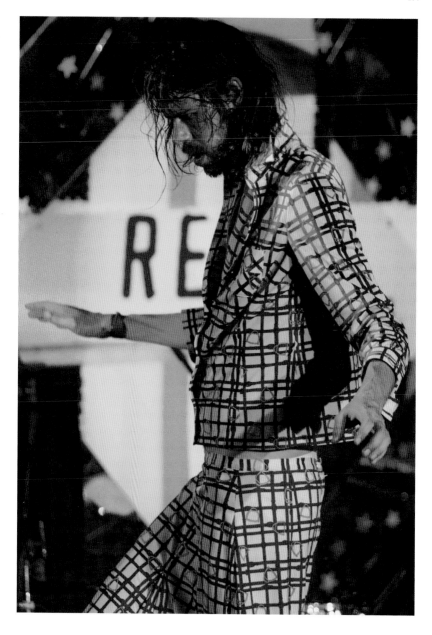

'Rebel Rebel At Home' in a checked boxy jacket and low-slung trousers.
2006 American singer Angus Andrew of Liars in concert, Sydney.

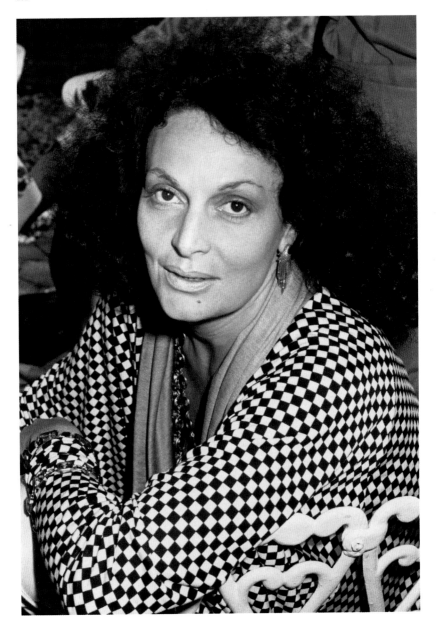

Memories from motion pictures, brooding in black-and-white checks, and a scarf.
1983 American designer Diane von Furstenberg at a tribute to Fay Kanin, USA.

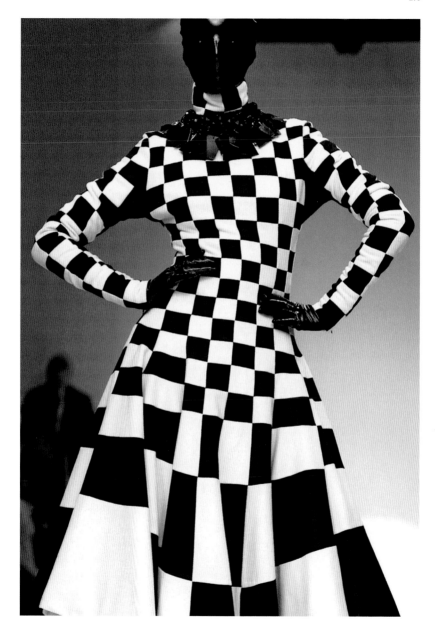

New generation, a chessboard dress in black-and-white blocks from little to large.
2007 British designer Gareth Pugh's spring/summer show, London.

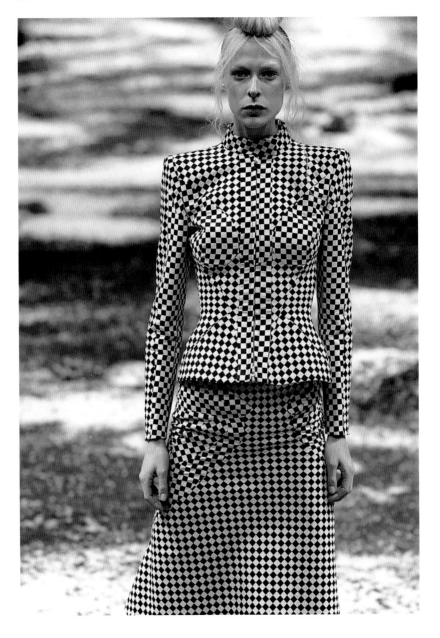

A sharp suit in black and white, an early inspiration for his 2009 collection.
2003 British designer Alexander McQueen's autumn/winter fashion show, Paris.

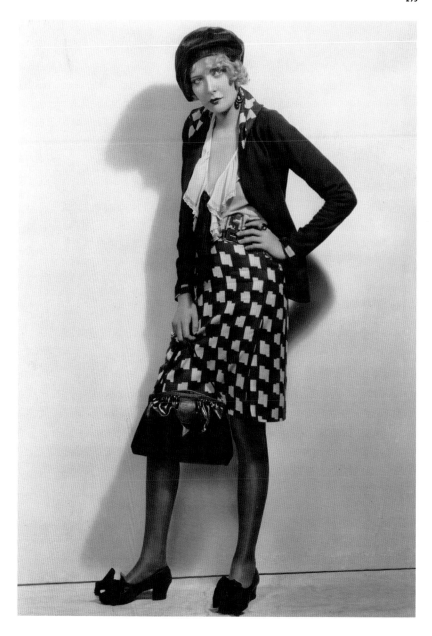

'The Girl Who Gave In', a studio shot in a polite checked dress and a cardigan.
c.1926 American actress and dancer Mary Nolan, briefly a Universal star.

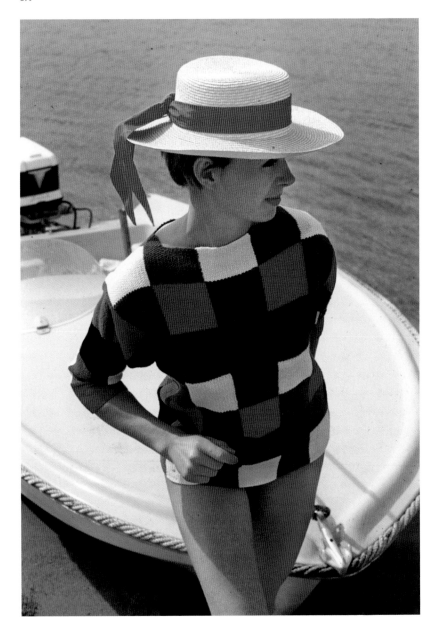

With a nod to a gondolier, in a straw hat with an orange ribbon on a speedboat.
1961 British model and wannabe actress Sue Turner in St. Tropez, France.

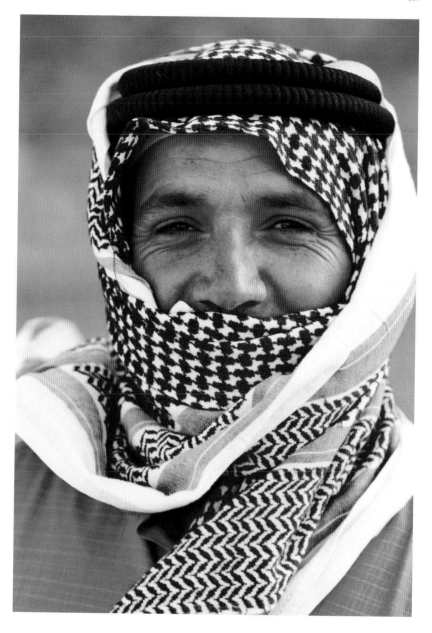

Desert dress, wrapped well against the winds in a red-and-white headdress.
20th Century A Bedouin man in traditional garb with a sand-coloured djellabah.

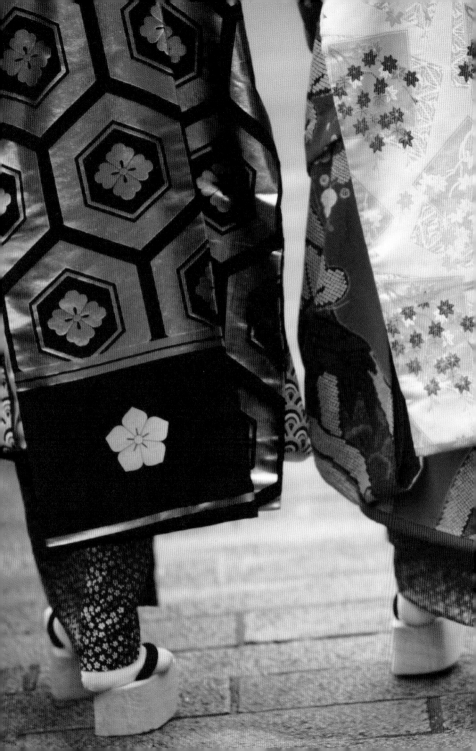

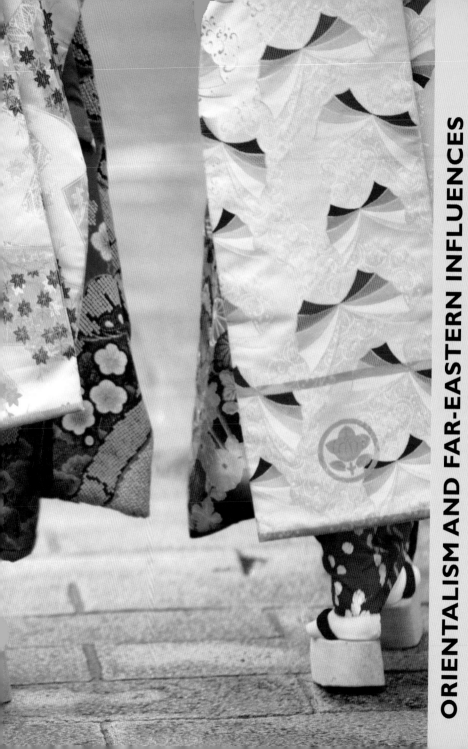

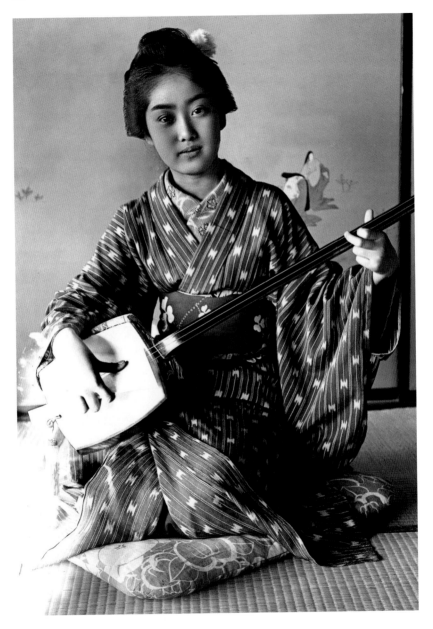

A portrait by H.G. Ponting, the photographer on Scott's last Antarctic expedition.
c.1900 A young Japanese geisha girl playing a traditional musical instrument.

Previous page Tripping along in their traditional finery, silk kimonos and obis, print upon print.
20th Century A trio of geishas parading around in wooden sandals, Kyoto.

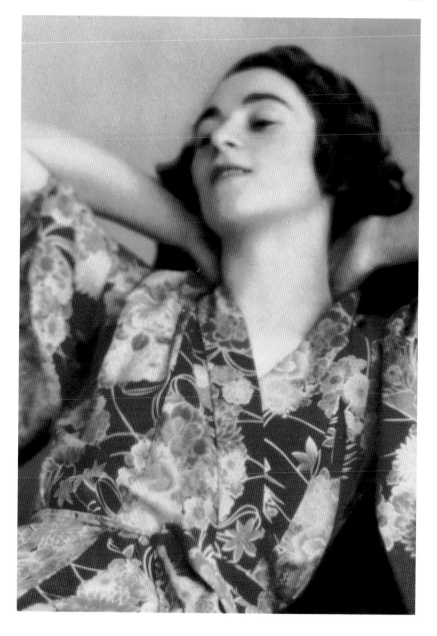

Billy Baker basks in the warm studio lights wearing a flowered red kimono.
1932 A portrait by Arnold Longman of the Royal Photographic Society, London.

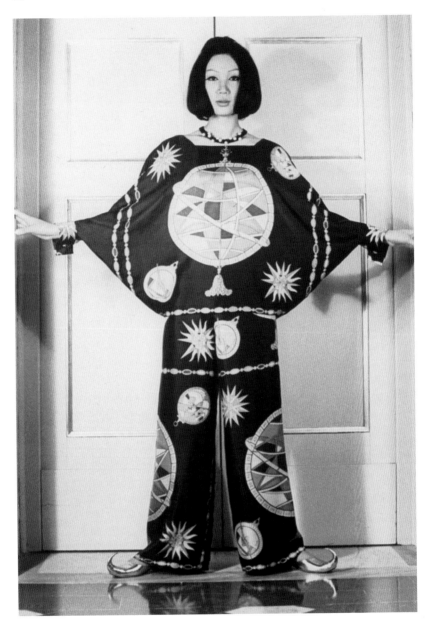

Taking inspiration from Japan and astronomy, printed with planispheres and suns.
1964 A model wearing Emilio Pucci pyjamas at a boutique show, Florence, Italy.

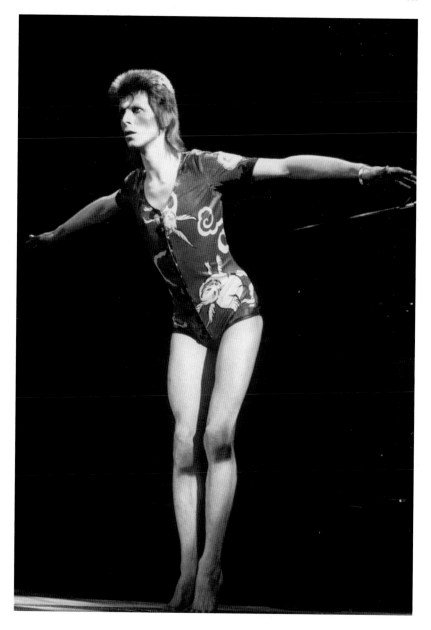

Ziggy Stardust in his woodland creature costume designed by Kansai Yamamoto.
1973 English musician David Bowie at the Hammersmith Odeon, London.

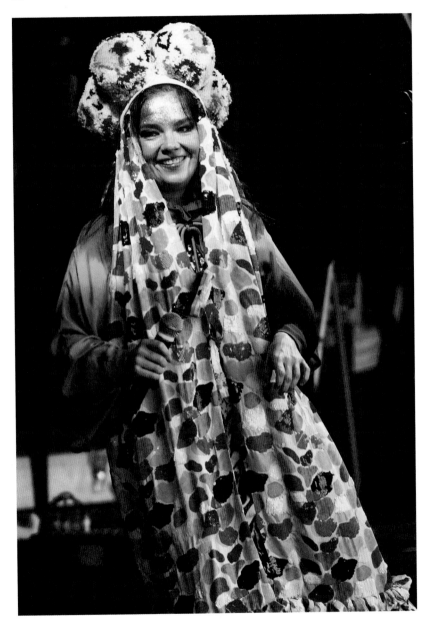

A curious folkloric costume, a multicoloured headdress with a scarf attached.
2008 Icelandic singer Björk at 'The Big Day Out', Auckland, New Zealand.

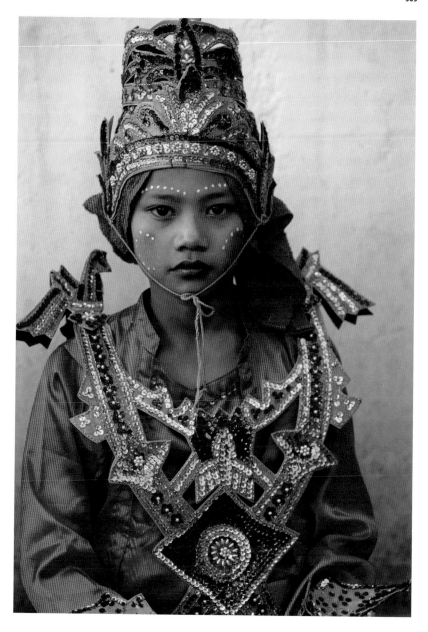

Perfect in pink with heavy embroidery, a Buddhist novice's ordination ceremony.
2009 A Burmese boy at the Maha Myat Muni monastery in Tachilek, Myanmar.

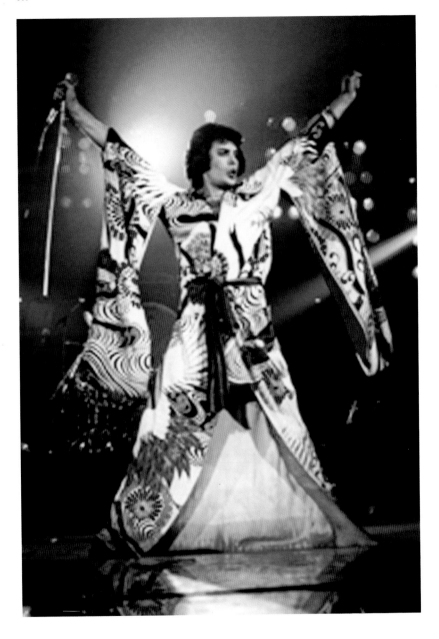

'Killer Queen', and Britain's 'first Asian rock star', outrageous as ever in a kimono.
c.1970 Musician Freddie Mercury performing with the band Queen.

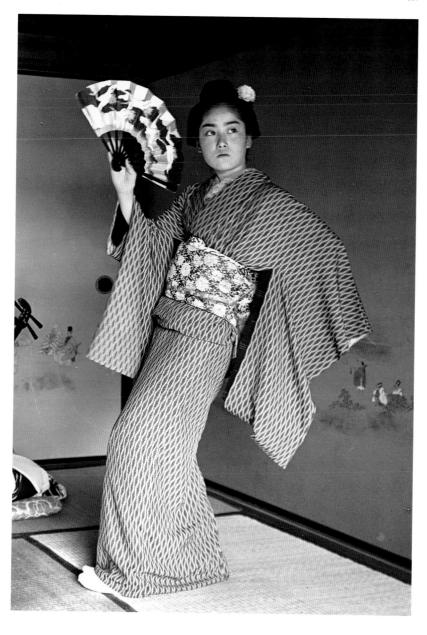

Mikado moments, fan dancing in a traditional but simple kimono and obi.
c.1900 A photograph of a geisha by Briton H.G Ponting on his Japanese tour.

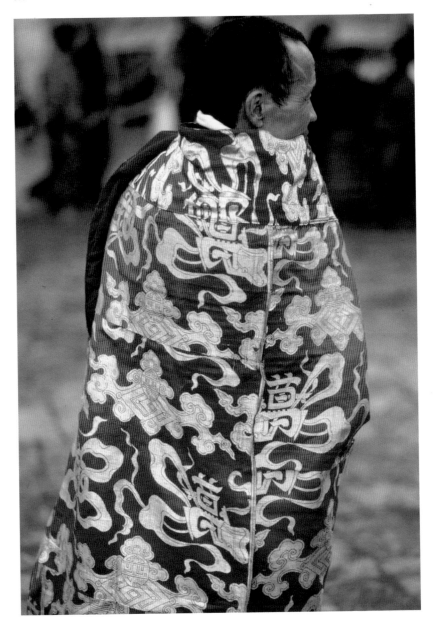

A monastic mantle in celebratory red silk decorated with gold symbols.
1982 A Buddhist monk dressed for a religious festival in the Paro Valley, Bhutan.

Silent star of stage and screen dressed in a bold printed kimono with a fan.
c.1935 The Hollywood actress Dorothy Gulliver, a former Miss Salt Lake City.

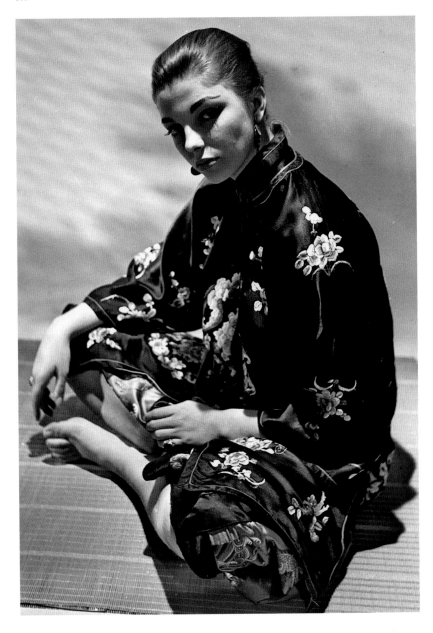

A press pose, nearly unrecognisable without her big hair and mounds of make-up.
1951 British actress Joan Collins, the year before her film debut in Hollywood.

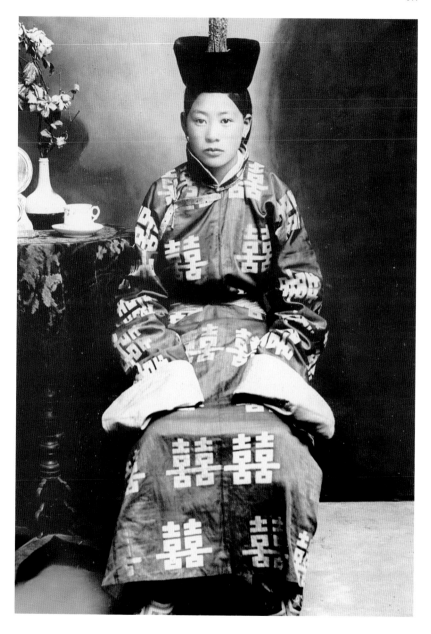

A classic quilted silk robe printed with Oriental characters, and a black velvet hat.
c.1925 A Mongolian lady dressed in her very best in time for tea.

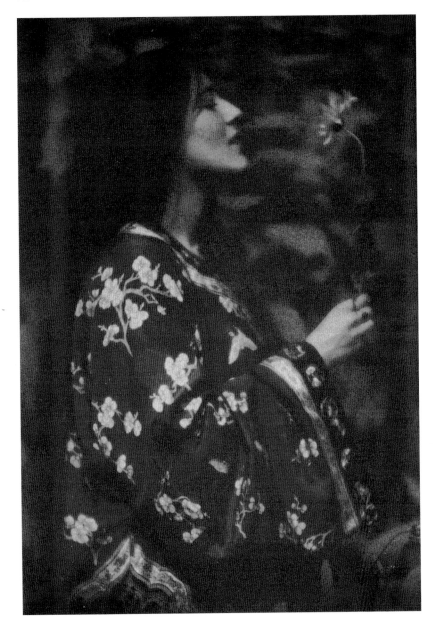

Admiring a sunflower dressed in a cherry-red kimono decorated with blossom.
1908 A photograph of Elsie 'Toodles' Thomas by American Alvin Langdon Coburn.

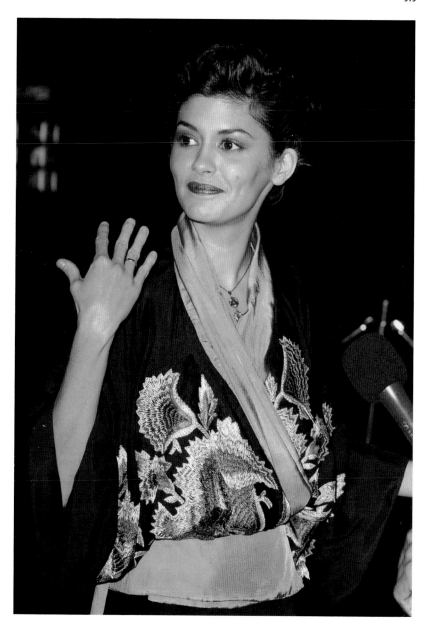

'La Fabuleuse' in an exotic black silk kimono embroidered with mauve flowers.
2004 French film actress Audrey Tautou at a film festival in Hollywood.

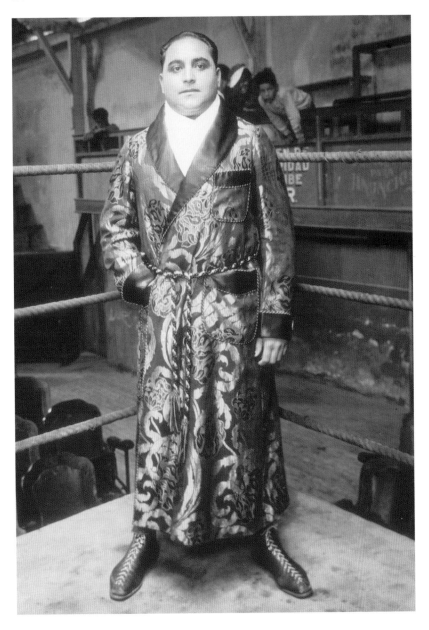

A fine figure of a man in a brocade dressing gown with pointed lace-up boots.
c.1935 A portrait of a wrestler in the corner of a ring, Mexico City.

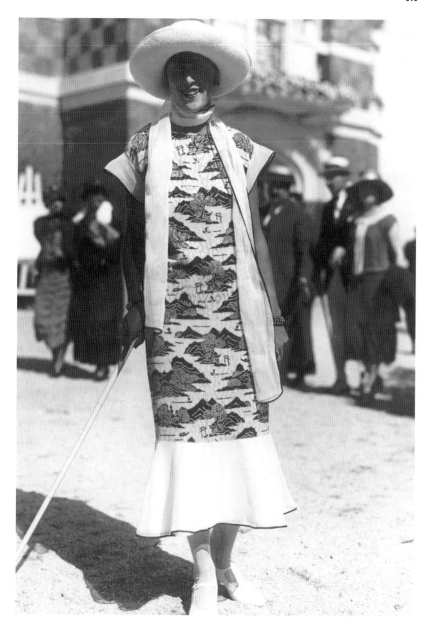

Perfectly poised for an afternoon promenade with a straw hat and a fine cane.
1927 A silk dress decorated with an oriental landscape, designed by Rolande.

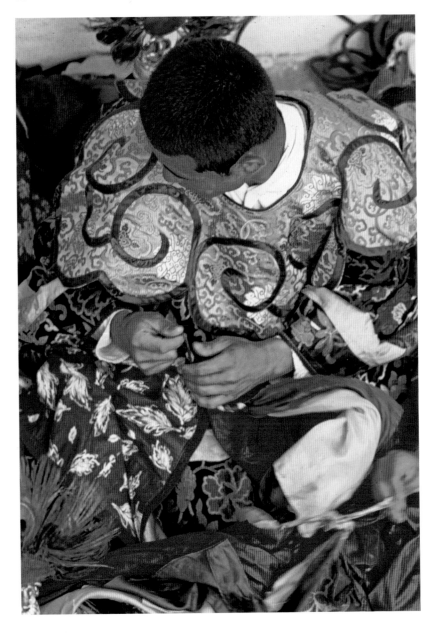

A substantial collar in yellow with blue scrolls over a leaf and a flower print.
1974 A Bhutanese dancer in an exotic, heavily embroidered silk costume.

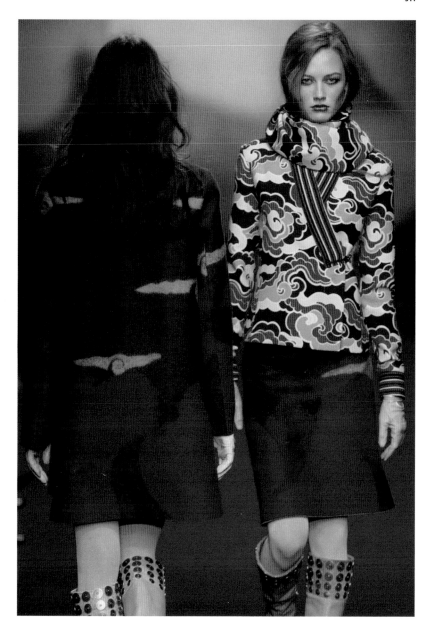

A prince among prints, a multicoloured jacket decorated with tsunami swirls.
2004 Turkish designer Rifat Ozbek's autumn/winter show for Pollini, Milan.

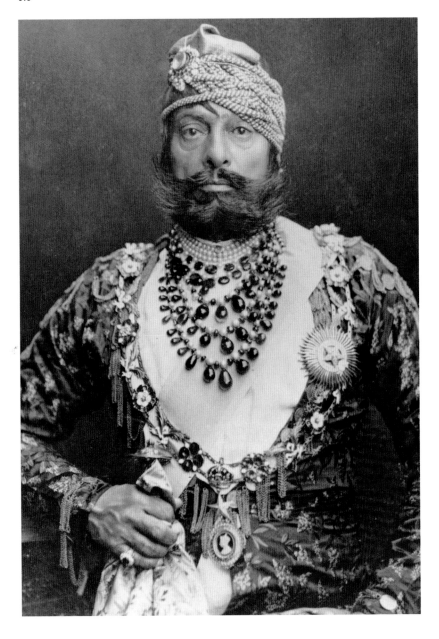

Laden with the jewels of state, superb sapphires and a cameo of Queen Victoria.
c.1870 His Highness the Maharajah of Jodhpur, a leading Indian principality.

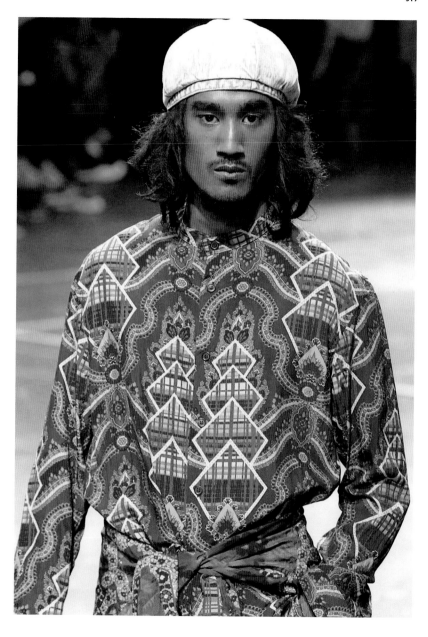

A tunic inspired by the costumes of Turkmenistan, in a brilliantly printed plaid.
2004 Japanese designer Yohji Yamamoto's spring/summer show, Paris.

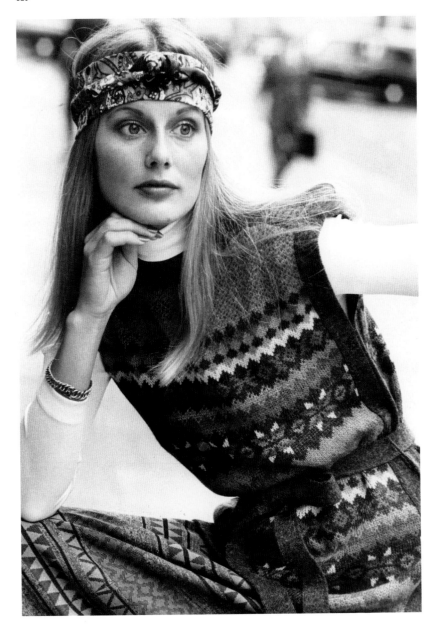

Zigzag knit in autumnal shades over a white polo-neck sweater with a bandeau.
c.1976 A tabard and skirt from Marks & Spencer's winter collection, London.

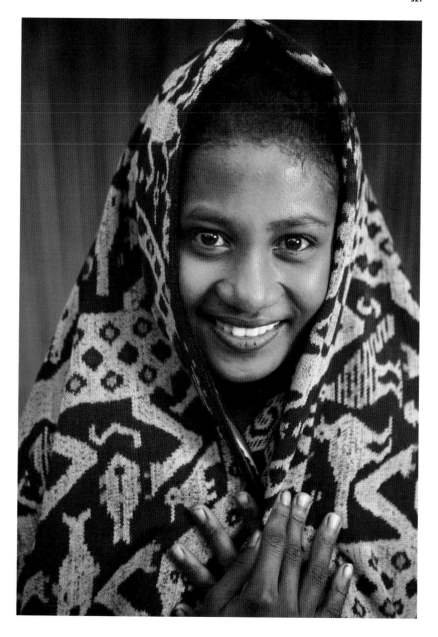

A joy to behold, birds and a bright smile are all a girl needs to attract attention.
20th Century A young West Timorese girl wearing a woven ikat shawl, Indonesia.

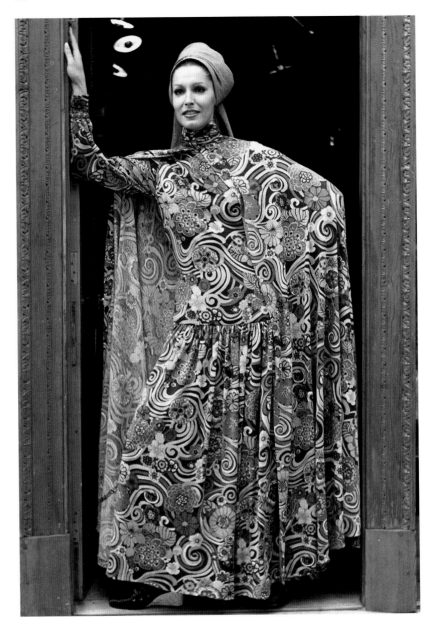

Caped crusader, an overwhelming ankle-length gown and a matching cape.
1971 Hardy Amies' autumn/winter collection in the door of his boutique, London.

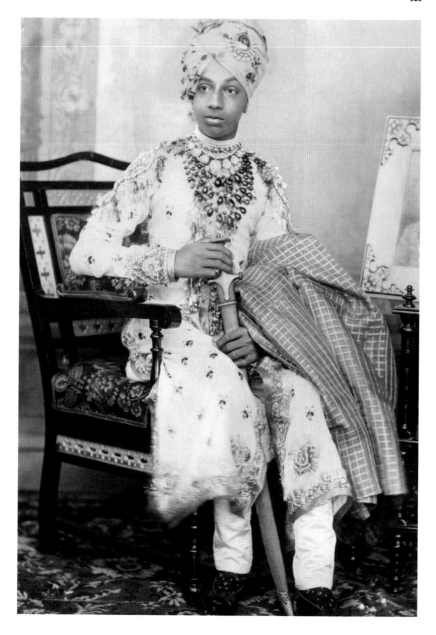

A gentleman in his finest garb with inherited jewels and a ceremonial sword.
1897 The Maharajah of Jodhpur, India.

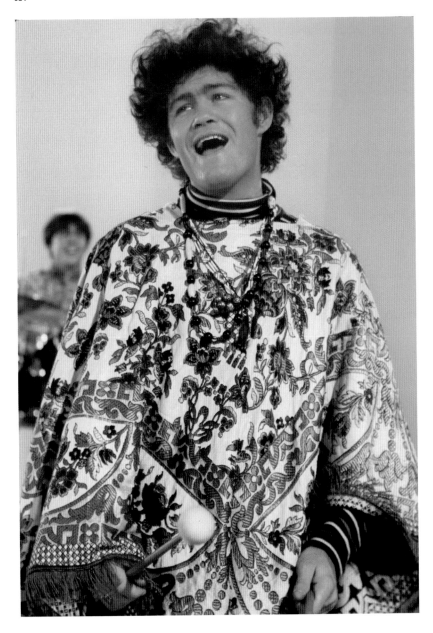

Peace man in a curious kaftan of brown and gold, complete with Buddhist beads.
1967 Mickey Dolenz of American pop band The Monkees, Los Angeles.

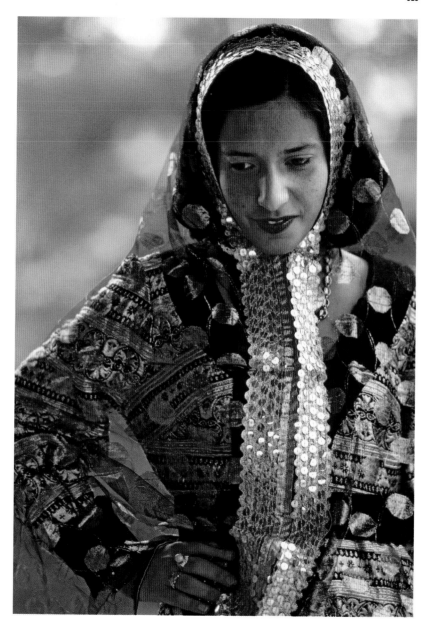

Shine on in a cloth of gold chiffon edged in sequins, over a black silk kaftan.
1979 A secretary wears her best robe to a family feast, Manama, Bahrain.

Clad as Cleopatra with an ornate collar over an exotic turquoise silk gown.
2009 Irish socialite Daphne Guinness at a launch party in New York.

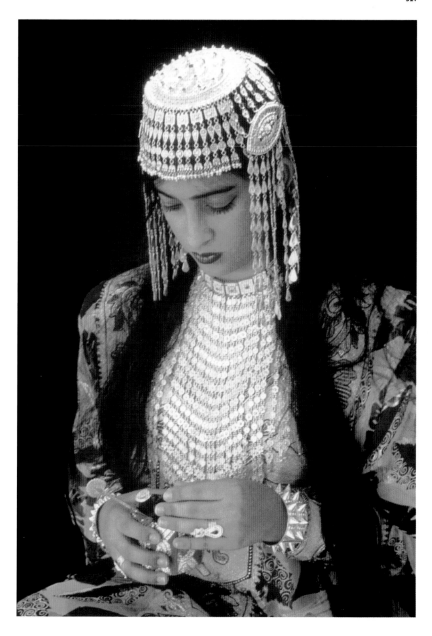

Worth her weight in gold, in brocade with a heavy golden collar and headdress.
1985 A girl in traditional costume covered with jewellery, United Arab Emirates.

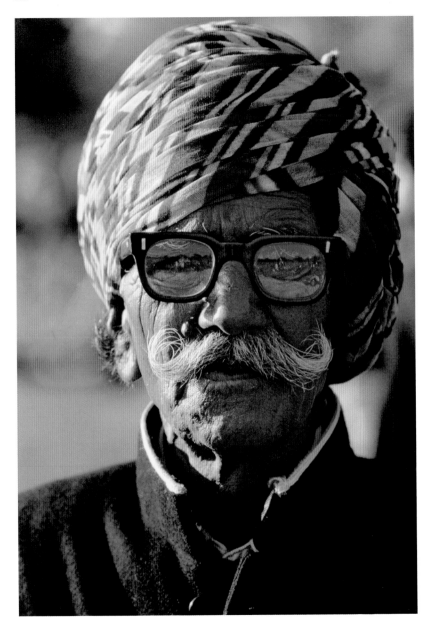

A marvellous moustache and a tremendous striped turban, with black shades.
1980 An impressive gentleman wearing traditional dress in Jaipur, India.

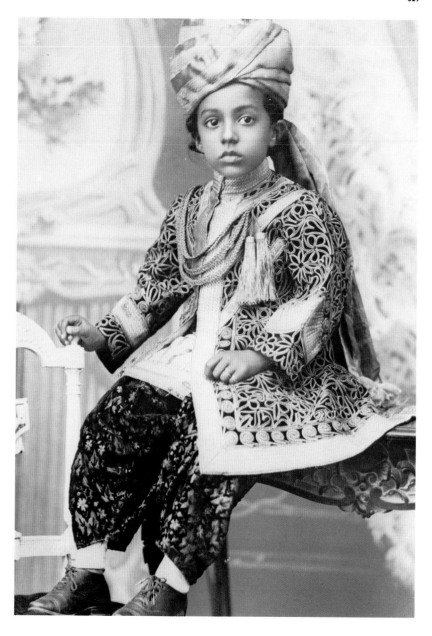

'Little Lord Fauntleroy' in an embroidered jacket, harem pants and a tiny turban.
c.1930 An Indian boy perched on a table, in Eastern dress with British boots.

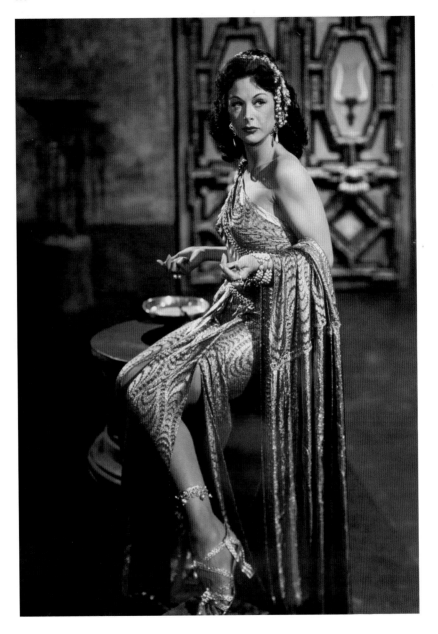

A golden girl in 'The Golden Age' of cinema wearing slivers of silk and bangles.
1949 Austrian actress Hedy Lamarr as Delilah in the film *Samson and Delilah*.

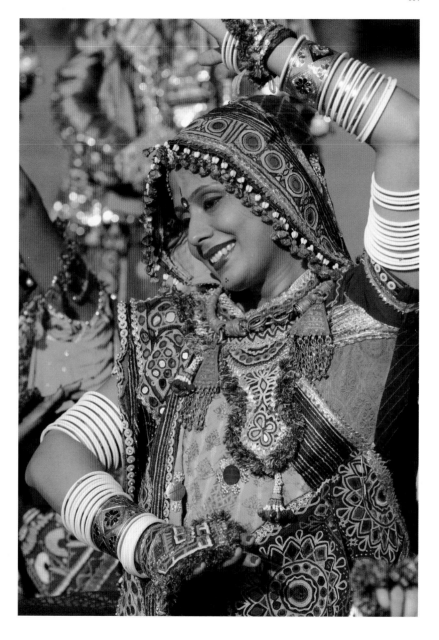

In praise of the Goddess Durga, bedecked in colourful embroidery and bangles.
2010 An Indian dancer at the Hindu Navratri (nine nights) festival in Ahmedabad, India.

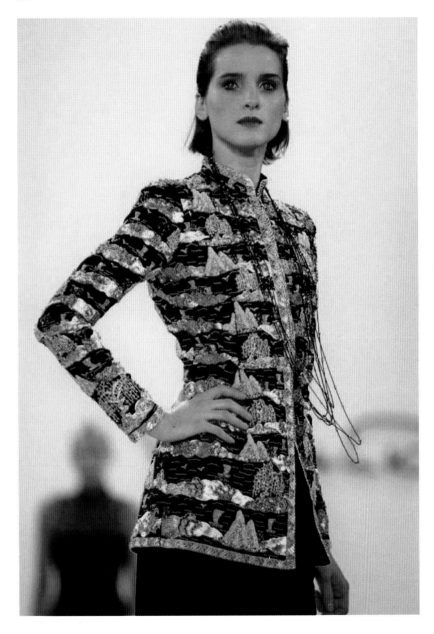

Eastern inspirations, a gold-and-black embroidered silk jacket over black velvet.
1996 American designer Oscar de la Renta's autumn/winter show, New York.

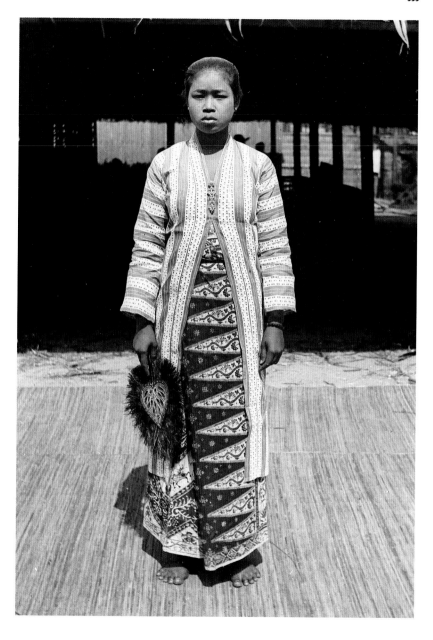

The best of batik, beautifully printed in classic patterns, and a feathered fan.
1889 An Indonesian woman in a sarong and long kabaya at the World Fair, Paris.

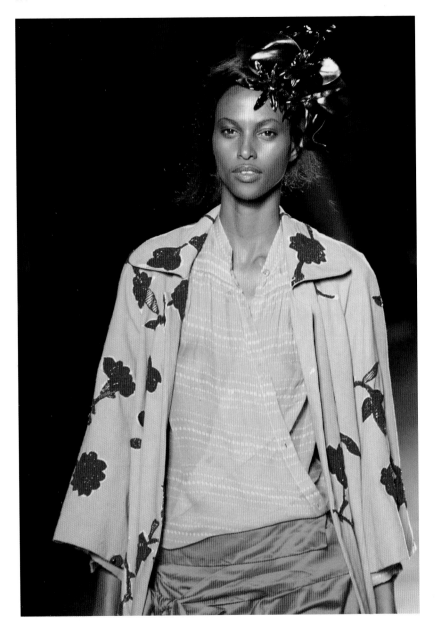

Prince amongst printmakers, a silk jacket in pale turquoise with coral flowers.
2005 Belgian designer Dries van Noten's autumn/winter show, Paris.

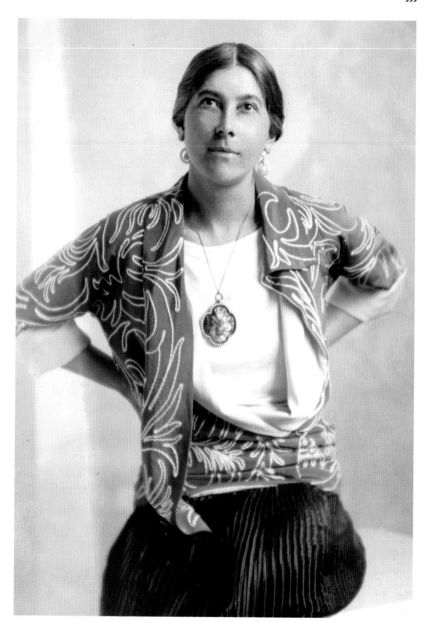

Marvellously modern, an appliquéd jacket worn over a simple white T-shirt.
c.1928 Denise Poiret, the wife of famous French designer Paul Poiret.

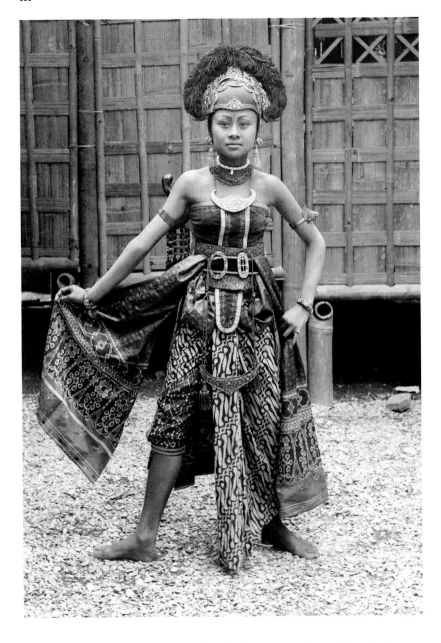

Barefoot and laden in jewels, poised wearing a batik costume in front of a local hut.
1889 A beautiful Javanese dancer in all her finery at the World Fair, Paris.

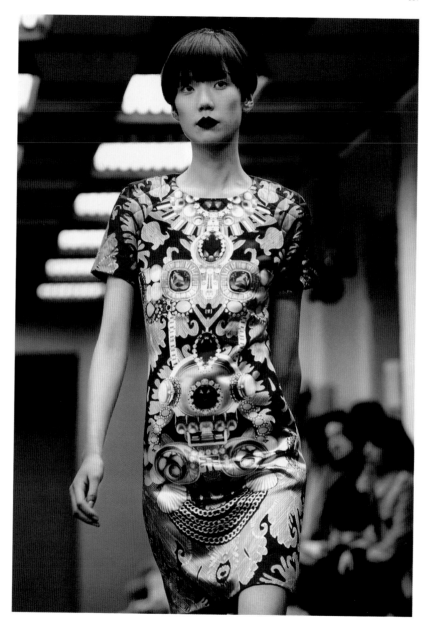

Tipped for the top, a plain shift dress printed with amethyst and turquoise jewels.
2010 Greek designer Mary Katrantzou's autumn/winter show, London.

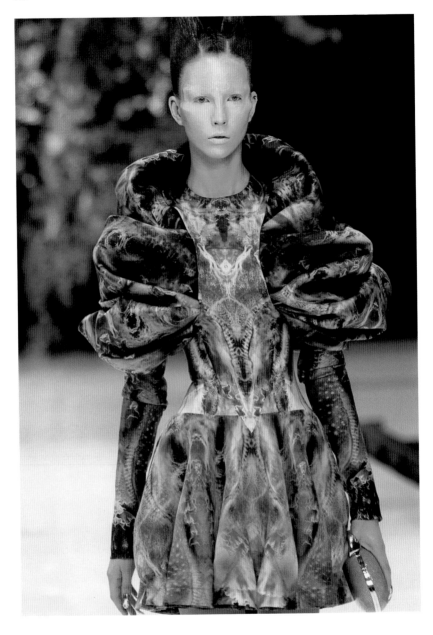

The final curtain, modelled on an alien, in a digital print of purples and blues.
2010 British designer Alexander McQueen's spring/summer show, Paris.

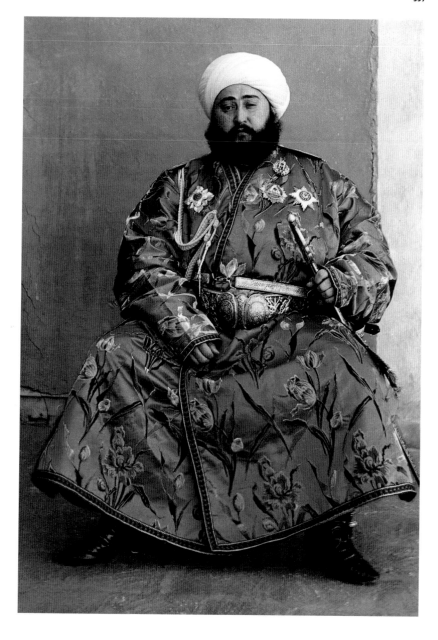

A rich robe in royal blue embroidered with birds and flowers, and wide gold belt.
1911 Alim Khan, the last emir of the Manghit dynasty of Bukhara, Uzbekistan.

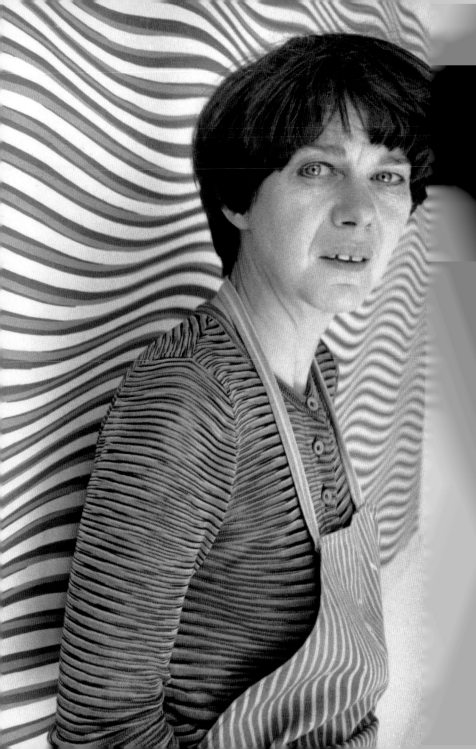

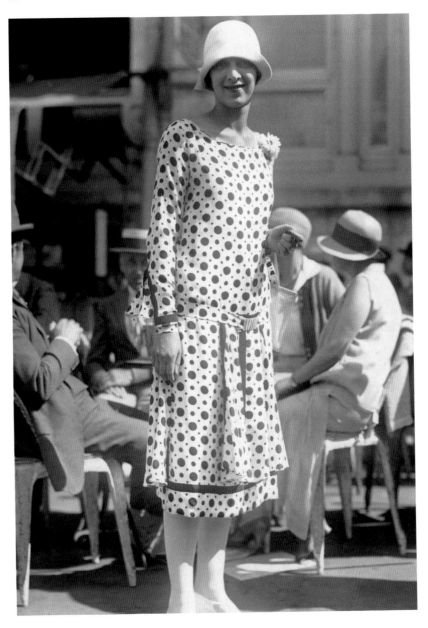

Café society and flapper chic, white stockings and a cloche hat are de rigueur.
1925 A spotted dress with a dropped waist by designer Duvine, Paris.

Previous page Dizzying stripes in black and white, in a bright sweater and an apron too.
1979 British painter Bridget Riley, a leading figure in the op art movement.

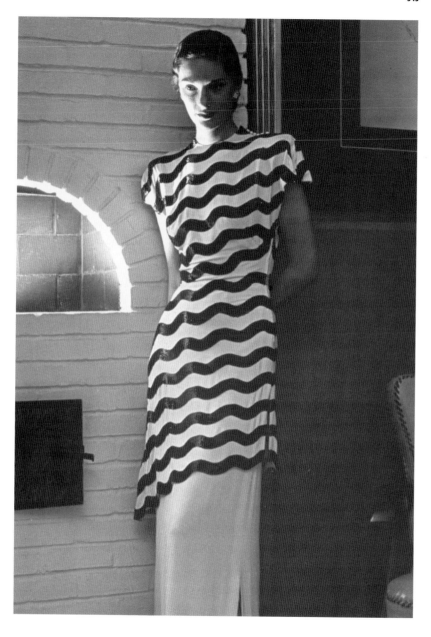

Made-to-measure and very modern, a long tunic over a lean, ankle-length skirt.
1946 A model wearing an evening gown in white crêpe with black wavy stripes.

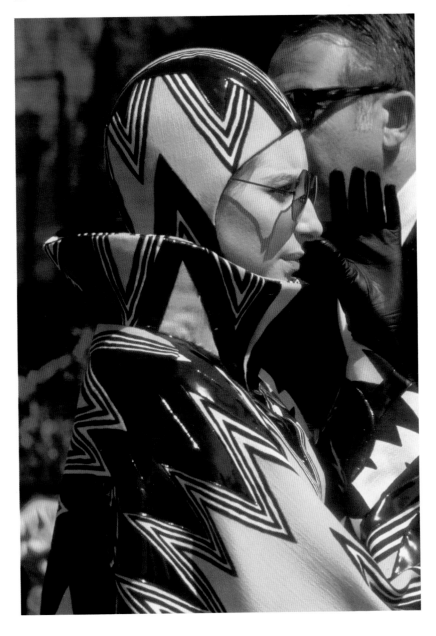

Singing and acting in dazzling zigzags of canary yellow, black and white.
1969 Barbra Streisand filming *On a Clear Day You Can See Forever.*

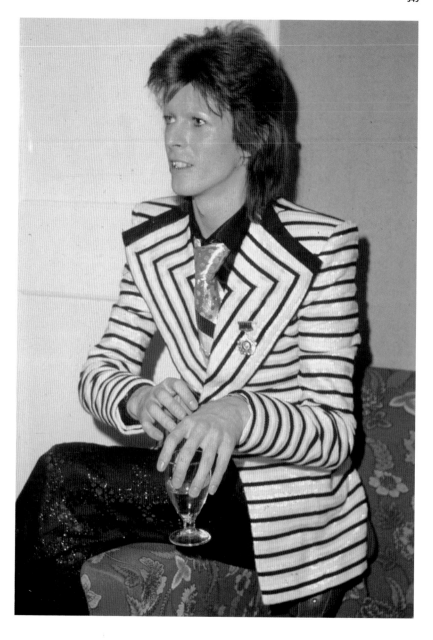

Glam rock, with lapels the size of elephant ears, and brilliantly red hair.
1973 British singer David Bowie in a black-and-white horizontally striped jacket.

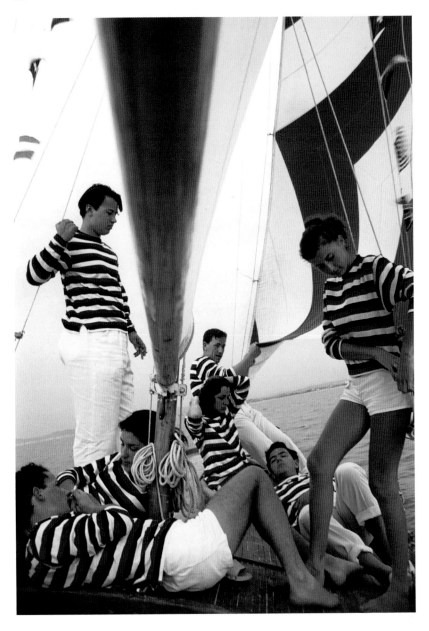

A classy crew lounging around in matching red, white and blue with tiny shorts.
1956 Young holidaymakers from Milan enjoy a sail on the Adriatic, Italy.

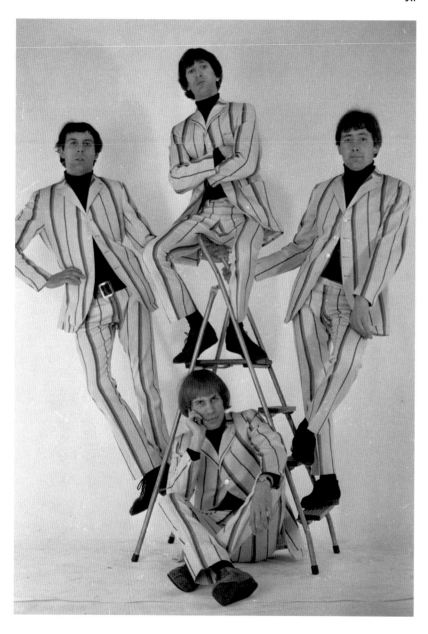

The swinging sixties in stripy suits from John Stephen of Carnaby Street, London.
1966 British pop group The Troggs, Pete, Ronnie, Chris and Reg.

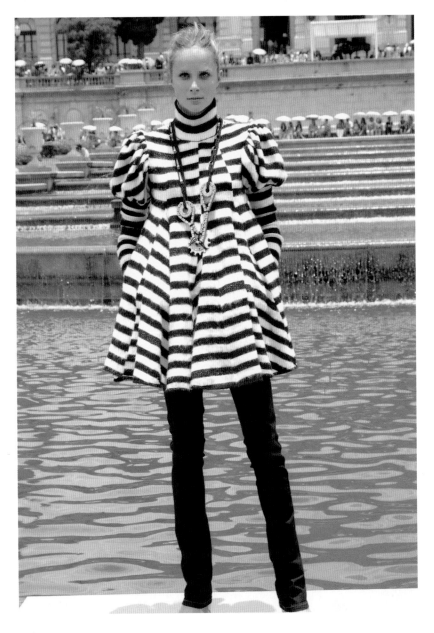

Bold stripes in monochrome, a dress with a polo neck and big puffed sleeves.
2006 Cavalera autumn/winter fashion show, Ipiranga Museum, São Paulo.

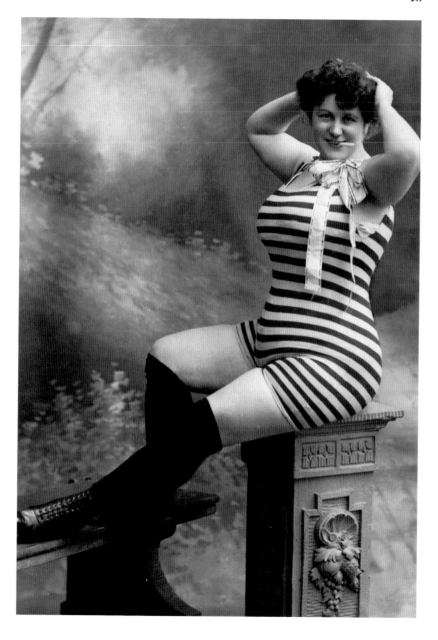

Cheerfully rotund in a fashionable bathing costume and saucy black stockings.
1915 A 'lady' sitting on a pedestal adjusting her hair and puffing a cigarette.

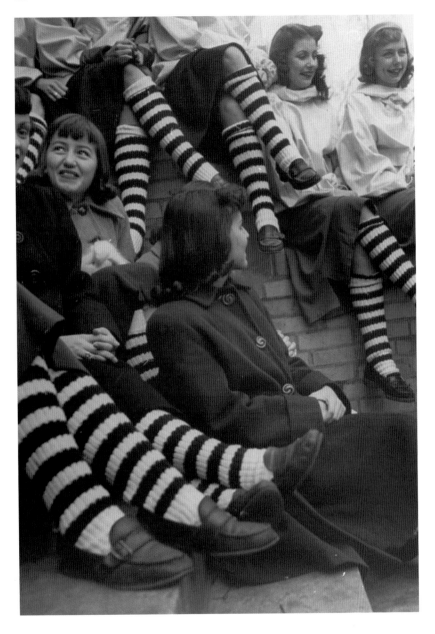

Identical kit, get the look and look the same, all very on trend post-World War II.
1948 Teenage girls wearing the latest fashion in stripy socks with penny loafers.

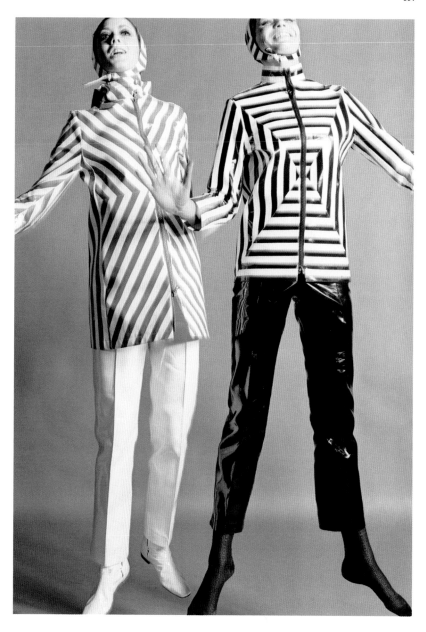

Op art and rainproof from top to toe, in plastic hooded anoraks and slim trousers.
1965 A page in *Queen* magazine with famous model Veruschka on the right.

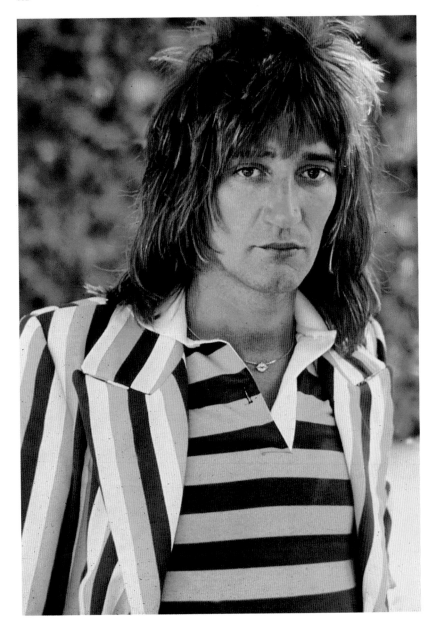

Bright as a bee, 'Rod the Mod' in a cricket blazer and a matching polo shirt.
1977 British rock star Rod Stewart while recording 'The First Cut is the Deepest'.

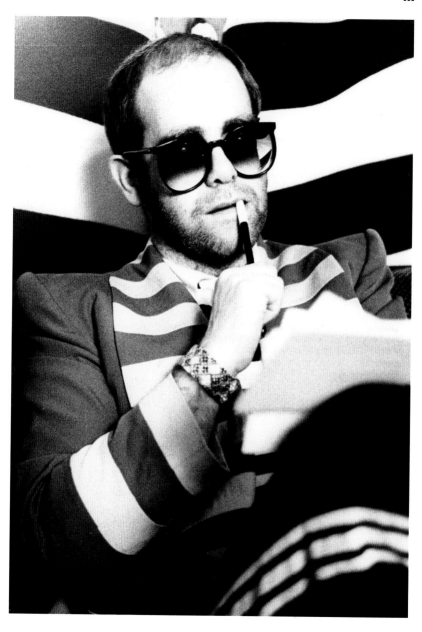

Never a shrinking violet in his trademark spectacles and a bold, striped jacket.
1976 British pop star Elton John reading fan letters in Hilversum, Holland.

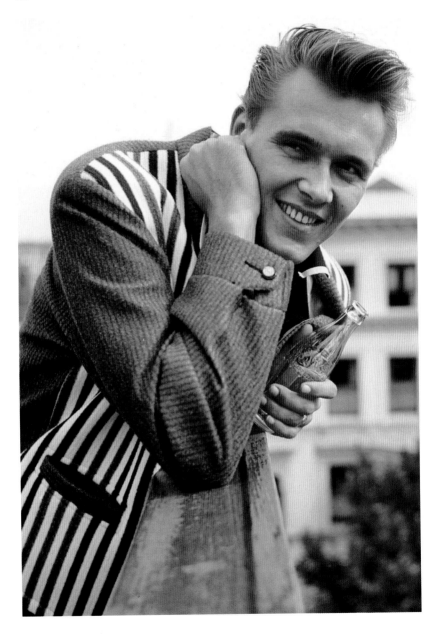

Liverpool lad in the latest gear, a grey pin-striped jacket with wide striped front.
1963 British rock 'n' roll singer Billy Fury grinning and relaxing with a Coca-Cola.

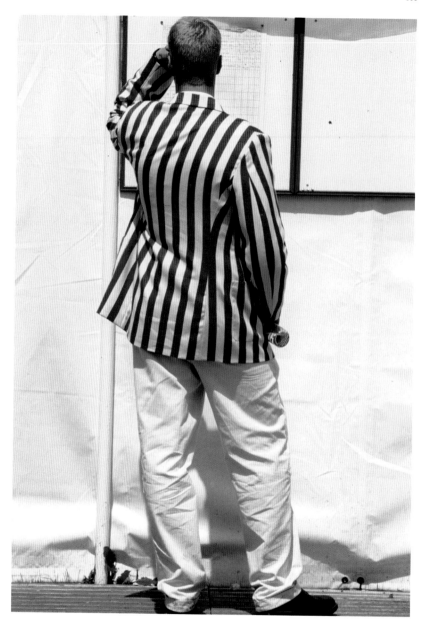

The right rig at the Royal Regatta, a red-and-white blazer and baggy trousers.
1997 'Images of an English Sporting Summer' at Henley-on-Thames, England.

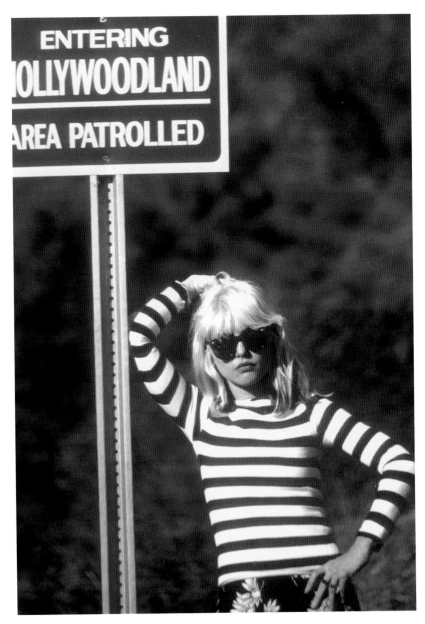

Hurrah for Hollywood, a blonde bob, cool Ray-Ban shades and a sailor's T-shirt.
c.1970 American punk-rock star and actress Debbie Harry posing for a pic.

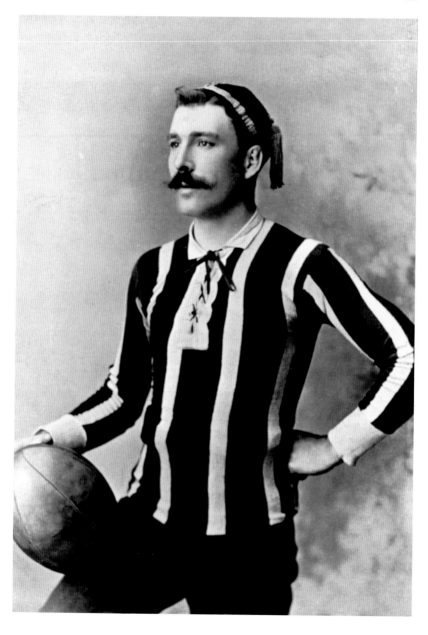

The correct kit, a handlebar moustache, tasselled cap and a team shirt in stripes.
c.1896 Rugby Union player E. Cooke, captain of Leicester, England.

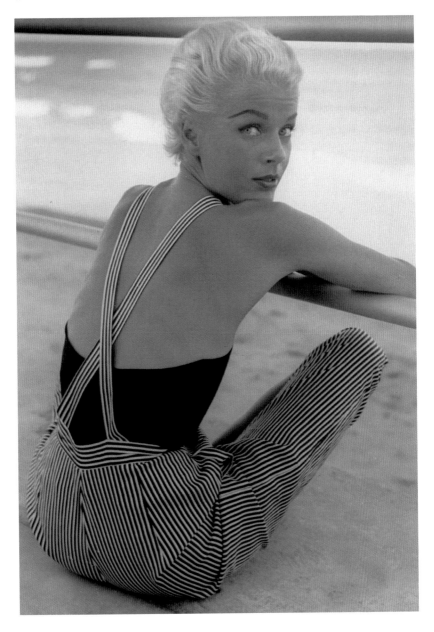

A platinum blonde crop and dungarees over a swimming costume tick the box.
1955 A fashion model in 'casual play clothes', Miami Beach, Florida.

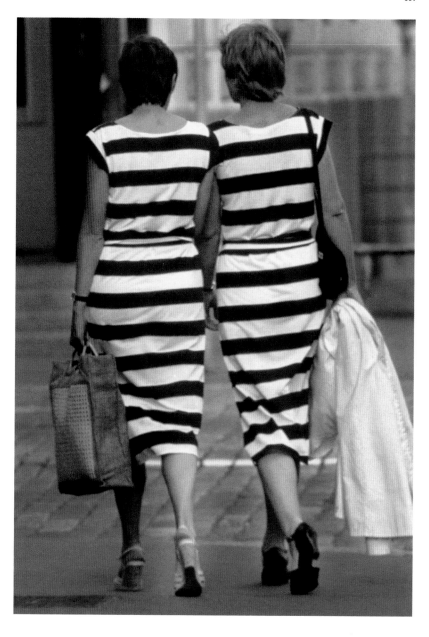

Double act, the simplest and the smartest black-and-white striped tube dresses.
1981 Street style, two ladies striding out in matching outfits, Helsinki, Finland.

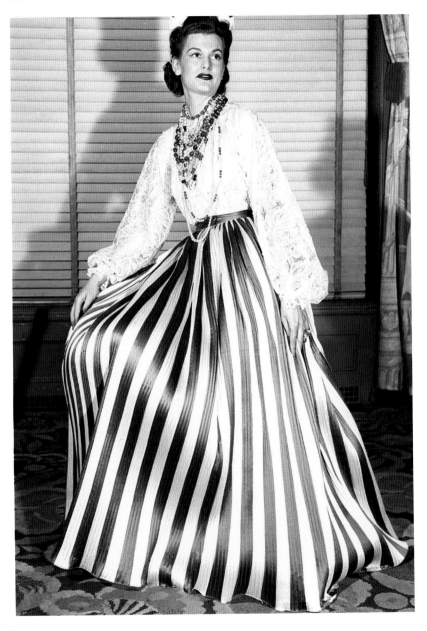

The best dressed lady in town in a satin accordion-pleated skirt and lace blouse.
c.1940 'Fashions Future' show at the Astor Hotel, New York.

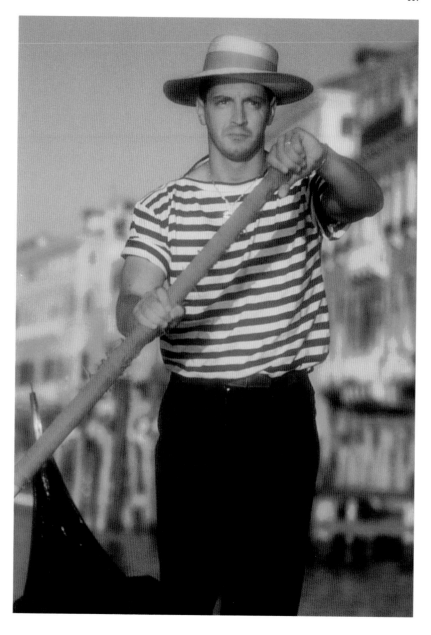

A glamorous gondolier punting his stuff in the traditional navy and white T-shirt.
20th Century A straw hat and strong muscles on a canal in Venice, Italy.

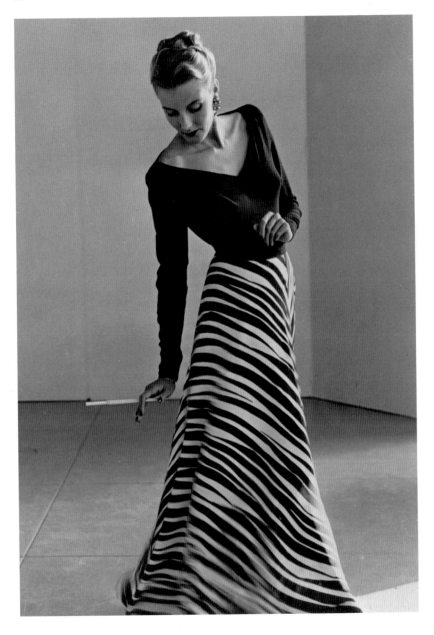

Elegance personified, taking a step wearing a gown with a zebra-print skirt.
1952 American socialite Peggy Hunt in a long dress, cigarette holder in hand.

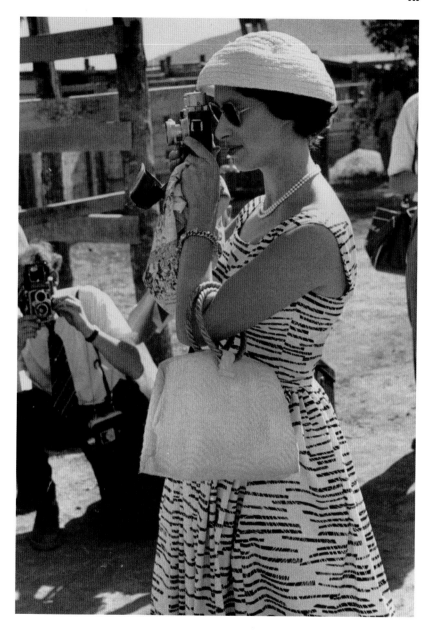

Happy snapping in a simple summer frock with a straw hat but no white gloves.
1956 British Princess Margaret Rose at a game farm in Tanganyika, East Africa.

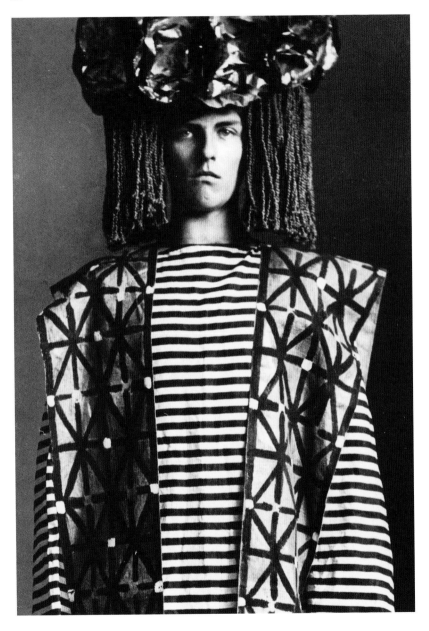

Pantomime prince, Rasta locks and square shapes in stripes and crosses.
c.1907 A costume for *The Dancer and the Marionette* by Max Mell, Austria.

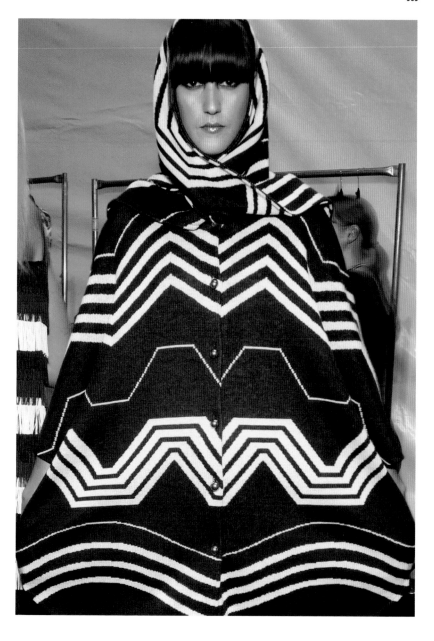

A strong silhouette, a blanket cape-coat with a hood in bold blue and white.
2011 Ivana Helsinki spring/summer fashion show, New York.

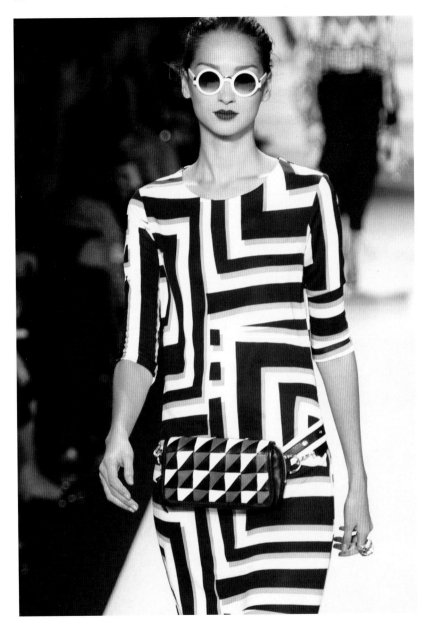

Eye-popping lines, a black-and-white shift dress with a handbag hung on the hip.
2011 Diane von Furstenberg's spring/summer fashion show, New York.

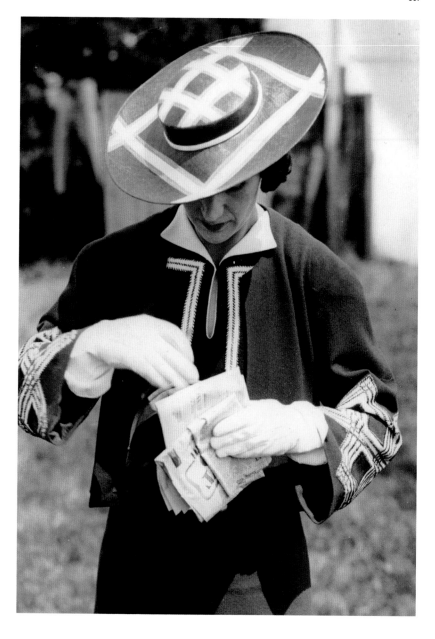

Smart track in a tidy suit with a matching hat trimmed with graphic lines.
1937 Mrs. George Edwards checking the form at Ascot Racecourse, England.

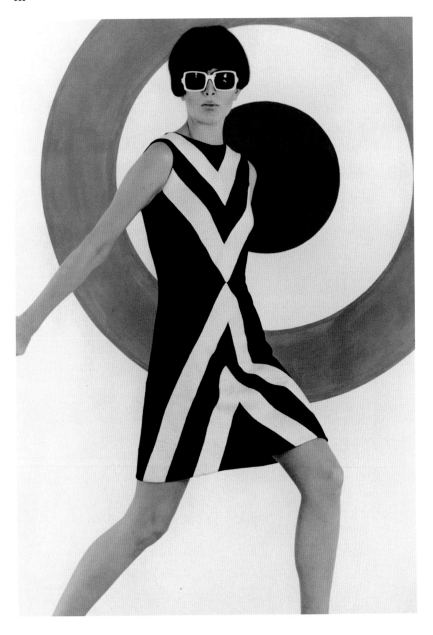

Bull's eye, a short shift in op art lines, a perfect picture of the sixties.
1966 A fashion photo, showcasing a mini-dress and white sunglasses in Milan.

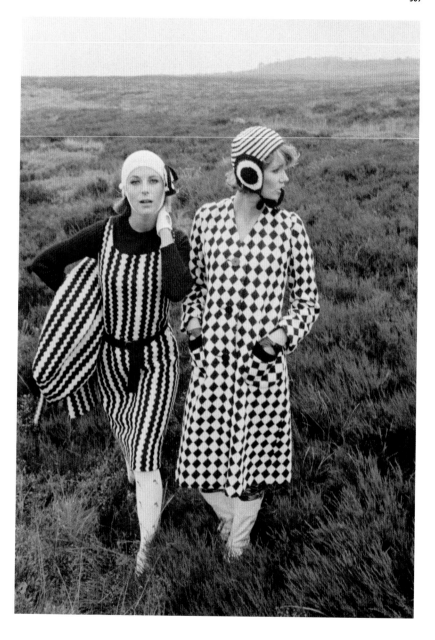

A fashion shoot, aviator helmets, pinafore dresses and coats in contrasting lines.
c.1966 Modelling on the moors in knitted checks and zigzag designs, England.

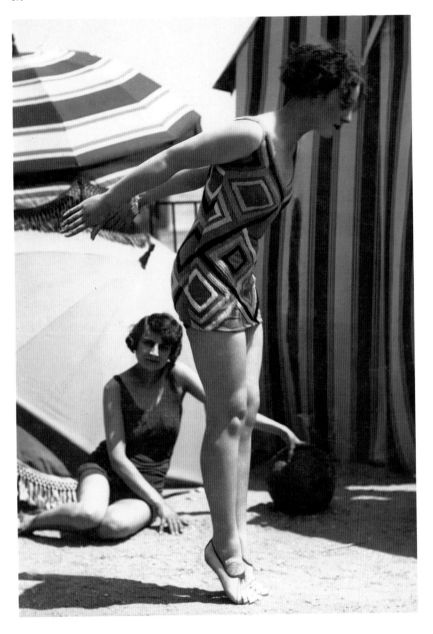

Taking the plunge in pale blue silk bathers embroidered in red, white and green.
c.1925 Bathing beauties in swimsuits designed by Russian artist Sonia Delaunay.

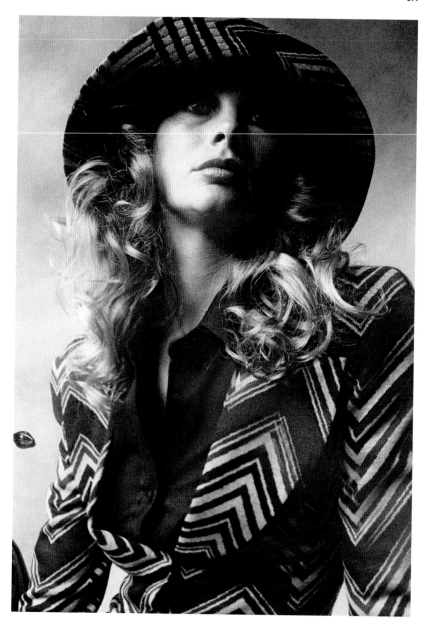

À la mode Biba designs in chevrons using autumnal shades of russet, cream and black.
c.1970 A fashionable photo in *The Daily Telegraph* newspaper, Britain.

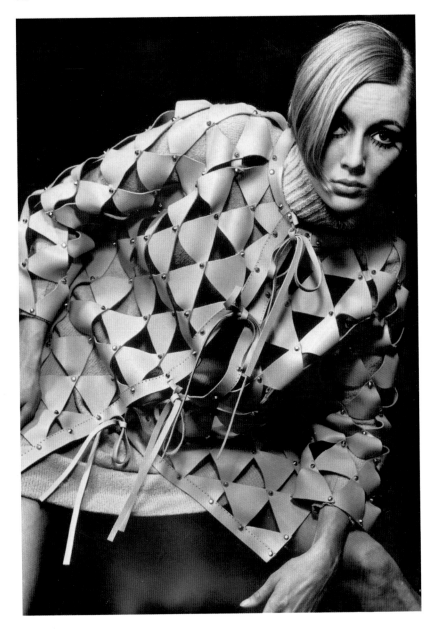

Chain mail, triangular pieces of leather riveted together, worn over a polo neck.
1967 A coat looking like armour created by French designer Paco Rabanne.

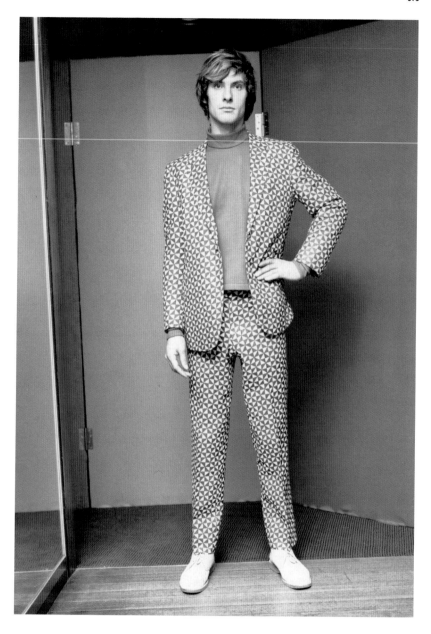

Lizard-like, a matching tight jacket and trousers in tiny monochrome triangles.
1967 Model Richard Hanson wears a patterned lounge suit made of cotton.

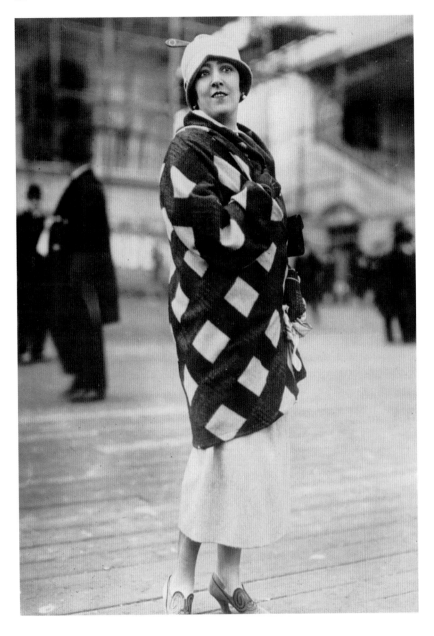

All the rage, a cocoon shape in plaid velour over a long skirt, and a cloche hat.
c.1924 A rust and cream coat from Paris, all set for sports and country wear.

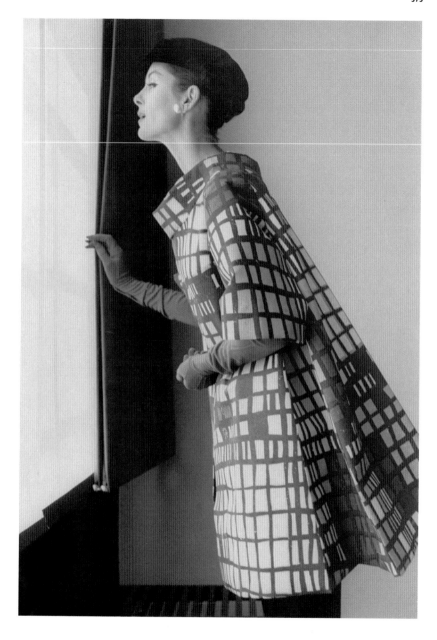

Mondrian checks, a very modern shape with elbow-length sleeves and gloves.
1956 A flared jacket with a stand-up collar by Lillian's Fashions, London.

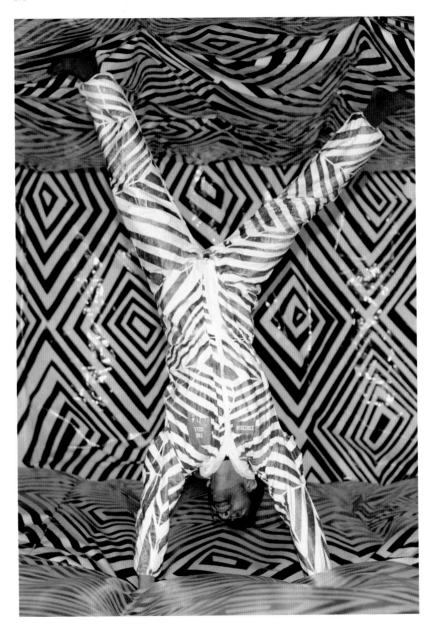

Chevron shapes, an installation called 'The Cell' decorated with Aboriginal motifs.
2010 Aaron de Souza in Australian artist Brook Andrews' exhibition in Sydney.

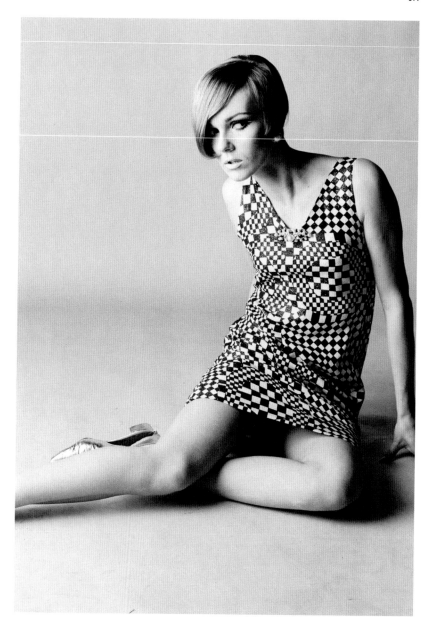

Pretty pins in a micro mini-dress, sleeveless with a V-neck and in little checks.
c.1965 A black-and-white photo shoot for *Queen* magazine, London.

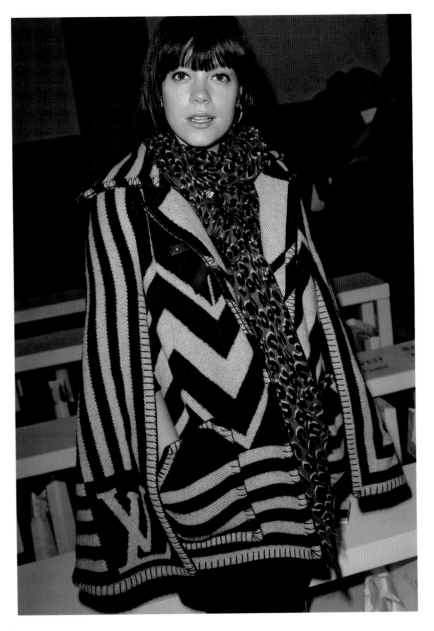

Designer diva in a blanket cape with an animal-print scarf, both by Louis Vuitton.
2010 English singer Lily Allen at the BodyAmr fashion show at London Fashion Week.

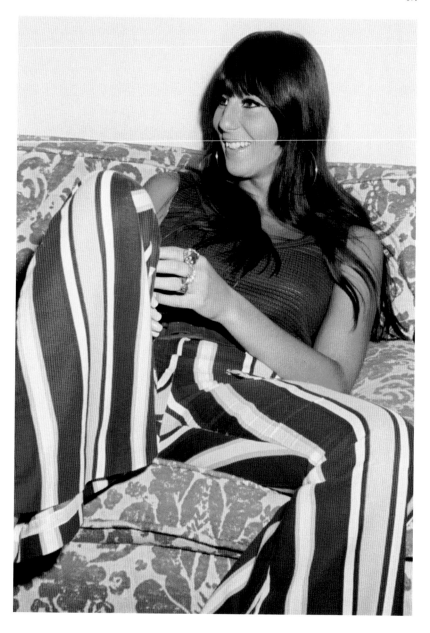

Laid-back in loons cut in deckchair stripes of red, yellow, navy and white.
c.1960 American singer Cher lounging around in Los Angeles.

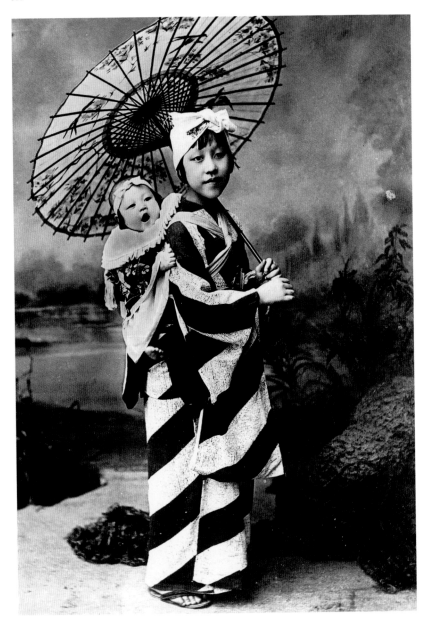

It's all a big yawn, a pretty portrait with a wide-striped kimono and a parasol.
19th Century A Japanese nursemaid with her charge strapped to her back.

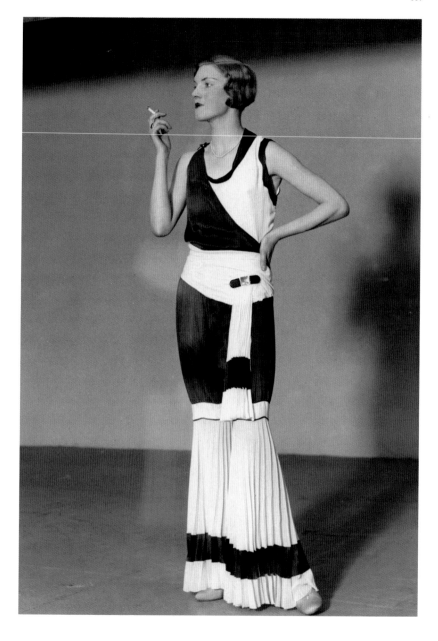

A Picasso-inspired tunic and pleated skirt in black-and-white crêpe, *très chic*.
1931 A cocktail dress at the Ideal Home Exhibition, London.

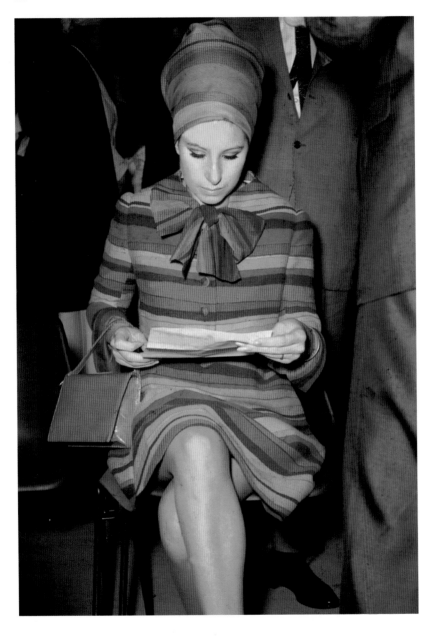

A strong suit in brilliant stripes of pink, red, navy and turquoise, with a turban on top.
1967 American singer Barbra Streisand at a pro-Israel rally in Los Angeles.

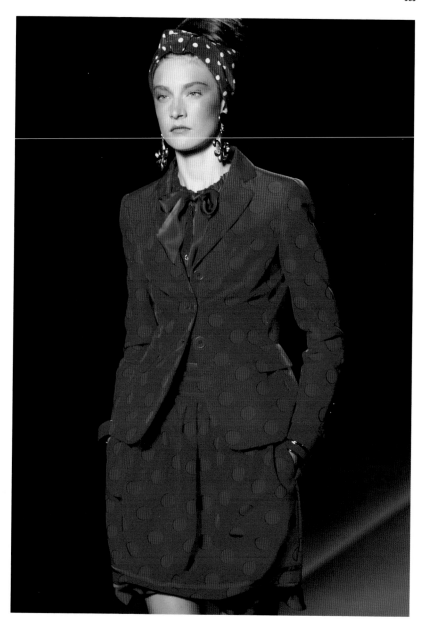

A similar suit, over half a century later, in red with blue dots, and a turban too.
2011 Moschino spring/summer fashion show, Milan.

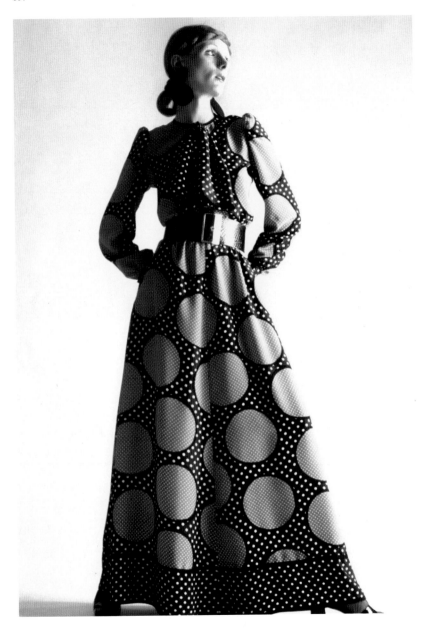

Little and large, a silk dress with enormous spots and tiny dots, and a wide belt.
1970 Christian Dior spring/summer haute couture collection, Paris.

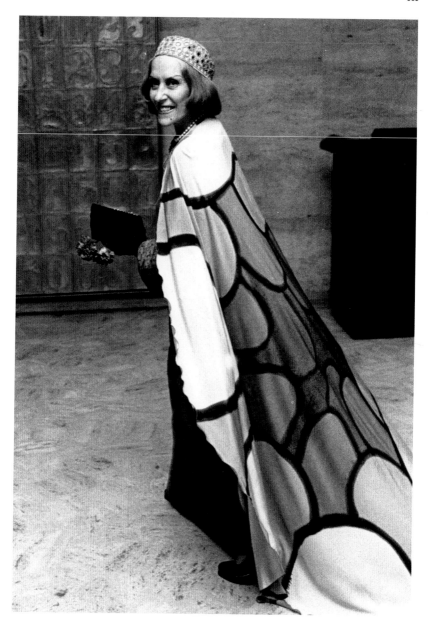

A caped crusader at a charity event wearing a billowing cloak and a skullcap.
1950s American actress Gloria Swanson at a party held by Bing Crosby.

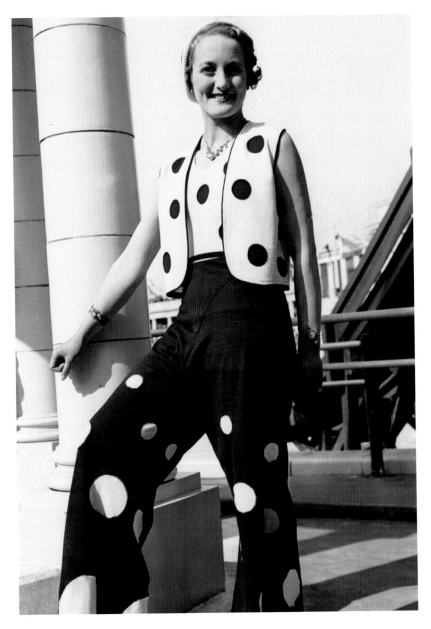

A very modern miss in a polka dot three-piece trouser suit in black and white.
1930s From a collection of photographs tracing the history of photography.

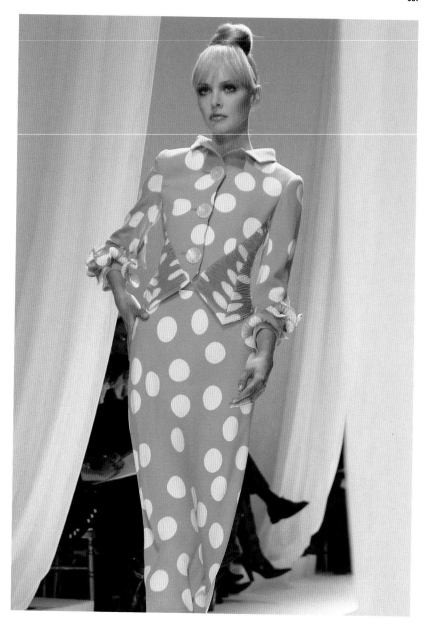

For ladies who lunch, a seriously smart suit in mustard with polka dots.
2007 Valentino spring/summer fashion show, Paris.

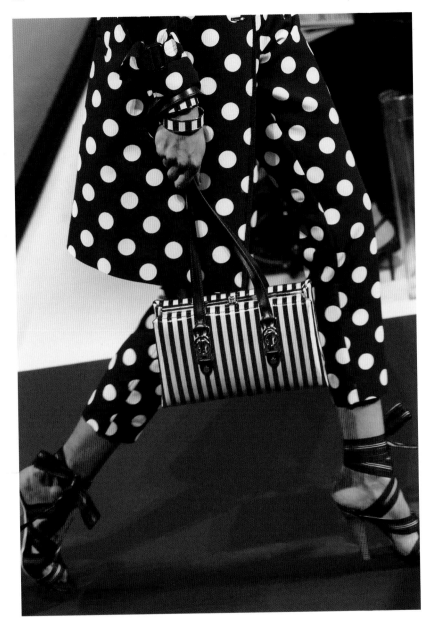

Stand out on a zebra crossing in a spotted coat and trousers with a striped bag.
2011 Moschino spring/summer fashion show, Milan.

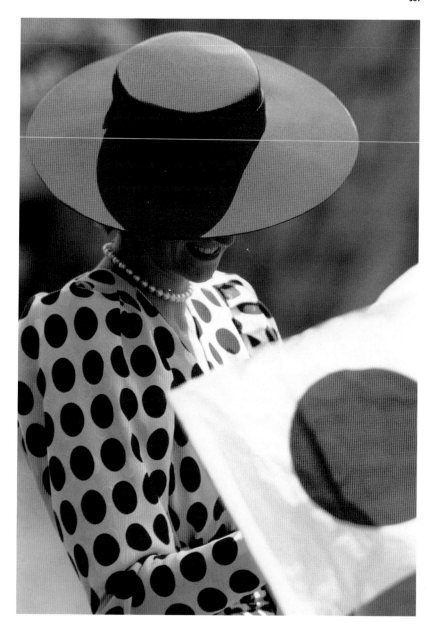

Flying the flag in a show-stopping suit by Tatters with very big shoulders.
1986 British Princess Diana in Japan wearing an outfit to honour her hosts.

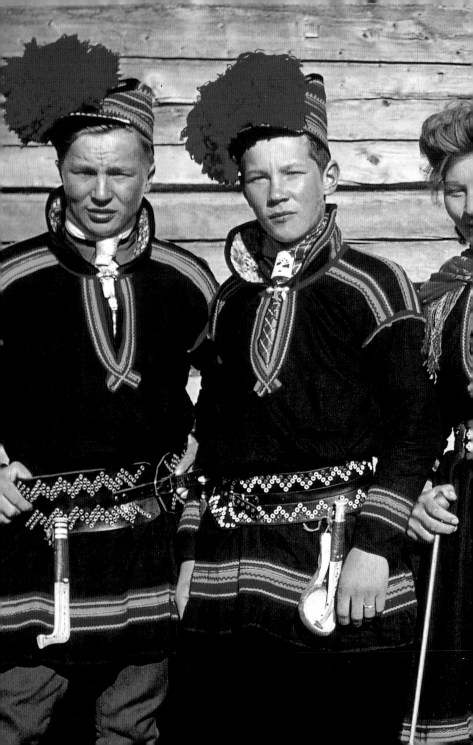

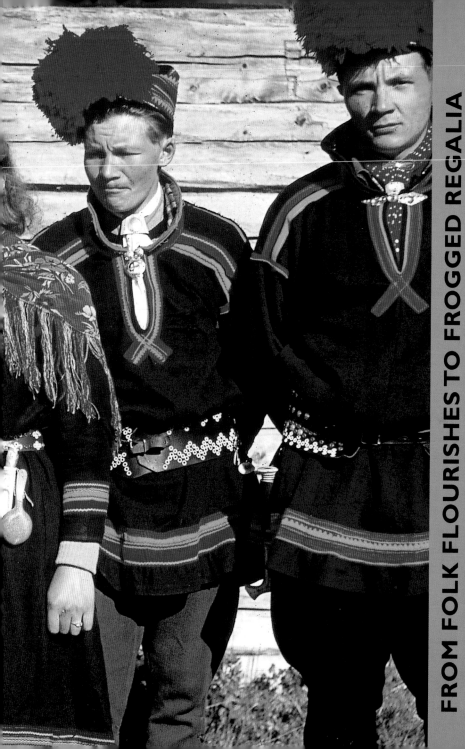

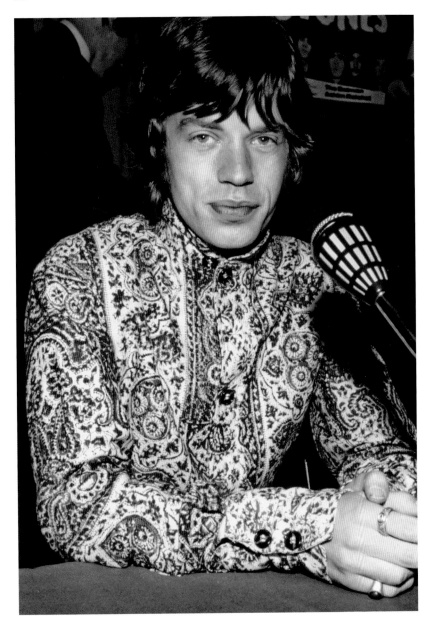

Paisley and pop, wearing an Indian cotton Nehru-style shirt in cream and red.
1967 British rocker Mick Jagger of The Rolling Stones at a press conference.

Previous page Folk in folk art, black with red embroidery and belts with hunting knives.
1944 A group of Samis in traditional costume, Lapland, Sweden.

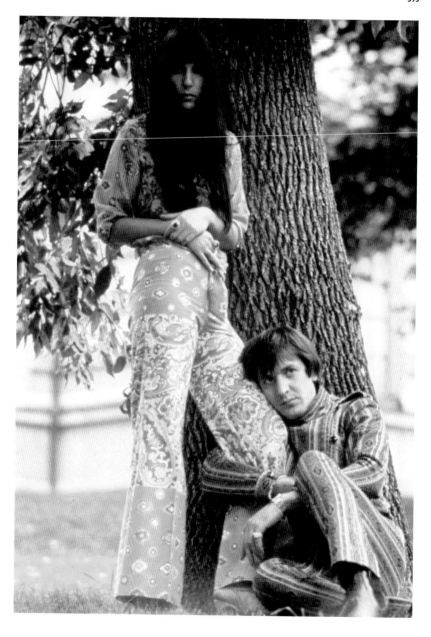

'I've Got You Babe', in paisley, emerald and pink loons and a matching shirt.
1960s American pop duo Sonny & Cher in the early days of their career.

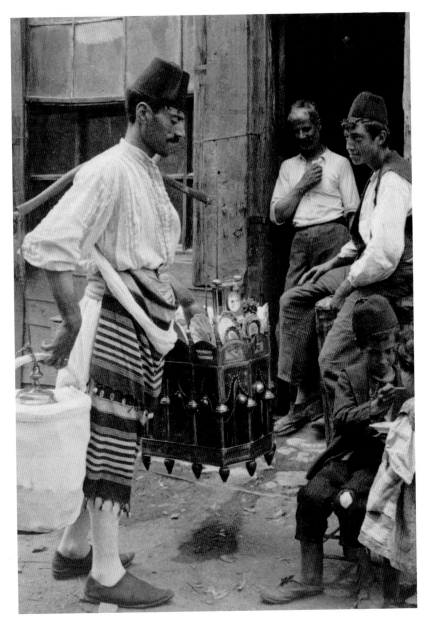

A Turk with treats dressed in a large white cotton shirt, a striped apron and a fez.
1898 An ice-cream vendor selling his wares in Constantinople.

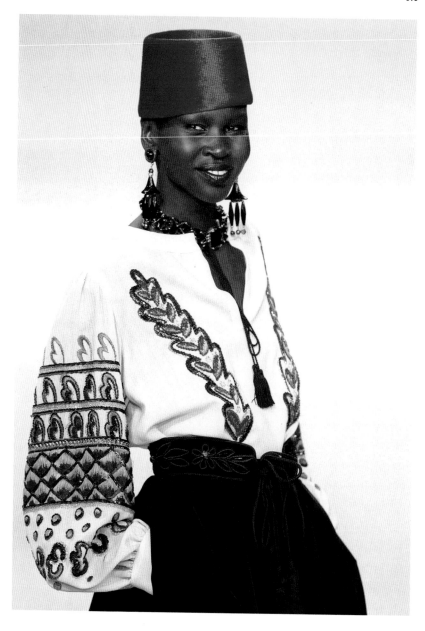

Moroccan-inspired moments, a monumental collection by the maestro designer.
2002 Farewell to couture, Yves Saint Laurent's final couture show in Paris.

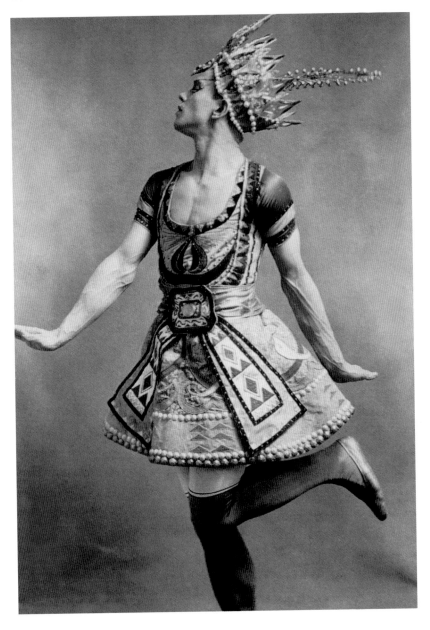

Exit stage right wearing an exotic crown and a heavily embroidered tunic.
1912 Russian dancer Vaslav Nijinsky in the ballet *Blue God*, Paris.

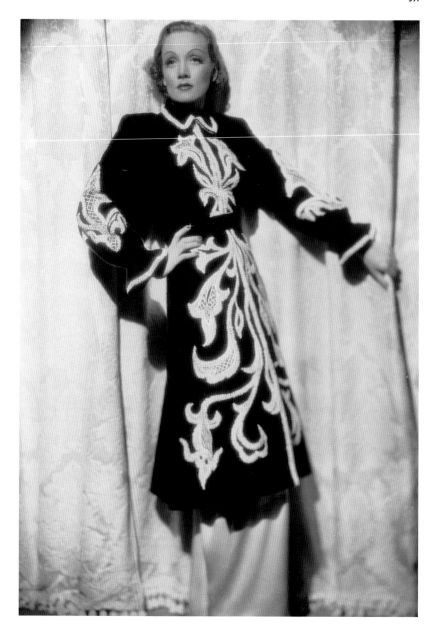

Femme fatale wearing an embroidered dressing gown over silk cocktail pyjamas.
1937 German actress and singer Marlene Dietrich in the film *The Blue Angel*.

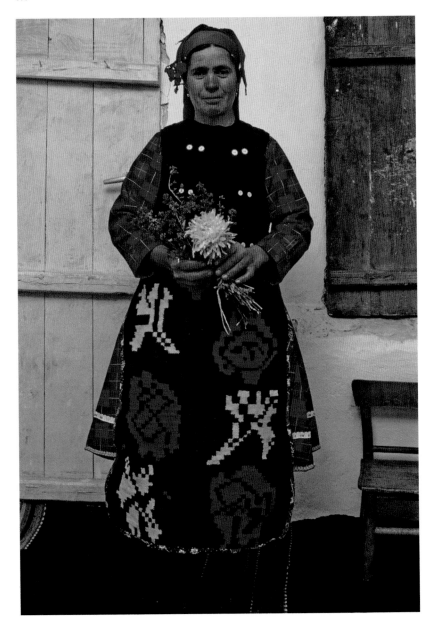

Delightful with a dahlia, a red, black and white skirt with a checked blouse.
c.1980 A Bulgarian woman in a hand-woven ceremonial gown, Gorna Sushitsa.

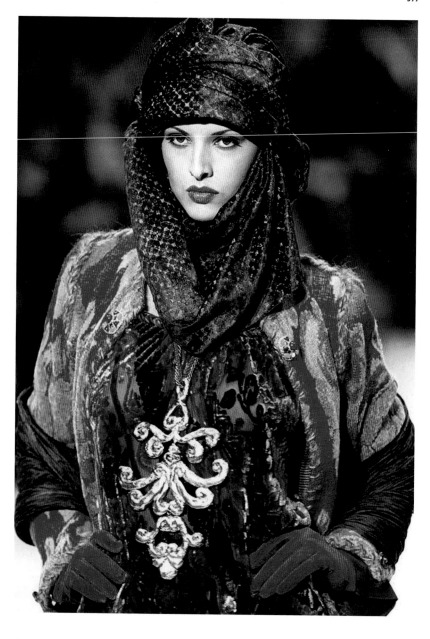

A real Russian doll, a babushka headdress and mohair coat, all in jewel colours.
1993 Emanuel Ungaro autumn/winter haute couture show, Paris.

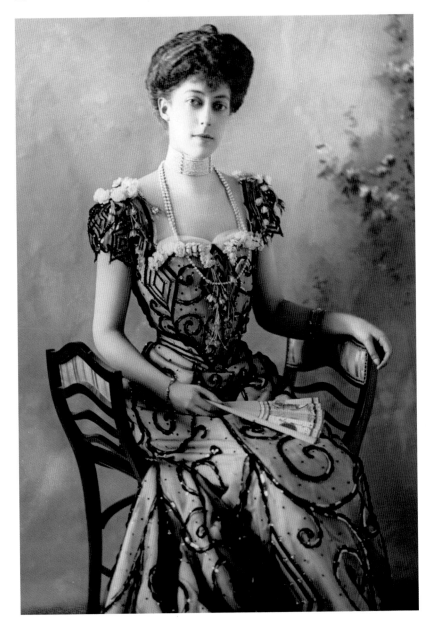

Portrait of a princess on a stool with a curvaceous figure and plenty of pearls.
1895 British Princess Victoria, daughter of King Edward VII and Queen Alexandra.

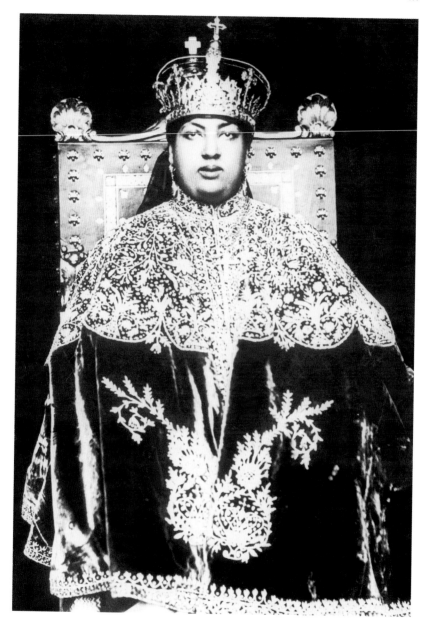

'The Lioness' on her throne in all her finery, a golden crown and a rich cape.
1928 The Empress of Ethiopia Woizero Menen Asfaw, wife of Haile Selassie.

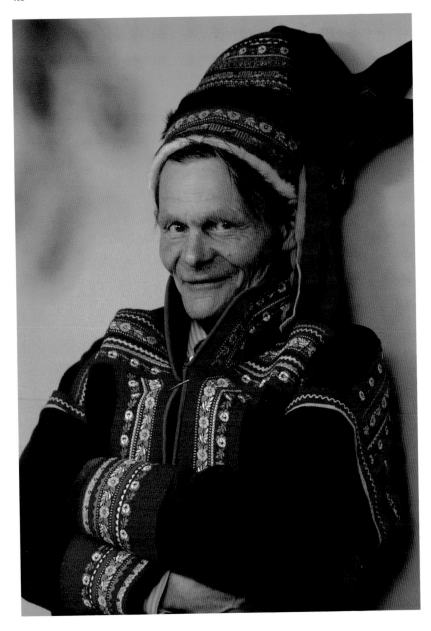

Woven warmth, a tunic and headdress in black wool with a red-and-white trim.
1968 A Sami grandfather wearing the traditional costume of Lisma, Finland.

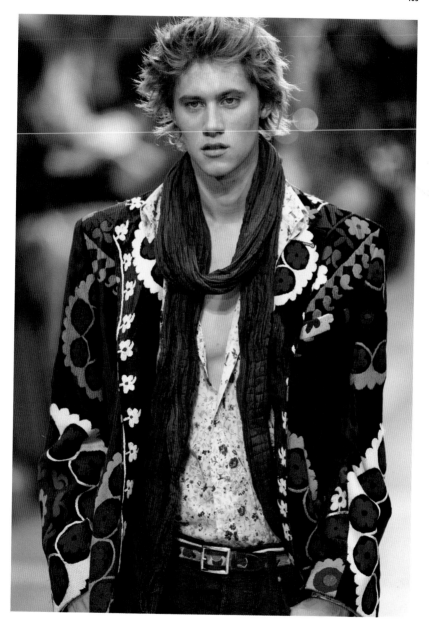

Big and bold, a brilliant woven jacket in reds and oranges on a maroon background.
2005 British designer Paul Smith's spring/summer men's show, Paris.

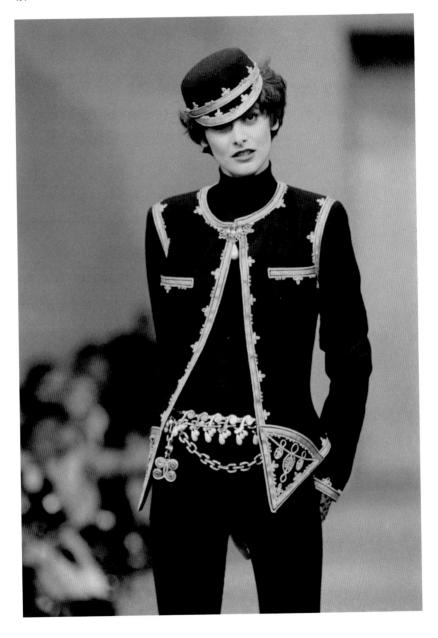

Bellboy and *branché*, a svelte black trouser suit with gold embroidery and a cap.
1989 French model Ines de la Fressange in Chanel's autumn/winter show, Paris.

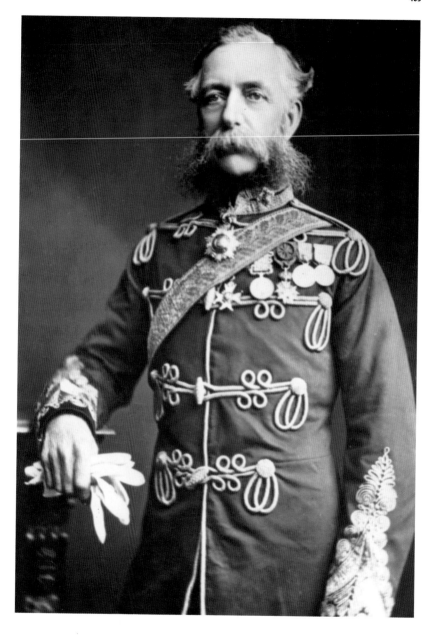

'The Charge of the Light Brigade', the general posing in his best bib and tucker.
1858 7th Earl of Cardigan, James Thomas Brudenell.

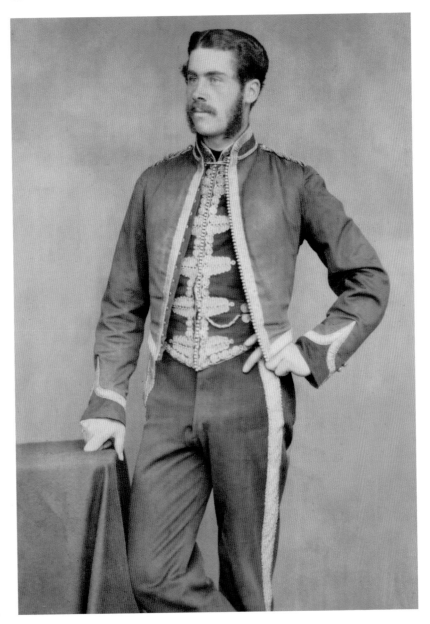

Buttoned-up and elegant as ever with embroidered frogging and a short jacket.
1860 A Victorian army officer in his best uniform, complete with a fine waistcoat.

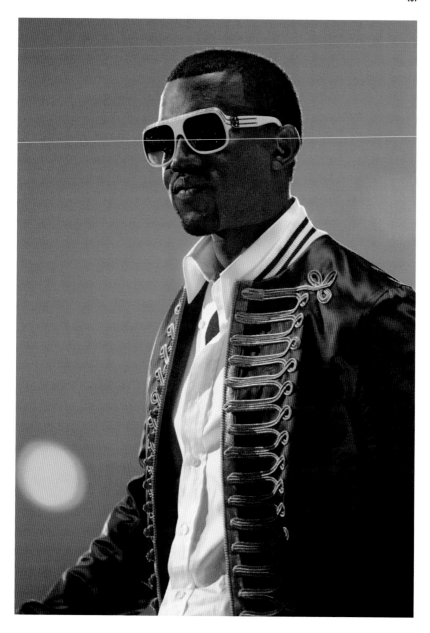

A right raver in a red silk military-style jacket with gold frogging and sunglasses.
2006 American rapper Kanye West, best male solo artist at The Brit Awards.

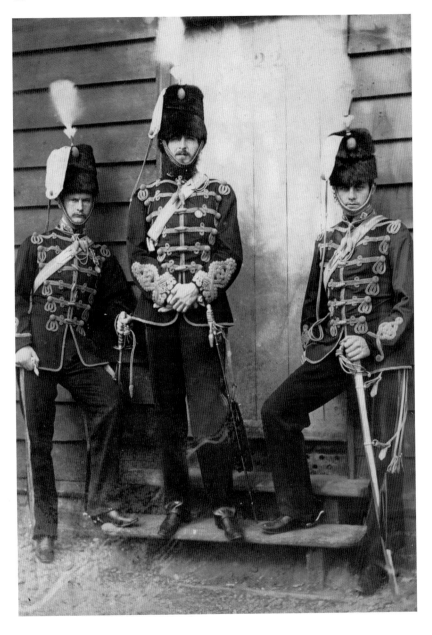

Ladies always love a man in uniform, the more gold 'spaghetti' the better.
c.1860 British soldiers of the 19th Hussars cavalry regiment in full fig.

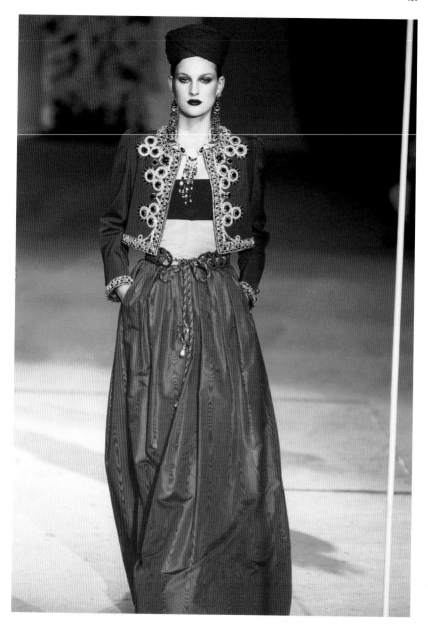

Inspired by Morocco and the military, a fez and an exotic embroidered blouse.
2002 Looking back to the seventies in YSL's swansong couture collection, Paris.

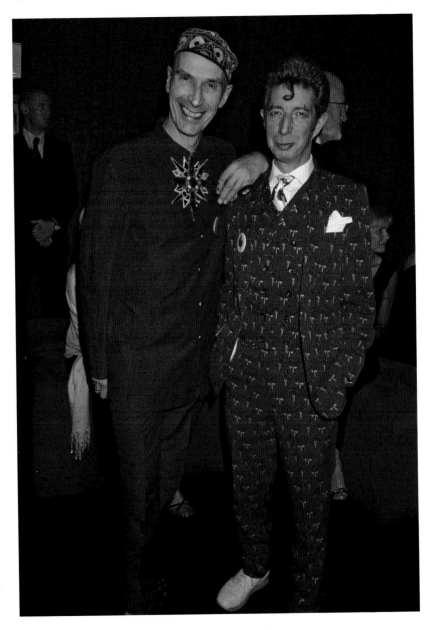

A duo of dandies, celebrating Shirley Bassey's birthday in cheerful red silk suits.
2007 British sculptor Andrew Logan and painter Duggie Fields at the party.

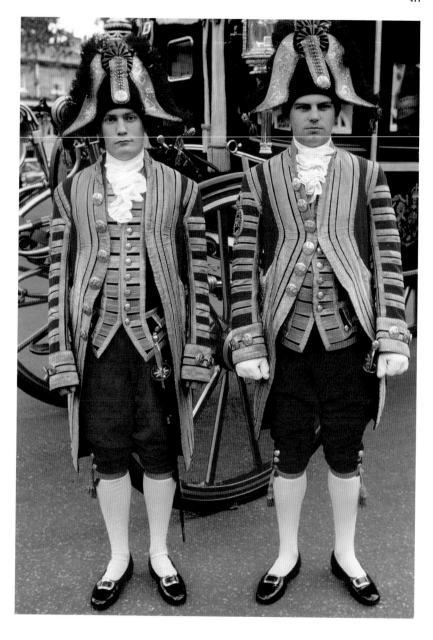

Perfect for a pantomime in red coats and breeches, dripping with golden braid.
1981 Coachmen in state livery at the Royal Mews, Buckingham Palace, London.

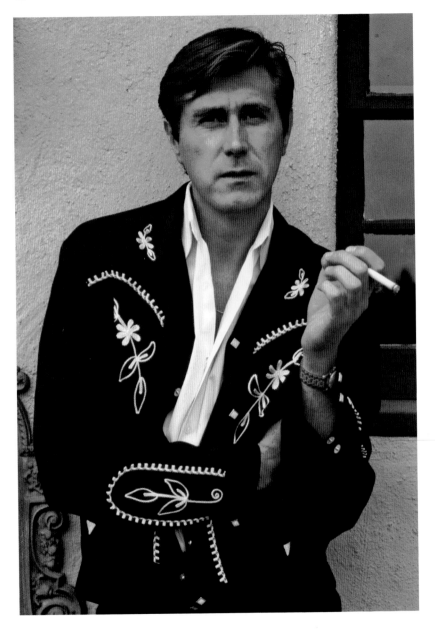

Down Mexico way wearing a black jacket with white embroidery and a crisp shirt.
1977 English singer Bryan Ferry of Roxy Music, in Los Angeles.

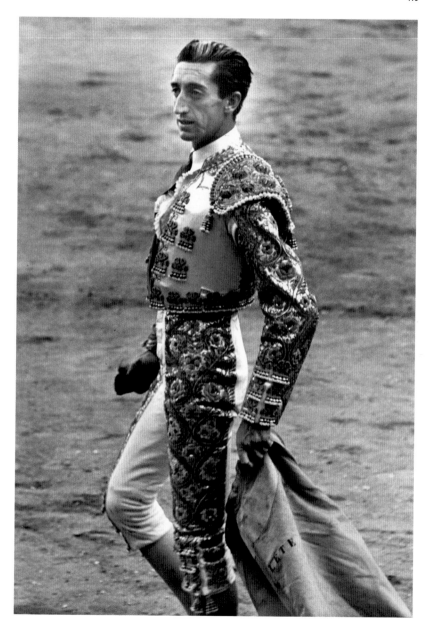

The good die young, with a sensational suit of lights and a swaggering demeanour.
1960 The famous Spanish bullfighter Manolete after dispatching his second bull.

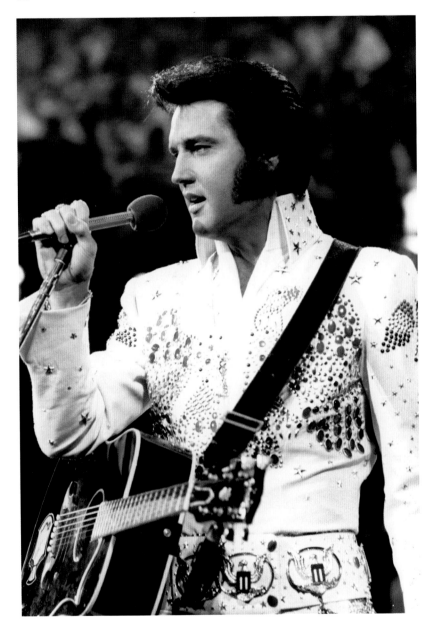

'The King of Rock and Roll' seducing his audience in his famous white suit.
1973 American singer Elvis Presley performing onstage in Honolulu, Hawaii.

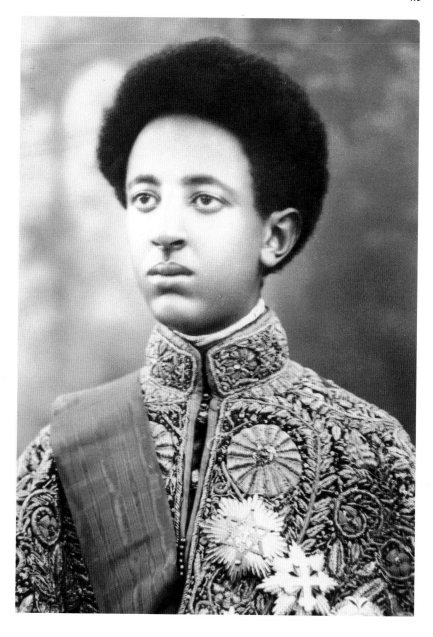

Regal with regalia, a heavily embroidered high-necked jacket with a silk sash.
1935 The Crown Prince Asfaw Wossen of Ethiopia, the son of Haile Selassie I.

PHOTO CREDITS

gettyimages® gallery

Many of the images in this book are available for purchase through Getty Images Gallery – www.gettyimagesgallery.com
Please call +44 (0) 20 7291 5380 or email gallery.enquiries@gettyimages.com